FOUNDATIONS
OF MODERN ART

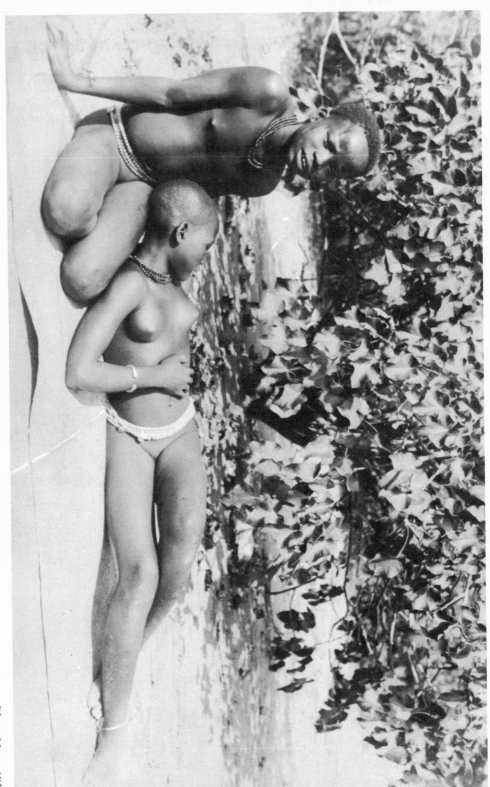

FOUNDATIONS
of
MODERN ART

OZENFANT, Amedee

TRANSLATION BY JOHN RODKER

PART I

THE BALANCE SHEET:
WRITING · PAINTING
SCULPTURE · ARCHITECTURE
MUSIC · SCIENCE · RELIGION
PHILOSOPHY

PART II

STRUCTURES FOR A NEW
SPIRIT

DOVER PUBLICATIONS, INC. NEW YORK

First German edition 1931 First English edition 1931

First French edition 1928 First American edition 1931

New American edition, augmented, 1952

COPYRIGHT 1952 BY
DOVER PUBLICATIONS, INC.
1780 BROADWAY, NEW YORK 19, N. Y.

ACKNOWLEDGMENT OF PLATES

THE photographs used in this book are reproduced by kind permission of :

M. Marc Allégret (pages ii, 41, 145, 297). These form part of the admirable collection brought back by him from the Congo and published in André Gide's " Voyage au Congo " (*Nouvelle Revue Française*).

Herr Karl Nierendorf (pages 270, 271, 272, 288). These beautiful plant forms are taken from the work *Urformen der Kunst* (Wasmuth, Berlin).

M. Scholten (page 168).

Herr Erich Mendelsohn (pages 146, 147, 148).

Bernheim-Jeune Galleries (pages 54, 63, 66, 67).

L'Effort Moderne Galleries (Léonce Rosenberg) (pages 51, 87, 112, 123).

Paul Guillaume Galleries (pages 114, 125, 239).

Percier Galleries (page 78).

Pierre Galleries (pages 29, 131).

Paul Rosenberg Galleries (pages 22, 28, 86, 96, 98).

Simon Galleries (pages 50, 65, 69, 71, 72, 75, 83, 85, 89, 91, 92, 105, 106, 111).

Van Leer Galleries (page 133).

Messrs. Cahiers d'Art (pages 20, 126).

Messrs. Archives Photographiques (page 205).

Messrs. Bernès Marouteau (page 81).

Messrs. City Photos (page 246).

Messrs. Giraudon (pages 238, 264, 280, 298).

Messrs. Horace Hurm (pages 160, 161).

Messrs. l'Illustration (pages 157, 220, 264, 294, 301).

Messrs. Keystone View Co., Inc. (pages 3, 5, 11, 14, 59, 60, 95, 97, 99, 149, 153, 156, 174, 188, 192, 200, 207, 209, 210, 219, 221, 243, 291, 295).

Messrs. de Masson, publisher (page iv).

Messrs. Grands Magasins du Printemps (page 163).

Messrs. Radio Umschau (pages 213, 236, 290).

Messrs. Rap (page 198).

Messrs. Wide World Photos (pages 56, 176, 179, 218).

Messrs. the *Daily Mirror* (pages 3, 60, 158, 164, 315).

Printed and Bound in the United States of America

DEDICACE
1952

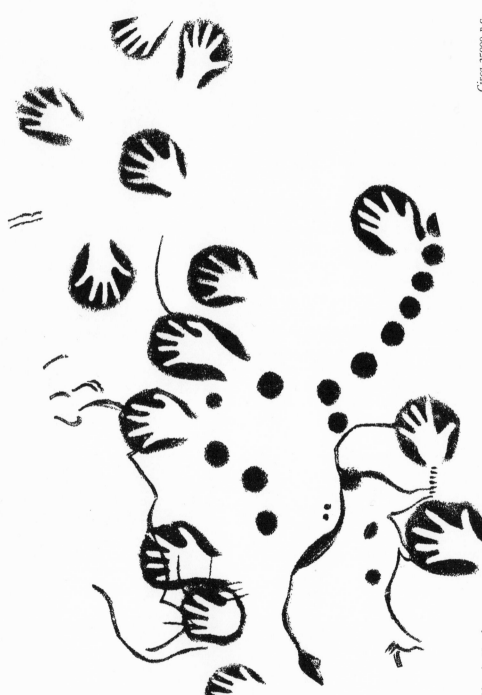

Circa 25000 B.C.

Prehistoric Hands.

PREFACE 1952

ENGENDERED by the most lyrical of scientists, the Atomic Age was secretly born at the University of Chicago on December 2nd, 1942, as the first atomic pile began splitting atoms.

More and more astonishing does the physical world reveal itself. It is going to be more and more difficult for artists to paint only what they see with their eyes. The new vision of the world was, but yesterday, the province of some few advanced specialists, physicists and astronomers. Now, thanks to the apocalyptic publicity given the Bomb, numbers of people no longer merely trust their eyes.

The material world has become immaterial: spiritual. Yesterday sun, moon, stars, oceans, and mountains were necessary for poets' dreams: their Muses needed mass and matter! Today we think there is in the tiny dot that ends this sentence more organized worlds than stars that glitter in heaven.

Yesterday our dreams of the universe were one-way dreams, soaring towards the sky. Today our thoughts oscillate between two fabulously distant but homologous poles: atoms and stars.

I presume that our school children in twenty years when their minds have digested the modern vision of the world, will laugh at the way our fathers saw the universe, as nowadays we smile to think of God with a long beard.

I predict changes in the arts, as for instance, from the currency of the idea that all existence is motion and thus Time. As a result we shall no longer content ourselves with works that a flicker of the eye exhausts. Our eyes will be offered elaborate interplays of forms designed to compel our sight to linger and to integrate them into the motion of Time. Forms and colors will pass before us like music.

The man of tomorrow will see via relays of new telescopic or microscopic *radars* not only what our superficial retinas see now but also living atoms and celestial bodies: he will see life functioning in living bodies and, possibly, what we call Thought.

The more science gives us new realities, the further progress true poetry makes. The more science prolongs its sight, the wider do dreams extend their wings and their flight.

Will the Atomic Age be merely a negative Prometheus age—or a new Promethean and creative era?

For myself, anyhow, I have chosen to continue to follow Vauvenargues' advice: *"As though we were never to die, so must we live."*

NEW YORK, 1952

TO ALL, MEN AND WOMEN,
WHO HAVE PLAYED SOME PART IN MY LIFE.
TO MY PUPILS AND OTHERS UNKNOWN TO ME
WHOSE DESIRE IS WORTHILY TO CREATE;
BUT WHO
ARE TROUBLED BY
THE MEANINGLESS IMBECILITIES
OFFERED AS THE VERY LAST WORD
IN CIVILISATION.
NOW HOMAGE TO OUR ANCESTORS;
AND FAITH IN THE RISING YOUNG!

AUTHOR'S PREFACE

(1931)

I consider " Art " as a preface. All our acts are the preface of what we shall never realise: our Ideal.

*

The English edition coming two years after the publication of the original French one, I had thought of completely revising " Art " in order to incorporate therein the important events in Art and Thought of these last two years.

I have not carried out this revision, however, for I find, with surprise, that in these two years no movement really new has taken place in the Arts, Letters, or in Thought. Everything has continued on the lines visible or foreseen in 1928.

If I had to write " Art " today, I should write exactly the same text that has served for this translation. The main body of this edition does not, then, differ from the original French text (now in its sixth edition).

*

In France the book has had a wide success, but it has not been entirely understood by all.

Some have appreciated the desire for precision embodied in it, but have only seen this precision, and not the goal I assign it. Others have regretted this precision that they call aridity. Others have regretted my philosophical

turn of mind, etc. I flatter myself that in Anglo-Saxon countries my ideas will be more completely penetrated, and the way in which the spirit of exactitude is matched with the sense of the relative.

*

Hence few have understood that, if in the first part of the book I write as historian and critic of facts, in the second I draw up the inventory of the clear notions, unhappily too rare, that we might have, in the impenetrable mystery of the world. And this effort to bring to light a few realities, does it not imply precisely that the author feels himself drowned in the unseizable cosmos, and stretches his arms ardently towards the slightest blade of reality that floats? Are we so rich in certitudes that we can afford to lose an atom of one?

For I am of the Occident. It is impossible to me to lay me down, or not to act or think.

I like Action, and praise it here because it makes us forget the tragedy of our ignorance.

Do I delude myself with the power of Action? Only a transcendental reality could satisfy me. But it is man's nature only to be able to see the "real," the highest transcendency; or, rather, what we name thus is still, without doubt, only reality without transcendency.

Renouncement : The Orient.
Action : The Occident.

I say somewhere in this book that Oriental wisdom is having the sense of the uselessness of everything, and of Idleness. Action has always made the greatness of the Occident. The greatest, indeed, have always seen the vanity of acts, measured in relation to the Infinite and the "Unknowable," and they have seen it just as well as the most pessimistic of Oriental sages: but they have understood the relative grandeur of Action in face of man's incapacity.

Besides, are we not ourselves Orientals long time emigrated? who, having evolved under Western skies, have had the power to create this great and high civilisation that is ours, my friends? And we have no reason yet to let fall our arms.

PARIS, *January*, 1931.

[*The author was kind enough to supply this special preface to the present edition in English.*]

PREFACE

GIVEN many lions and few fleas, the lions are in no danger; but when the fleas multiply, how pitiful is the lions' lot!

Up to the middle of last century a fairly small but highly cultured élite was the arbiter of all creations of the spirit. The verdicts pronounced by it were accepted by a public anxious to elevate itself, and the authority of certain great minds made up for that one charming defect of our race: lack of seriousness. Today, however, the so-called aristocracy and masses are satisfied with a culture purely derivative and unorganised, with the painters and writers it honours on a similar level, the cinema level. What, then, has happened? Those who cannot treat everything lightly are scoffed at, and thinkers and great artists are merely tolerated when they are not quite simply exterminated. But oh, the rewards of the entertainers and those who parody their betters!

Let us beware lest the earnest effort of younger peoples relegates us to the necropolis of effete nations, as mighty Rome did to the dilettantes of the Greek decadence, or the Gauls to worn-out Rome.

<p style="text-align:center">*</p>

I needed an axis round which to focus my own thoughts.

What becomes of the sidereal dust, the shooting-stars of light? And the thoughts, so swift, so sudden, which all our lives dash madly over the screens of our minds? Little by little that dust accumulates in the orbits, which with infinite slowness, but irresistibly, are determined by natural forces; then earth comes, propitious to the voyaging seed, the first root takes, an axis round which will focus all the structure of a tree. So with our fleeting thoughts: a day comes when they fall within some "gravitational field." I felt an axis tauten in me too, but only by fits and starts.

Then, fortunately, my 5 h.p. broke down in the Dordogne, so that for some hours I was stuck. I look up my position on my map, and find I am half an inch from the famous caves of Les Eysies.

Had I not heard that the charming inhabitants of the province of Quercy were direct descendants of palæolithic man, and that their metropolis had been Les Eysies de Tayac, the Paris of the Ice Age? How could I not pay it a visit? Later, deeply moved, I gaze at a through-section of earth where, for fifteen feet, superimposed one upon the other, are to be seen the successive levels of this site, which over a period of three hundred centuries, it may be, had always been inhabited. Now the high-road runs close by with all its

burden of motor-cars. In these various layers, certain cinder-coloured streaks
signified the ancient hearths. Merely by bending you could pick up the
stone implements of the primordial races, numerous as the pebbles on a
beach. At Cabrerets a cave has just been discovered which some fall of
earth has blocked for fifteen thousand years: deeply moving are the pictures
that were found in it. Man in his entirety is revealed in them.

Ah, those HANDS! those silhouettes of hands, spread out and stencilled
on an ochre ground! Go and see them. I promise you the most intense
emotion you have ever experienced. Eternal Man awaits you.

LOVE. There you will see the mother and her infant following her.
The woman's footprints are still discernible in the earth, which was soft
then, but petrified later; they alternate with those of the child.

THE LAW OF THE UNIVERSE. A drop of water falls for countless
æons upon a stone, wears it into a pebble in the hollow of a little cup, and
goes on smoothing and perfecting it: such is our dependence on the laws of
the universe and its ceaseless perfecting.

RELIGION. The immanence of death: the cave was a temple and the
" frescoes " totems.

DEATH. A bear's skeleton in the rock, the marks made by its claws
intact in the clay.

ART. Certain of these totems are beautiful.

I have seen plenty of curiosities all over the world, and much that was
magnificent, from Paris to the Ural Mountains, Finland to Rome, Amster-
dam to Granada. But nothing, nothing, nothing ever caused in me a shock
so prodigious, or was accompanied by such protracted echoes and reverbera-
tions. For the eternity of Cabrerets liberates in us those secret infinite
potencies which are stifled by all our frivolities, and posits as foundation for
every act, our immutability and the ineluctable eternity of all our actions
when they issue from our uttermost depths.

Monsieur and madame, tourists, were also present, waiting for the guide.
We began talking of Paris, composers, writers, painters in vogue: but when
we came out, pensive, there was no more talking. What a clean sweep!

I had found the Ariadne's thread for my book. Monsieur and madame,
you were with me on my road to Damascus: I had found my axis without
which nothing can be constructed: eternity was my touchstone.

One more paper-weight fetish has been added to my work-table; it is a
stone axe, reminder of our " constants "; it is the pendant to my pyramid of
rock crystal, something to induce hypnosis, symbol of Art.

This book is a fugue on that theme whose profound elements irresistibly
took possession of me, underground, beneath the still-living gesture of our
remote progenitors.

*

Our " Constants " is the problem on which I have tried to throw light, for that art into which they do not enter is the art in vogue, a distinction which has its value nowadays; for without and within, it is the ephemeral that matters to us. Art is becoming something fugitive, and that is the quality we seek in it.

But what strikes me, on the contrary, is not how ephemeral all is, but particularly how prodigiously stable mankind is, and the common qualities that characterise everything that everywhere and at all times has profoundly affected him.

Such a conception emphasises the prestige and human significance of art. What would result if art passed away? And it would pass away if our nature changed. Fortunately, relics from the very abysms of the ages vouch for its perpetuity.

These vast "constants" in mankind, these primeval cadences, I have related to the conception of "Tropisms."

A plant grows in a cellar, it branches out towards the light: Tropism. The dying day saddens, and dawn makes us rejoice like birds: Tropism. The Pyramids move us: the unchanging character of a Tropism. The ritual masks of negroes fill us, like them, with religious feeling: the universality of a Tropism. A top-hat is solemn in the eyes of every man on earth: Tropism of a shape. Mankind is attracted to love like iron to the magnet; all react to given conditions, temperature, electricity, gravity, or deeds: Tropisms. I have made a generalisation of this term because to me it seems fecund, comprehensive, comprehensible. It reveals our gods, physical, metaphysical.

Man is a soloist in the universal orchestra, but he is free to play true or false, that is, in harmony with his "constants" or in disharmony with them. It does not seem to me derogatory to know I am subject to the laws of gravity, a crystal shaped by superior power, directed by the impalpable and rigid threads of the forces that govern the universe. It is a joy to feel myself a messenger-pigeon, an arrow that undeviating returns straight to its loft. And yet, above all things, liberty is most important to me. If the loadstone that draws me is clearly apprehended by me, surely then I can encourage its love for me. But also I can, if I wish, resist it, derail my tropisms, so to speak. Clearly then, it is of my own freewill I switch over, and in this fashion we are free.

I have sought to formulate those tropisms which are most clearly apprehended. On them I base the art that derives from " constants." I call it " Purism."

Purism is not an æsthetic, but a sort of super-æsthetic in the same way that the League of Nations is a super-state. By which I mean that, superior to individual fashions of feeling, thinking and acting remain always the

"constants." Purism is therefore not a form of art, but an attitude of mind and a procedure. (Neither is it an eclecticism, for it will only bow to what is lofty.) Here I am generalising and completing certain ideas expressed elsewhere on the subject of painting, for one of the intentions of this book, to make a synthesis, may turn out to be a pretension merely. For that reason I call ART everything that takes us out of real life and tends to ELEVATE us. Such a definition would include among the major arts that of pure speculation, whether scientific or philosophic. And why not? Art is not a matter of the particular technic used; that is merely the interpretative agent.*

This is the moment to give precedence to that art which determines every other.

THE ART OF LIVING

IT is often imagined that freedom, in art as in life, is identical with trusting to luck. But the best work does not spring from the endowments of that all too friendly purveyor which absolves us from the need to live at our highest; it is a product determined by our own attitudes as inevitably as a bunch of grapes is the result of the vine it springs from. I shall show that we create our own determinism and in what manner we are responsible for it. And for that reason I have formulated a system of ethics.

The one aim an artist could confess to should be that of producing great art. But this postulates a nobility of spirit that at no period has been so difficult to attain. Has man ever found himself in so tragic a moral situation? Every belief has been bled white or abolished, and we are left stewing in our own skins. Yet heroes and saints do exist, but they are civilians and wear hard hats. Scientists devote their lives, and do not in return expect either fortune or paradise; there is something fine in the stoicism of today, only it is rather rare. But the ordinary run of artists cannot be taken seriously, because it is so hard for them to dispense with acclamation.

The wretched attitude towards art that is general today wobbles on a foundation of Turkish Delight. This is a gifted age, yet think of the gifts that have been ruined by the need for distraction. We demand that the painter shall lead us from surprise to surprise; it is not the matured egg we demand, but Easter eggs in the latest fashion. The result is that the miserable artist, harried by the bored rapacity of his patron, goes on pretending to lay new sensational wonders. Frivolities merely. Or again. Nowadays the word "new" is the highest praise, even when applied to the

* I ask the reader to keep this principle in mind (those whose habit it is not to read prefaces will miss much of the point, and it will be their own fault).

worst trash. It is easy enough to seem " new " by perpetrating something
the masters would never have permitted themselves, had they even thought
of it. What imbecility, this prejudice of the hideous called beautiful is,
merely because it is new : as if every novelty necessarily meant something!

I have completely finished with what is pleasurable and with pleasure.
Europe is just cram-full of art, the result of the ferocious existence led by
its inhabitants, for which some antidote must be found; but no race has
ever invented worse sauces for it. Enough of this art for up-to-date
messieurs, mesdames, and mesdemoiselles, who know everything, but to
whom a mere trifle passes for art, a flirtation for love, Jean Jacques Rousseau
for the Douanier Rousseau, the Meistersingers for singing masters, Monet
for Manet, Pissarro for a Cubist, Henri Poincaré for a President of the
Republic, Chateaubriand for a way of cooking beef.*

That sort of person I am not writing for, but for artists who seek to
scale the summits, and for such men as seek in art grandeur and the
breath of inspiration. I write for the elect whose ideal it is to be the
repository of grandeur, and who, because of the jeers they meet with, hide
it as a blemish. The object of this book is to aid those whose desire is
the reconciliation of the heart and reason, and to prove themselves accord-
ing to that most generous interpretation.

My desire is to provide them with arguments in favour of an active
optimism, and to indicate a technic capable of leading them to some sort
of fulfilment, the only happiness permitted us : that which results from the
realising of some magnificent concept elaborated from the fundamental
" constants " of humanity.

Shut out from that splendid highway traced by Faith, which allowed
us to traverse life without too much anguish, Art still remains on which
to drift a while. Yet for that, too, we need a certain depth.

This book is in favour of " constants " and against the conventions
dictated by circumstance : in favour of an Art based on our categorical and
eternal feelings.

Being French, I should have preferred to demonstrate the time on a
dial most scrupulously marked; but consider my difficulty, when so many
people seem to have mislaid noon and to be looking for it round two p.m.

Yet so that my readers may find their way in the mazes of this book,
I offer them the thread which will guide them through its elaborations (as
electricians colour their wires variously in order to distinguish them).

The first is black and green inextricably commingled, and is the dramatic
soliloquy which treats of the problem of the universe, our lives, our destiny,

* *Am I exaggerating? Larousse's " Universel," the well-known Dictionary, gives:
" CUBIST, relating to Cubism. CUBIST PAINTER, expert at Cubism. Pissarro (sic) is a
Cubist (sic)."*

our death. This thread ends in an oasis. THE UNCERTAINTY OF UNCER-
TAINTY. Consequence: the right to believe.

The second is red. Familiarity with certain "constants." ART BASED
ON THEIR EVERLASTINGNESS.

The third is a singing blue like the gusty expanses of a summer's day.:
GREAT ART. Distractions scorned.

The fourth is of crystal most difficult of apprehension. Love of under-
lying laws, of interrelations, cadences, and fine STRUCTURES.

The fifth acts as a spring-board to fling us to the heights of ELEVATION.

Les Eysies, France, 1927-1928.

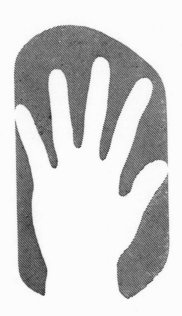

A Prehistoric Hand.

TABLE OF CONTENTS

xvii

TABLE OF CONTENTS

With the exception of PREFACE 1952, *the new chapters* EVOLUTION OF PURISM *and* PREFORMS, *and* NOTES 1952, *the present edition is an exact reproduction of the original English edition of 1931.*

FOUNDATIONS
OF MODERN ART

PART I

BALANCE-SHEET

INTRODUCTION

SOME chapters in this book are long, others short, above all towards the end. In seeking indications of a common spirit underlying various forms of expression, it was hardly necessary to repeat what has already been stated; besides, certain forms of Art are better adapted to reveal such a spirit. The lack of proportion therefore, in the various parts of this Balance-Sheet, does not at all imply that I attach more importance to any one art than another. Where excellence is concerned all the arts are equal.

Let us, if we can, isolate what is common to the thousand masks of today. I seek the degree of difference between the work of art of this age and of the past. I shall not, therefore, stop long over the accessory divergencies revealed in their authors, but I shall treat of the main trends of this age, and in particular of its most striking manifestations. It is wisest to register them now, while still fresh in the memory of witnesses, for we cannot know whether they will seem as important to posterity as they do to us.

Let us be quite clear. My object is to treat of the conceptions, or, failing them, the manifestations, of what are known as the *Advanced* schools. I am not writing the whole history of Art and its creators, but that only of those whose ambition it was to innovate, who did innovate or were considered to have done so. For which reason there will be no mention here of great artists whose work did not produce an outcry, for that is the indication of the innovation or revolutionary change.

We shall ignore "nuances"; autumn is the time for russet tints, as spring for all the world to be green; but if urban chestnut trees pretend October is May, does that in any way affect the seasons?

I shall not cite many names. No particular achievement is completely typical of its school, and the reference to names is an immediate reminder of the differences between them, each in spite of the common direction, having its own personal .co-efficient. Nothing conforms strictly to type. My intention has been to indicate where the most important members of each group are in harmony with each other. Certainly those who sat at

their feet, and drew nourishment from their thoughts or creations, were able to produce beautiful things, thanks to the master-minds; what counts, however, is not the quantity of passive drops, but the energising sweep of the current. Besides, we are too close to the facts to be able to make such an inventory without injustice. That certain names are quoted or omitted, does not in any way imply either praise or detraction.

Let us trace out the main trends of today. The rest can be left to the reviews, the catalogues of bookshops or picture galleries, directories, or dreary historians with no dominant theories. There are, it is said, thirty thousand painters in Paris, rather more writers, but how many thinkers? However, I am not a census official.

I keep to main trends; I am not dealing with variables.

Had a careful record been kept in 1789 of all the oscillations in the behaviour of the revolutionaries, the resulting graph would have been undetermined and zigzag; yet the revolution had its axis, something was dominant; it made history, and our lives today are determined by it.

Science today is ruled by relativity. Does that necessarily mean that Einstein and all the scientists are agreed on every point? Nevertheless, Relativity is something that can be spoken of. The technic, the mannerisms of the Cubists: Braque, Picasso, Metzinger, Gleizes, etc., have they always been in perfect harmony? Yet Cubism came into being.

It is because, more important than all the divergencies, are the convergences, by whose means an axis is provided round which conceptions, systems, technics, may be grouped into an organic whole. This is the essence of synthesis, not to be confounded with mere symmetry: even in assymetry the axis dominates.

THE REVOLUTIONARY IMPULSE

IN 1789 the simmering free-thinking of Montaigne, Montesquieu, and the Encyclopædists burst like a bomb. Followed the Revolution, which quite suddenly justified and legalised that attitude to life. The right to think was delivered from all legal interference and from all penalties whatsoever. No more *lettres de cachet*! It was a right which paved the way to innumerable consequences, and helped to liberate every mode of thought from then on: art, science, our very thoughts. Even in what seems most opposed to it the 1789 spirit persists, as, for instance, the case of Léon Daudet.*

* *Léon Daudet, the well-known Royalist of the Action Française group, whose avowed object to restore the Monarchy to France would consequently overturn the Republic.*

Up-to-date Zulu Chief leading a Tribal Dance.

Freedom of thought, so violently suppressed in the past, once it was lawful, became a normal trend of the spirit. Yet that right, so yearned for, for which men have fought and died, do we always make good use of it? We make a great show of it, but in the manner of a negro king with an umbrella. Nevertheless, for more than a hundred years we have owed to 1789 everything that has been truly great.

As for the philosophers: after the harsh battering-ram blows of Bacon, Locke, Hume, Kant, etc., upon the Bastille of *Accepted Ideas*, they let themselves go entirely, even to the point of questioning Descartes' argument of "evidence," on which was founded all the philosophy of the eighteenth century: the extraordinary consequence of which was that the agility communicated to the mind by the Cartesian method caused the destruction, at a given point, of that method.

Mathematicians, too, found wings. Gauss, Euler, Riemann, Lobat-chewsky prepared that algebraic method which, no longer trammelled by common sense, now provides the means whereby Henri Poincaré and Einstein demolish the classical universe.

Darwin made use of this freedom of thought magnificently when he dared derive mankind from the ape. . . . All the same, there had first to be no risk of burning by the Inquisition. Freedom of thought and speech exalted the individual, and his faith in his reason. An era of scientific romanticism began: Rationalism.

In poetry Victor Hugo rushed athletically between the classical shafts. Read aloud, portions of his work read like contemporary "Dadaist" manifestoes.

Landscape painters had the daring to blow out the nightlight of the "schools." They came out into the full light of day. The independence of Théodore Rousseau, Millet, etc., is too much forgotten nowadays: they were the first Girondins of the arts. But that is what generally happens: the real instinctive revolutionaries are pushed into the background by the professionals of revolution, the men who exploit a formula, living or dead. Very soon however, the Impressionists, in revolt against academic formalism, either broke through the new standards or greatly modified them.

Of their momentary sensations they made their lyre.

But the individualism of today is the spirit of liberty made subservient to SELF: the universe and mankind at the feet of the individual. The one consideration is that self be satisfied. The artist imagines, paints, writes just as he pleases, and much more for himself than for society. To be understood is no longer his preoccupation: his idea is that it is the public which is to go to the trouble of seeking him out, accepting his behaviour, his decrees, his proclamations. An anarchy of the Self: egotism, whether unconscious or conscious and directed. Chateaubriand, posing as a pyramid

in the desert, prepares the way for the "god" of Guernsey. Hugo is the cinematographic enlargement of the individualism of today, the Sandow of Poetry. Not to mention his rôle of old Mother Goose, parent of innumerable tiny Phœnixes of no importance whatever, all busily preoccupied with their own individualities.

Yet this awareness of self had a certain fecundity; it, as it were, dug the grave of every privilege save that of man as God. It accepted nothing it had not personally verified; self was the centre of the world, and the world was fashioned in its image. Result, a thorough "revision." Good. But the obverse of the romantic medal is a preference for what is extraordinary, and especially for what is remarkable. The Romanticist has in him something of the Exhibitionist.

Fortunately, the cult of Humanity seems inseparable from a certain lyricism. In the art of the past this lyricism fulfilled a social function, and was therefore legitimate. But nowadays lyricism derives from the individual's antagonism to the world outside him. It is this lyric individualism which is the mainspring of our modern freedom of invention, the mighty effort signed by a single name: Napoleon, Victor Hugo, Rimbaud, Darwin, Einstein, Cézanne, Lenin.

In this Balance-Sheet I attach extreme importance to the method of expression which was sought after or employed. The study of the technic chosen is admirably revelatory of its creator's intention; it defines the æsthetic bias. When a hammer is lifted we realise there is a nail somewhere about. We realise that thoughts, feelings, and individual emotions require languages that must be new and "to measure." Up to the middle of the nineteenth century all men expressed themselves as they had learnt to do, and only the most audacious, though with utmost timidity, dared introduce modifications. But today, in the marching column of art, literature, and science, the battle is always an individual one, each creating, with no shadow of a scruple, a language for himself, which, whether good or bad, remains personal always. Of course, inexperienced pilots rejecting *a priori* known methods of flying, cannot all of them escape death: not everyone can invent "looping the loop" and so save himself. Yet nothing of all we consider valuable today, would have been so, had it not been for this new and special trend: the individual search for technics better adapted to the needs of each of us. Renan most excellently said: "Only that art, in which the form is inseparable from the content, is capable of being handed down to posterity, in all its entirety."

Is it better worth while to play some new melody on a highly perfected instrument or upon an instrument to be invented? The question is futile, because all we can know is the past: but the artists I speak of chose "innovation," and often succeeded in creating splendid works: proof sufficient that at times they were in the right.

I believe man to be identical with himself, and that, whether contemptible or noble, he has always been so. Nevertheless, not every period of his artistic history has an equal significance for us; some, indeed, only help to swell the tide of accepted tradition. But our own age takes nothing for granted: it is the era of living springs, and in consequence thrilling to live in. Unexpected leaps, startling pirouettes, are the special indications of innovating epochs. In these last years a thousand unimagined aspects of thought and art have been made manifest, so that it begins to seem as if all were sheer wilfulness, or the result of perfectly irrational decisions. As in the chain of Darwinian evolution, where vast stretches of time must accumulate before the links are at all distinguishable from each

other. Vehicles remain ridiculously like each other from age to age, then suddenly there is the train, the automobile, the aeroplane. So it is in contemporary art: sudden mutations and metamorphoses.

In the past, great artists were the salient peaks of continuous ranges: the " schools" developed with extreme slowness: the outstanding individual succeeded more greatly, but within the limits of the accepted norm. Greek art through various epochs insensibly passes from the archaic to the culmination of the fifth century, then back to the naturalism of the fourth: in Egypt, twenty centuries express themselves always in the same tongue: Byzantium is perpetuated by Rome, and Gothic only gradually takes the lead. Art developed gradually, because the soul of man developed gradually, and art is a mirror. In point of fact, the Renaissance continued almost into our own generation. Even a painter like David is the product of the technic and æsthetic of Raphael: Delacroix carries on Tintoretto, Ingres is continually preoccupied with antiquity. But nowadays the attitude is not to take the past into account at all. And in fact, what preoccupies us is something very different.

And Michael Angelo, Rembrandt: those meteors?

Yes, I know! But we shall see even stranger breaks with tradition than those of Michael Angelo or Rembrandt. Nowadays certain kinds of painting are so strange that if these masters could see them, it might not even occur to them they were looking at painting, or that we considered it as such. Is not that new? From century to century Montaigne, Voltaire, Chateaubriand, eminently different though they were, spoke almost the same tongue and submitted to the same rules. Baudelaire's vocabulary, his syntax, his grammar, were the same as Bossuet's. At most a Saint-Simon took a few liberties with the language that were considered daring, but how mild they are compared with what certain of our young writers permit themselves!

Rimbaud was one of the first revolutionary extremists. He helped to release poetry from the dictatorship of poetic convention. Mallarmé went much further; he invented a technic that was entirely new, and broke absolutely with the customary use of syntax, grammar, language, the better to intensify his lyricism. As a result, lyricism is no longer a state of feeling stimulated by an original bringing together of logical conceptions, but a play of imagery, or fragments of thoughts which are often illogical or absurd. This is something entirely new; an absolute liberation. Excess itself even has become permissible and praiseworthy. The poet's effort is here parallel to that of Rodin, of Cézanne, of Matisse, in liberating painting from its representative function.

I shall not refer much to musicians, for their art has always been less cluttered up with convention. Nor had their revolution in æsthetic and technic to be nearly as fundamental as that of those who practised other arts.

The liberty inherent in their art came from the fact that music does not have to be representative. Nevertheless, Berlioz, Wagner, Fauré, Debussy, Ravel, Satie, Stravinsky, Schönberg, like Rimbaud, Mallarmé, Rodin, Cézanne, Matisse, and the Cubists, fought to free the arts.

As for the scientists, they were conservative without being aware of it. The prestige of Newton dominated them, and none among the free-thinkers of the eighteenth century was independent enough to contemplate questioning the theories of that great thinker. If new experiments seemed to throw doubt on them they were quickly modified to fall in with the " leading " theory. For which reason certain discoveries as to light, polarisation, etc., for which no place could be found in the Newtonian scheme, had at all costs to be reconciled with the orthodox creed. The spirit of the free-thinking revolution had to penetrate into the sciences before Fresnel, in 1819, dared strip Newton of some of his prestige.

And Galileo? Was he not a remarkable revolutionary even earlier than 1789?

So were our own scientists, but far differently. Galileo pointed out that it was not the sun which moved, as the Bible asserted, but the earth : the Galilean universe was still that to which our senses bore witness, an Euclidean universe : but thanks to Gauss, Riemann, Lobatchewsky, the poet-mathematicians Poincaré and Einstein dared envisage a space that our senses could not know, with the result that the common sense of Descartes is proved wrong by their untrammelled and lyrical imaginings. At which point our universe becomes a hypothetical one, based on astonishing laws, with geometries of more than three dimensions, which go so far as to assume that, owing to the curvature of space, the rays issuing from the sun curve at the extreme limits of space and return to their point of departure. An extraordinary universe in which the stars are but virtual illusions caused by rays curving back to the place where once, ages ago, shone suns now extinct. An infinite world despite its finiteness. Infinite because everything in the universe must be curved as a result of gravitational fields; but a " bounded infinite," the presentation of which is no longer a straight line projected to infinity, but a curve for ever recommencing. Galileo was more cautious. All the same, he just missed being burnt for calling attention to a simple optical illusion.

Thus then, on every side, we are liberating ourselves from classical and realistic modes of thought, derived from present aspects. Here is the curious duality :

{ The free-thinking rationalism and materialism of the past have brought about individualism, which is responsible for lyricism, irrationalism, and anti-realism.

An opposing duality of reason and phantasy, which I hope our age will succeed in resolving into a lyric reality.

The mere fact of liberty is an intoxication, which to those who have once tasted it, grows into a passion. Super-geometry, super-poetry, super-painting, super-music: all these result from the need for extreme liberty and extreme intensity of feeling. The taste for liberty is always more and more closely associated with that of intensity. In the past men sought for effect by means of long poems, vast symphonies, immense canvases. Nowadays the impulse is all towards efficiency: to say and make as intensively as possible.

There are marvellous passages in Beethoven, but much that should be swept away; so, too, with Tintoretto, Rousseau, Chateaubriand. But think what a powerful accumulator Rimbaud's slim volume is: the power in small compass of a painting by Cézanne, a composition by Debussy, an electro-magnetic formula. Force derives either from mass or energy. And the modern method is energy. Larks prefer a tiny twinkling mirror to a calm pool.

Art and ancient thought were in some sort linear, leisurely: modern art is active, determined, compact: complexity, polyvalence. One of the tendencies of modern machinery is to make one agent serve over and over again: the turbine, for instance, where the propulsive power of steam is directed against thousands of vanes, thus utilising all the energy available, instead of dissipating most of it into the air after one big feeble impact, as in the case of old-fashioned piston chambers.

Cézanne, Rimbaud, Mallarmé, Poincaré, Debussy invented the compact, dense poem. Conceptions, forms, sounds, became innumerable cogs acting and reacting on each other. The work of art became efficient and significant to a degree undreamed of.

The trend towards efficiency leads to synthesis. For example, in the past, a confused pluralism ruled over the sciences. Mechanics, physics, chemistry, biology, etc., were almost independent of each other. Nowadays they tend to merge into electro-magnetics, a monism with innumerable attributes.

> "Electro-magnetism bears within it an astonishing capacity for development, considering with what little effort it has assimilated the immense domain of light and radiant heat, and the new discoveries it is perpetually making, after, as far as mechanics was concerned, having come to a dead stop. Electro-magnetism has assimilated the major part of physics, absorbed chemistry, and reconciled an enormous number of observations which before were formless and unrelated." (P. Langevin, Evolution de l'espace et du temps.)

The ideal of science is to discover formulas whose function is to reconcile all possible phenomena. The equations of Einstein, in which time ranges with the three classical Euclidean co-ordinates, attempt a complete synthesis of the universe and claim to be able to account for every possibility.

> "*What is generally meant by a great thought is when something is said which reveals a whole host of other thoughts, so that we discover something suddenly which only hours of reading could make clear to us.*" (Montesquieu.)

Yet deep in every revolution, discreetly hidden, presides a classicism, which is a form of "constant."

Nevertheless, one objectionable aspect of modern art there is, and that is its cult of "astonishing." This autocratic method of procedure is a legacy from the Romantics. There is no liberty which has not to be paid for, and the longing for liberty very easily leads to blows. To be "outrageous," independent, subversive, are all ancient modes of monopolising attention which are still in vogue. The victor returning from a campaign still retains some of his aggressiveness. Children when they have their first gun fire off hundreds of cartridges at non-existent sparrows. It is a world of fantasy.

Naturally, after a hundred years of this sort of thing, an artist is hard put to it to invent some new means of being "outrageous."

In the arts, as in the Chambre des Députés, the "right" is distressed at not being taken for the "left." The supreme talent is to be "left," still more "left," always more "left," extreme "left," extremest "left," super-"left." And what is not done to be so! It is the universal panacea. I mentioned 1789. Tradition! Why, Hugo was saying: "*I clapped the red bonnet of freedom on the dictionary of the past.*" Well! I ask you!

Our age is a propitious one for great achievements. And if we are justified in thinking its art not always at a satisfactory level, let us not forget that upon the artists and thinkers of this epoch has devolved the onerous task of questioning forty centuries of accumulated and academised thought. A Great Wall of China of stereotyped thinking, debts to the past and inherited usages, has had to be demolished. An Augean era. If, for a hundred years, the most eminent of them have concentrated so much effort on this form of vacuum cleaning, they must be forgiven if occasionally they lose sight of the fact, that a work of art is the expression of beauty at its loftiest, and only that.

What heroism! Yet with virility they took up arms against what was accepted as truth, though often but hoary convention. Such demolition was necessary, in order that art might one day attain the truest freedom

from every limiting influence (save only that of its proper ends). Do we ever give sufficient credit to the determined effort of these scavengers now that, thanks to them, we are free as wild ponies? Recall to mind the habitual tragedy in the lives of these pioneering masters, their toil as patient in application as their discoveries were remarkable. That independence of theirs was dearly bought: but others often thought it sufficient merely to imitate a freedom which they had done nothing to merit.

Masters of the first importance have been revolutionaries. Yes. People seem to assume that every artist owes it to himself to be a Lenin, but against what nowadays, O God of the Arts? This tic is becoming the worst

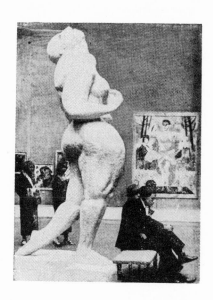

tyranny of all. Is the result worth it? What ridiculous figures they cut, the traditionalists of the artistic revolution, the pantalooned Tartarins and garrulous Nimrods, hunting lions at the North Pole and tracking illusory diplodocuses. To leap over a wall is not a particularly good joke when the door is open. I esteem the revolutionary spirit. And as a lever there is often much to be said for its qualities, its generosity, its charm. But the one revolution essential to art nowadays should be the breaking with all revolutions that have no object, for artists from now on have full right to do anything they please in music, literature, painting, ideas, all of which in no wise resemble those of tradition. Art from now on proceeds in all nakedness: more than naked even. Let the scientists reveal a universe to us that is completely topsy-turvy, and we will acclaim them. It is the very Eden of Liberty. So then?

In short, let us congratulate ourselves that we have gone far, sometimes too far. Some expeditions were sacrificed, but it was necessary. But once we have information that certain deserts are sterile, what purpose can be served in returning? When innumerable brave men perish cutting the barbed wire, we others must go through, else why the wasted lives? In art we stand before that open breach, cutters in hand, languidly or nervously looking for wire that does not exist. Let us once a year make the most of the 14th of July and enjoy all our rights, including that of not abusing them.

⎧We must beware lest new and futile obligations be forced upon
⎪us. It would seem that that is exactly what the academic attitude
⎨to revolution in art does stand for. The art of storming non-
⎩existent Bastilles quickly becomes " vieux jeu."

To consider yourself obliged to abuse every right is to create very dangerous obligations for yourself. Art would perish if it went on idiotically admiring its navel and repeating that it was free, free, free. Yes, it is free, fortunately, at last: but art is intended for mankind, which has its laws too. I mean those of feeling, of soul, of heart, which, in spite of what is said, have their own logic and needs. Nothing of our common humanity is truly free if tested by our conceptions of liberty. The abuse of liberty can give nothing to art: art is " structure," and every construction has its laws.

It is not difficult to abuse our liberties, but it is difficult to reject those which do not promise to be fruitful.

But I am anticipating. These problems will be dealt with in the second part of this work: *Discipline*. Let us draw up a balance-sheet of the revolutions, as a result of which we now enjoy that complete liberty mankind set out to conquer more than a hundred years ago. For fifty years our epoch has been thrilled, for twenty impassioned, for ten feverish: now at this moment it seems that, as after fever, lassitude and longings have overtaken it: surely it must be pregnant!

LITERATURE

IN ITS LYRICAL ASPECTS

PEOPLE of wide reading, aware of the masterpieces written by our ancestors, are often inclined to crush modern poetry under the august names of the past, the names of the eras of perfection, achievement. And there are many to whom the patina is infinitely more alluring than the work itself. They have read, or think they have, Goethe, Heine, Virgil, Ronsard, Villon, so they can afford to laugh at the moderns.

But dare one remark that for forty admirable pages in the "Iliad," there are at least three hundred unreadable ones: that Ronsard, in spite of all his elegance, is often second-rate Renaissance: Villon sometimes in the worst taste: Heine stale and Goethe terribly prosaic. And, above all, it is always in the name of the undeniable errors of these great masters of the past that the young are blamed for their most real qualities, while the fact that some of their efforts have been remarkably successful is ignored.

No one can deny that a characteristic of this age is its anxiety, its curiosity, its spirit of research and non-conformism. Its disgust with established form lends an abiding interest, and sometimes pathos, to it. It is too easy to remark that the moderns seem often to be merely stammering, which they do in the manner of children trying their tongues, and not as do the old and feeble, mumbling their words. Anyhow, what chance have they got of mumbling? Nowadays the artist is only too often finished by the time he is thirty.

To judge the poetry of the pre-war epoch at its true worth, it must be looked at in perspective, and chiefly with an eye to its intentions. I shall indicate the sources which fed it, not to deprive it of any merit due to its discoveries, but to reveal it from a vantage-point of perspective, similar to that enjoyed by the dead. It would be purposely damning contemporary poetry to pretend it to be derived solely from the typewriter, as Athene was born from the divine skull. It would be unjust to exclude it from participating in the prestige of a Poe, a Byron, a Hugo, a Baudelaire, etc., even that of a lexicographer; for philology, semantics, phonetics, all these are

preoccupations of modern poetry, and in some cases almost exclusively so. God alone, they say, owes nothing to anyone.

The poetical idiom of the past is in effect a prose made supple, malleable to lyrical needs, a form released from the consecutive unfolding of prose and the tedium of logic: a short-cut language, more forceful yet tenderer, equipped with a special and accepted vocabulary considered noble (azure,

sirens, conches, etc.), yet with its own logic. Rhythm helped it more generously than it did prose: the sonorousness of music reverberated through it, but all its technic was closely subjected to prosody, metre, despotic rhyme. This age has no love for tyrants. Besides, these rules were not like those inevitable laws promulgated by nature, which are not to be transgressed save under peril of death (as swallowing arsenic).

RIMBAUD broke through all that with an audacity Hugo could never summon up.

Which is not to say that he was responsible for every change since the

days of Boileau. But he was a representative genius, as they say, a revolutionary figure. He bends the knee to no rules, his aim is always towards a poetry which is purely lyrical and effusive. He writes as he feels, and while the masters of the past work over their poems, testing them by all the laws of prosody before they can give them definitive form, Rimbaud runs what directly emanates from him into the mould that instinctively suggests itself. It is all spontaneity. No longer is it the champagne prepared with infinite care, but the first pressing of the grape: there is less architecture, but more sap, arabesques, perfumes, richer savours: less learning and more feeling: less chemistry, more nature: less physics, more chemistry: not so much thought but more resonance: something infinitely moving, indefinable, a sort of facile miracle with an aura of perfection, and yet raucous and passionate and creative of tension.

BAUDELAIRE and VERLAINE are great poets: but after Rimbaud can we read them with the same pleasure? Sometimes they suggest him, but once evoked, the angel interposes and disposes of them. He has all the fire of one, all the elegance of the other, and a violence of passion absent from both.

Rimbaud: that sea from which poetry after him drew all its salt, its lustral water, or its poison.

But does that mean that after Rimbaud no more poetry is to be written? Is Bergson negligible as coming after Schopenhauer, or Einstein after Poincaré, or Cubism after Cézanne. Certain men fecundate a whole era. As for our own age, certain moderns would only too willingly treat it as something apart: but it has its foundations like every other, and it is pure vanity to consider it a thunderbolt. Rimbaud and Cézanne are the heads of comets, yet like them they are subject to the force of gravity: Victor Hugo, Poe, Baudelaire to one; Poussin, El Greco, Chardin, Courbet, Manet to the other: the universe is an immense field of forces in which the power of attraction of various suns lays down the laws.

Baudelaire and the hashish-eaters bequeathed to Rimbaud his legacy of dream-life and mystery for which they themselves were mostly indebted to Poe, who got it from gin: with Rimbaud that dream-life in a form less morbid became the heritage of this generation.

He communicated also the taste for unexpected, out-of-date, uncommon, simple, extravagant things, and for technical researches into language.

His *Alchimie du verbe*, 1873, is the Ali Baba's cave of modern poetry:

"*I loved senseless paintings, entablatures of doorways, backgrounds, the backcloths at fairs, signboards, popular colour-prints,**

* *One might perhaps wonder whether, without Rimbaud to prepare the way, the moderns would have discovered the Douanier Rousseau.*

*out-of-date literature, church Latin, erotic books with no spelling,
the novels of our ancestors, fairy tales, the little books of children,
old-time operas, idiotic refrains, rudimentary rhythms.*

*" I invented the colours of the vowel. A, black; E, white; I, red;
O, blue; U, green. I determined the shape and movement of every
consonant, and, with instinctive rhythms, I flattered myself I was
inventing a poetic formula that some day or other would be accessible
to all the senses. The application I reserved for later.*

*" First of all, it was an exercise. I wrote of silence, night. I
noted down the inexpressible. I mapped out my bewilderments.*

*" The old-fashioned stuff of poetry played no small part in my
alchemy of the word.*

*" I inured myself to simple states of hallucination: without pre-
tending I would picture a mosque in place of a factory, a drum-
school for angels, see coaches rolling on the highways of the sky,
drawing-rooms on the beds of lakes, monstrosities, mysteries; the
title of a music-hall turn environed me with terrors.*

*" And after, I revealed my magical sophistries by the hallucina-
tion of words."*

The poet's cosmogony. Earth issued from the Sun and from the
Earth the Moon (from the Atlantic's tremendous abyss). From Rimbaud's
sun issued MALLARMÉ's moon, and from him practically every modern or
ultra-modern asteroid.

If Rimbaud is a sort of Cézanne, Mallarmé was the Cubist of this
revolution, the idea of which he carried to its furthest conclusions. He
analysed that amazing poet and theorised with genius. His poems are as
rationally, as lucidly constructed as a poem by Boileau or a magneto; and
this capacity for premeditating his poems distinguishes him fundamentally
from his predecessor : for, having perceived in the poetry of the past, and
above all in that of Rimbaud, the value of certain associations, certain ellipses,
certain functional elements of words, he used them as a keyboard on which
to play, no longer Rimbaud, but Mallarmé.

After the immense sweep of the wings of that triplane Hugo, Rimbaud
was needed in order that the rigorous technic of verse, now seriously
battered, might altogether be eliminated and an entirely new form become
possible. Mallarmé, as it were, legalised this radical liberty, from which the
poets who came after him benefited. Result : " only poetry adequately
defines prosody." Grammar and classical syntax exist only to be remem-
bered by those who have good memories : words are spare parts that anyone
can put together as he will, so long only as they reveal a poet's nature. And
that nature is most mysterious, caressing, glittering, crystal clear, passionate

icy, odorous: profound also, according to the modern notion of poetical profundity.

Poetry is no longer, as in the past, the lucid treatment of ideas or sentimental situations real or possible: but the glory of images, sounds, rhythm, sensation, fragments of ideas.

The poets of today are the legatees of an art that does not concern itself with the for and against of reason and its verdicts. And this is the essence of prudence if their chief aim is an absolute lyricism. The free effusion of all they feel is now their right.

Thus far I have demonstrated only near relationships. The double influence of Gide and Barrés must also be taken into account. Even the "Surrealists" owe to *Paludes,* and above all to the Lafcadio of the *Caves du Vatican,* their particular turn of thought: anxious, elegant, melancholy, tangential, incidental, elliptical, their taste for evoking emotion through what is singular: their oneiric glossolalia: and their interest in the unmotivated act. Note also the influence of Claudel: of Péguy for words as litanies, and the futurism of the Italian Marinetti.

Many other infiltrations, actions, and reactions remain to be demonstrated, but I shall content myself with a few names, particularly significant and popular with the modernists. Remark that I do not ignore the influence of Shelley, Montesquiou-Fezensac, Paul Fort, Léon-Paul Fargue on nearly all the more refined modernists, nor that of Nietzsche, Verhaeren, Valéry-Larbaud, Maeterlinck on the more robust. I have already said that it is in no wise my intention to write a history of literature, and for that reason I shall only add the names of Barrés, Gide, Maurras, who, though not practising poets, are nevertheless in the truest sense lyrical. In this book I deal only with the freebooters, naturally or wilfully so.

One aspect of modern poetry is often a highly emphasised extremism. That must be attributed largely to the influence of the extraordinary JARRY, the Cambronne of poetry. Jarry is the last high-powered romantic. He seems to have gone as far as was possible in invective, truculence, Flemish garrulousness, roguishness, hatred of the bourgeois.

Pasteboard figures of a cock-shy. The wit, often piercing, often profound, of this professional toper, because of its monumental indifference, made an immense impression on the often highly intelligent originators of Fauvism, Cubism, and Dadaism in painting, literature, and music. Many contemporaries reveal this influence, most curiously allied with the eccentricities of various original characters out of Gide. Picasso, Satie, the Cocteau of *Parade* (1917), and the Apollinaire of *Les Mamelles de Tirésias* (1917), owe a debt to *Ubu-Roi,* as does the *Matoum et Tévibar* of P. Albert Birot (1919). The Dadaists paid the tribute they owed him in those idiotic meetings they called " *Soirées Dada."* Nor let us forget those perfectly

respectable shows, *Le Bœuf sur le Toit* (1920), *Les Mariés de la Tour Eiffel* (1921), and *Antigone* (1926), by Cocteau: sophisticated puppet shows for high-class music halls suitable to semi-intellectual digestions.

The public influence of APOLLINAIRE was tremendous. Possibly he may have benefited by all the scandalous publicity he was able to provoke for his friends the Cubists. Certainly everything that had to do with that movement came in for some, even the moth-eaten Place du Tertre and the provincial rue Ravignan.

His *œuvre* was considerable and of quality. Influenced in many ways by Verlaine, he was generally styled Cubist, because of the predilection of this kind of painting and literature for puns and puzzles; but the trend itself was only a by-path and not truly Cubist. The wart was mistaken for the nose.

The most Cubist of poets, without any doubt, remains Mallarmé, for the essential virtue of the movement inaugurated by him was the determination to separate the created thing as widely as might be from reality. Yet the influence of painting on the poetry of Apollinaire is most apparent, his images being almost entirely visual. I remember, for example, that typographical arrangements had an immense importance for Apollinaire. Mallarmé in *Un coup de Dé* and the Italian futurists associated with the revue *Lacerba* had already used such devices, and for a time at least nearly every poet was designing such "ideograms." Apollinaire is, as a poet, a humanist: many of his poems bring to mind the formal rondeau of the French Renaissance. They have a savour as of the *lieder* of the Rhineland or Poland, of Heine, and something common to all good poets, Apollinaire included.

MAX JACOB is, they say, the wittiest poet of today. He appreciated Alphonse Allais.* His wittiness developed rather late in life. First, incontestably he applied the equivocations of words to things. The originality

* *Alphonse Allais the humorist and modern Art. The Anglo-Saxon influence on the "Montmartre spirit" and the Cubists!*

Honfleur in Normandy was, towards the end of the nineteenth century, one of the most active of Anglo-French ports. The bars and cafés were open all night long. Alphonse Allais was born there, as was also his friend, the musician Eric Satie.

Obviously, the humour of Alphonse Allais derives from those English naval officers who, pipe in mouth, told tall stories without turning a hair, as they sat gaffing with their French comrades.

Montmartre owes its special humour to Alphonse Allais, who was one of its pillars; Satie's humour owes much to Allais; and Picasso with the other Cubists lived in Montmartre.

Towards 1915 Satie and Picasso collaborated in "Parade." Through Cocteau one can easily trace a certain cast of style in their art that might appropriately be restored to the British Merchant Service.

 Author's Note, 1930.

of his technic comes from his extraordinary liking for the *quiproquo*, irrational jumps, punning. And admirably he makes frequent use of

Que mon
Flacon
Me semble bon!
Sans lui
L'ennui
Me nuit,
Me suit.
Je sens
Mes sens
Mourants,
Pesants.
Quand je la tiens,
Dieux! que je suis bien!
Que son aspect est agréable!
Que je fais cas de ses divins présents!
C'est de son sein fécond, c'est de ses heureux flancs
Que coule ce nectar si doux, si délectable,
Qui rend tous les esprits, tous les cœurs satisfaits.
Cher objet de mes vœux, tu fais toute ma gloire.
Tant que mon cœur vivra, de tes charmants bienfaits
Il saura conserver la fidèle mémoire.
Ma muse à te louer se consacre à jamais,
Tantôt dans un caveau, tantôt sous une treille,
Ma lyre, de ma voix accompagnant le son,
Répétera cent fois cette aimable chanson:
'Règne sans fin, ma charmante bouteille;
Règne sans cesse, mon flacon.

One of the First Ideograms:
Panard, 1674-1765.

S
A
LUT
M
O N
D E
DONT
JE SUIS
LA LAN
GUE É
LOQUEN
TE QUESA
BOUCHE
O PARIS
TIRE ET TIRERA
T O U JOURS
AUX A L
LEM ANDS

Ideogram by Apollinaire.

alliteration ("*Non, il n'est rien que Nanine n'honore,*" Voltaire) which gives his work a very particular charm. Jacob had a tremendous influence on " epidermic " poetry, notably on Apollinaire. His technic is admirable, recognisable by the incredible ease of its flow: at times he is capable of

restraining it and writing good prose, rather in the manner of the eighteenth century. He is also responsible for some charming drawings in wash!

ANDRÉ SALMON, not so addicted to excess, produced a poetry that was refined, measured, reflective, ingenious, and discreet even in its amplitude. His name is somewhat less known than those of the two poets I have just quoted, doubtless because his work wins no publicity and because in the last twenty years success has always gone to eccentrics, whether with genius or without.

Less accomplished than that of his elders, the poetry of REVERDY is delicious in its freshness. He was the friend of the painter Juan Gris, whose theories tended towards a poetry of painting: each reciprocally

Jean Lurçat *and* *Max Jacob.*

influenced the other. It is difficult to see in Reverdy any new contribution to the technic of poetry, but he has a certain excellence, suavity, conscientiousness, and a charming imagination with a bias particularly optical.

JEAN COCTEAU did not come to " modern poetry " till the end of the war. His influence soon became considerable, rather in the manner of a megaphone. Into a battle that was growing lethargic he flung all the vitality of his writer's talent. The most recalcitrant theories were explained by him agreeably, wittily, comprehensively, and made to seem respectable. This led to the vogue, for such as were not yet acquainted with them, of Apollinaire and Max Jacob. There was no difficulty in winning appreciation for what was witty, charming, elegant: but what was rugged, or excessive, was either ignored or made palatable. The hedge being a bit high, Cocteau with his hands behind his back and parading in front of it, trimmed it sufficiently to enable the dilettantes to take the jump: this they

all did, and imagined they had suddenly got taller. Amateurs ask only to be amused, but all the same they want their soles amicably filleted, sprinkled with shrimps. Among those who flock to the standard of the advanced, must be included those happy adolescents for whom everything that dates earlier than their own birth, is sedentary and boring. These youngsters fell all over the elegant enchanter who reduced the crudeness of modern art, poetry, music, painting, to the very best canons of good taste. They thought they had to pluck up all their courage to swallow a hedgehog, and it turned out to be as easy as swallowing sweets. The best traditions of the chemist: Cocteau knew how to gild his pill. Once art was discovered to be so easy, so delicious, the next thing was to feel terrifically gifted: clouds of poetaster puppies appeared on the horizon.

" Beware of poets who too early win the approval of the young. Nothing goes flat sooner than too facile success, even when justified." (Jean Cocteau, *Le Secret Professionnel.*)

Cocteau turned modern art into a Japanese garden in which spun glass ships sail among trees made out of hair, the sails reflected in a sky the colour of a pigeon's breast, which happens to be the waters of an aquarium where everything harmonises, the *quis* frolicking wantonly with the *quos.* So successfully, indeed, that five years later Cocteau was thought by the masses to be at the head of the " terrible " modern school, much to the profit of the ideas he had so gallantly assumed. His influence was the same in literature, music, and painting. He discovered the virtual links for agglomerating the *Six* which for a time represented the music of all time. He threw a glance at painting, and his own drawings were quite charming. He popularised Picasso. Indubitably his influence on that painter was not all for the best, for by gaining particular appreciation for his inventive qualities, the possession of so much invention at last came to seem altogether too much.

His work has its own distinction. His prose and certain poems will always be among the most successful of the day. Cocteau is an eminent stylist. If for a while he coquetted with the extremists, by nature his technic seems oriented towards the polished, even, regular, and meditated, and no doubt it will be for these qualities that his influence will continue: it announces a certain commencement of established order.

Nevertheless, it would be disastrous if such a state of affairs was inaugurated according to " the manner of the Greeks "* or to the rhythm of Renaissance pavans or trifling airs.

That is why there must always be obstructionists to such panderings,

* *A reference to Cocteau's rewriting of "Antigone," acted with success in Paris.*

the agitators, in fact. MARCEL DUCHAMP, PICABIA, TZARA, BRETON, and their friends belong to this group, all of them posing as the Marats of Art (*" Dada is artistic free-thinking,"* Breton). The thing was *" to disturb the ceremony "* (Breton) of the conventions, and *" maintain a situation that would be propitious to revolt "* (Breton), which since 1789 has been the only attitude avowable. Sometimes it has its point, as here. Demolition wholesale! And during that stale epoch, which lasted from 1918-1924 (?), it was very natural for young energies to be dissatisfied with the mannerisms all round them, the accepted, the neo. Yet it was an attitude not so very dissimilar from that of the Fauves, the Cubists, and the Futurists in regard to Impressionism.

Per contra, the Dadaist researches into language are not without interest.

Picasso.

Marcel Duchamp, Breton, Tzara, Jean Paulhan, etc., frequently eliminated all logical or ideological sequence from their poems, carrying the freedom of their technic to its limits and beyond even. Another point gained.

The manifesto of " Surrealism " appeared in 1924; it was a continuation of the protest and aggression of the Dadaist movement. But the dictatorship of ANDRÉ BRETON and LOUIS ARAGON directed it towards a special interest in the obscure workings of the mind. Dreams and madness, which were once the province of the psychiatrist, have now become the regular thing, both artistically and in literature. It is to be imagined that such a focussing upon certain phenomena may prove to have some virtue propitious to meditation. Humanity too easily finds a stupid contentment in habitual aspects, and it is not to be regretted that interferers arise, who periodically strike against that cage of glass, in which we move with all the smug satisfaction of our false freedom. In this way they remind us that we ourselves are but fictions, and

that the mystery inherent in all things is certainly no less important than the browsing banality of our days.

Yes, yes, indeed. The turn of thought of the Surrealists of 1927 is melancholy: but it forces us to think, and that is much. Their preoccupations mean something.

<p align="center">*</p>

NO one will fail to remark that modern poetry is anything but repetitive. So it is with all the arts of today: new technics, new aspects. In their defence or praise we might say that an aeroplane does not much resemble a coach, though it travels more speedily.

For all, the most important consideration appears to have been, to concoct a new language, adequate to the artist's desire to express himself. Every poet sought his own formula, but finally all arrived at practically the same formula, that of each bearing a fairly close resemblance to his neighbour's. For an epoch creates a sort of community of vision, even though generally misapprehended by those who are plunged in it.

These new technics aim, above all, to attain and express the unusual. The preference for the unusual goes parallel with that for the profound, but it is an impenetrable profundity. Poetry has become scientific: the experiments with words of the moderns resemble in some ways those of the learned troubadours, not to mention the linguistic acrobatics of the dandies of the eighteenth century, and of the Exquisites, who by the elegance of their verbal *tours de force* helped so much to refine our French.

That tongue, so classic, so crystal clear, was not adapted to express thoughts which were possible to Anglo-Saxons. Poets compromised by creating a language that had every quality demanded, perfect elasticity, no grammar, no syntax: by which means, according to the professionals, it at last became adapted to follow up the most secret windings of the spirit, and to reach beyond the border line, where the unconscious passes into consciousness.

No longer is it the impact, however tempered, of ideas, but a bouquet of heat and ice, a suave melody stifled, at times resurging in brutal crudity: scraps of phantasies disappear in the very moment of their appearance: iridescences, pearly lustres, pearls, words in scales, mutual contacts, interact, interpenetrate: complexities, polyvalences. Hugo tries some of these tricks when he lays aside his trumpet to take up the lyre. Something like the threefold sense hidden in each line of the Hebrew screed that no one, not even the Chief Rabbi, entirely comprehends, but which is charged with profound meaning. Poetry nowadays deals in silences: the felted pedal calms the trumpeting outburst of the Parnassians and even that of Baudelaire or Rimbaud. Because of such asides the function of this kind of poetry is to suggest to us what we do not consciously know or what we fear to say. Poetry behind closed doors.

The clavichord has become a Steinway with innumerable harmonics. Compare Handel with Debussy, Ronsard with Mallarmé, Descartes with Bergson.

Engines puffing, doors slamming, broken conversations: from all this medley of sounds a melody issues, or, rather, upon this background do we weave our melody.

There are many today who aspire to exactitude, to clarity. We are issuing from a period, which still, in effect continues, when only night had charms. Those who, to some extent, are fairly stable in their relation to yesterday and tomorrow, seem to feel within them a dual urge towards these contraries. The case of VALÉRY reveals this indecision; his earlier roots still cling to symbolism, but his lucid mind stretches its branches towards the bright future, and he reconciles his heredity and his aspirations by creating " tempered brightness." " Qu'est ce qu'il y a de plus mystérieux que la clarté?" he writes. Is this not a sort of shadow that he is treating as light? Thus it is we are affected by the colour of our age, however much we may wish to impose our own upon it. Valéry avails himself of every Mallarméan art to create obscurity with clear words and apparent clarity with obscure ones. This tendency towards chiaroscuro is very apparent in the words that issue from the mouth of the fictitious Socrates in Eupalinos, who sometimes talks French prose as if he were talking Greek after a heavy meal, and as if his usual keenness had degenerated into something Maeterlinckian.

" I understand and do not understand. I understand something, but I am not sure if it is really what he meant."

Barrés had already written in his Le Voyage à Sparte:

" Have you noticed that clarity is not necessary in order that certain works shall move us? The influence of obscurity on children and the untutored is undeniable."

Since clear poems have clearly revealed their inadequacy, it would not be fatal if the categorical poetry of the past were to be ignored from now on. And if practically all the great work of this class in France belongs to the Renaissance and the age of Racine, that does not necessarily mean that the source has dried up once and for all. It is not generally bottled, that is all. Yet at times Cendrars persuades us otherwise.

*

I have set down these lines as they came, following the natural development of the subject. But now they come with more difficulty, and as a result the personal notes that follow, have arranged themselves rather

casually in this chapter. I consider them therefore as lying rather outside my thesis.

CENDRARS is not among those poets of the modern school who are all delicacy and shifting colour. No, his work brings to mind those auto-mobile klaxons that brutally burst out hooting in the street, while we indoors are listening to some throbbing quartet. No aura about him, nothing moonstruck or absent, but brief, harsh, exact words releasing direct thoughts. He is no garret poet, no boudoir or café poet, but like a mechanism in its brutality, and, above all, in its precision. Poetry minus pastel shades. Certain aspects of his work, staccato, elliptic, are related to that of various poets of this epoch : all the same, a fundamental diver-gence marks him out, his use of the " categorical." Cendrars is raw yellow, raw red, raw green. His poetry never whispers, it commands. Of course, he owes something to Rimbaud : they all do, much as every painter is in Cézanne's debt. But Rimbaud has passed on to him some of his heat and none of his shivers. He is indebted to Verhaeren, too, that elemental poet. The note Cendrars struck in contemporary poetry was an individual one, and its influence still persists. There are rever-berations of Cendrars in PAUL MORAND's first poems and in those of DELTEIL and various foreigners : it is also the inspiration in certain of the young who show promise.

An effort towards a purely intellectualised poetry seems to be revealed in the poetical works of FERNAND DIVOIRE, a spiritualist in the depths fulminating against the sensualism of modern poetry. This author appears voluntarily to have held aloof from the mass of readers : his work is still in progress : intellect is reintegrated in it. Read *Itineraire*.

*

It is worth while meditating on the extraordinary mixture of admira-tion and apologetics that characterised M. Paul Valéry's speech in favour of the Symbolists' " research laboratories " on the occasion (1927) of his recep-tion into the Académie Française :

> "*A host of ephemeral publications, extraordinary booklets, opuscules, intensely surprising to the eye, the ear, and the mind, appeared and vanished. Schools came to birth, died, and were re-born, absorbed each other or, perpetually rent by schisms, bore witness to the measure of oceanic vitality hidden deep in this coming literature. Nor will I pretend that a desire to shock or break with tradition was entirely absent from every member of those groups. Meanwhile we accepted our rôles of literary demons in our inferno, busily occupied tormenting our mother-tongue or tor-*

*turing verse, tearing from it its lovely rhyme or initial capitals,
dragging the line out to incredible lengths, perverting its regular
habits, or intoxicating it with unaccustomed reverberances.*

*"Nevertheless, however severely such attacks, such remarkable
outrages, might have been judged in the past, we must remember
that some necessity called them forth. Man invents nothing that
circumstances do not force upon him.*

*". . . Thus nothing less than total liberty for the various forms
of art and their expression was demanded.*

*". . . Well, even the most daring experiments have some time
or other to be attempted, and, as a result, what remained of the
traditional, the conventional, was subjected to unrelenting tests.
Our particular anxiety was how to restitute the natural laws of the
music of poetry, how to isolate pure poetry from every element
foreign to its true nature, how to acquire a more precise concep-
tion of the means and possibilities of that art by a new enquiry into,
and meditation upon, vocabulary, syntax, prosody, figures of speech.*

*". . . It was inevitable, therefore, that such special and often
daring research should give birth not infrequently to works either
difficult or disconcerting.*

*". . . Those little chapels in which the spirit glows, those
enclosures which grow always more select, in which values are
exaggerated, are veritable research laboratories of letters. There
cannot be any doubt, gentlemen, that as a whole, the public
is perfectly entitled to the regular and approved products of the
literary industry; but the growth of industry demands much ex-
periment, audacious theorising, even imprudence sometimes; and it
is only in laboratories that the highest temperatures can be reached,
and unusual experiments enacted, and that degree of enthusiasm
come into being, without which neither the arts nor the sciences
could have any future in the least impredictable. . . .*

". . . Such were our conventicles of forty years ago."

Valéry's praise of these forty-year-old chapels seems extraordinarily
appropriate to those of the last few years. Can symbolism in its many
forms survive? Its tail, like the lizard's, goes on sprouting, sprouting.

Is "romantic" poetry very different from that of the Symbolists? And
does modern poetry differ from the latter?

And how, in any case, is fifty years to make so much difference in the
poet's heart when mechanics on suburban lines go to their aeroplane shops
in trains drawn by Crampton engines which date back to Victor Hugo?
Romanticism, 1830, living spring, precious lustral spring, but the water

is too medicinal, and the result is anæmia. And really, as a result of imbibing too much Rimbaud, are we not just the least little bit 1870-ish ourselves? And can the discovery of that Lautréamont, the ebullient, the romantic, save us from Romanticism? For a hundred years, under all sorts of banners, the poetry of Romanticism has been gradually extinguishing itself.

It is impossible for us to subscribe to the theoretic boundaries of those chapels: their sectarians imagine themselves immensely original, but actually they are separated by nuances hardly to be distinguished. Everything is closely mingled in the present and the recent past. In a hundred years 1914 will have joined up with 1830, Guillaume Apollinaire and Co. will join hands with Hugo, Banville, Rimbaud, as Soutine with Monticelli. Unusual words are quickly forgotten again, too elaborate intentions lose their point, dust softens the corners, the varnish turns yellow, book-covers fade and the crackle of varnish spreads into crow's-feet. Picasso's marionettes, terrifying ten years ago, have with all the grace in the world already gone to join the playthings of 1830. For which reason this truth, proved by experience, should teach us to be economical in our striving for arbitrary or forced effects.

Nothing could have been more scarlet than the amiable Théophile Gautier's waistcoat: he thought he was devastating, but in fact he was just a pleasant and eccentric poet.

What a delicious confiding melancholy planes over all recent poetry! Doubtless verse rhymed too easily in those happy days when comfort was an adequate substitute for certainties. Melancholy and Night in small doses helped to introduce that anxiety into our lives without which nothing can be profound.

But today surely this sense of the mysterious which modifies the precise outlines of phenomena is now deeply part of us. And no added mist can increase our certainty that all is relative.

Our poetry is not for reading in aeroplanes but in gondolas. Exiled from Venice by the motor-boats, the out-of-work gondolas now serve publicity in a muddy swamp by Nice.

The following passage however, from Leonardo da Vinci, gives a fairly adequate idea of the modern poem, which is often the web upon which the reader embroiders, as upon that noise of trains I spoke of earlier :

> " If you look at certain walls covered with stains and built of mingled stones, and if it is necessary you should invent some background, you will be able to discern in that wall the likeness of various provinces with their mountains, their rivers, rocks, trees, plains, great valleys, hills in many aspects; you will discern battles

*and the swift movement of faces and singular expressions, clothes
and innumerable other things.*

*" This is true with walls of uniform or mingled texture, as with
the sounds of bells, the strokes of which call up every name, every
sound that can be imagined."*

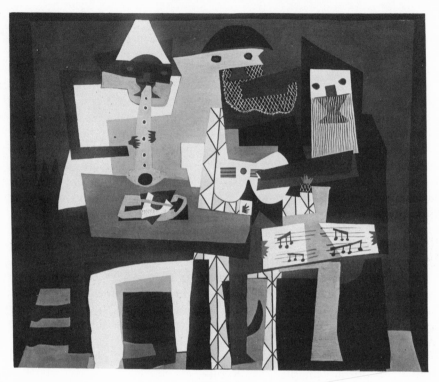

Picasso.

This all sounds most Surrealist, and Surrealism, in its least living aspect,
may turn out to be the last wave of the same liking for problematical
mirages, realisable yes, but disturbingly uncertain. It is evident that
modern poetry is nearer the art spoken of by the Florentine, with its vast
emptiness into which the reader's imagination flows, than to the poetry,
architectural and derived from Racine, of which mention is made in *L'Art
Poétique*, as speaking more to the soul and intellect than to the senses, for it
is interpretable in one sense only, common sense, which is not at all what it is
generally imagined to be, though not inevitably different; whereas our own
time can be interpreted in a thousand senses at least, except at times by common
sense. Can any speech, however profound, take the place of thought?

It is better to be beginning than ending. But that is the extreme difficulty of drawing up a balance-sheet from my point of view. Where, exactly, is the past of the past, and where does the seed of the future begin? Most of what we take for dawn is but twilight glimmer, and it may be that the light that seems dim to us is the dawning of bright day.

Mirò.

Is not the Dadaist negation a sign that something is finished, a sign of a certain disgust?

And will tomorrow be satisfied with the evasion implied in this statement by Valéry: *" Conceive nothing but as experiment and transitional form "*? It answered very well forty years ago, and many nowadays seem to find pleasure in its lack of precision, somewhat too reminiscent of the goose-quill.

Romulus drove the chariot that traced out the nucleus of Rome, of the New Paris, of Europe, of the New World.

{ And since our ideas as to the relative values of all things are now { clear, is not that a certitude gained and a stable basis found at last?

This new vision of mankind on earth will find its poetical expression, for the medium is already in certain propitious hands.

ADDENDUM

A DETECTOR

To support this chapter I had prepared a number of quotations from the modern poets, but I found they led me too far afield and my examples proved even more than I intended: in fact, the very evident partiality they revealed rather terrified me. I have my likes and dislikes, I say so frankly, but caricature I detest. I therefore suppressed my quotations, providing copious references instead, but the solution proved of little practical value, in view of the fact that few readers generally take the trouble to look up the texts. Besides, they are not always handy. I looked round, therefore, for an adequate and easily available anthology to which I could turn to simplify the reader's task. The volume published by Messrs. Kra was suggested to me. And when I was going through my typescript I read it. In their Preface its anonymous authors stated:

> "In 1920 we had heard . . . a modern spirit spoken of. A picture, a piece of mechanism, a poem, a philosophic or mathematical system was admired because it was in the modern spirit.
> ". . . And we feel that this anthology will help to make clear what that spirit is. . . . Is not every anthology by definition the mirror of an age?
> ". . . We have deliberately omitted the Symbolists because we personally think they have had no part at all in the formation of the modern spirit, and because, on the other hand, they stand for the end of an epoch. Verlaine has been omitted for the same reasons. Verlaine is a terminus. . . .
> "A new spirit animated his poetry (Baudelaire's)."

The new spirit. Could I have found anything better? Compiled by the truest connoisseurs, one of whom was a real poet, I had in my hands all that was valid in the whole range of what was worth while as conceived by contemporary writers. Verlaine will not be met there, nor the Symbolists, bards of Night, Stars, Rain, Soul, nuances. "Nuances, always nuances."

But would even one hundred pages of Verlaine have changed the curve of its graph at all?

There are some dead who have to go on being killed, easy as it may be. And I fully realise, Messieurs the anthologists, that you sought for what was living and energetic, and it does you credit. But have you found it? Could you even? I wanted to make sure, and I re-read that anthology.

I saw then that certain expressions recurred very frequently. So I noted down for each poet the return of certain "dynamic" words. By "dynamic" I mean words, independent of their context, which powerfully express some idea or feeling. Thus I was able to construct the table on page 35 *et seq.* I chose out words like Rain, Frost, Snow, Ice, Hoarfrost, Moon, Night, Star because they were categorical, implacable, dominating. With words it is as with colours: a grey can be turned pink by placing it near green, but red can never be made pink, nor pink red, nor sun moon, nor gaiety rain, nor dynamism blue.

I can assure you that no work could be more tiresome than the registering of such words. Yet think how interesting to uncover so many keys to the poet's soul!

500 pages represent a century of poetry. Is it chance alone that reveals always the same words in each and all?

Not too much must be said against "Freudism" or graphology. The present attempt is in some ways analogous, an experiment to show that all our behaviour is predetermined, the revelation of our deepest being. A word recurring perpetually is a forced card that has to be taken.

These tests disclose individual tendencies and reveal the kind of weather: as regards poetry, naturally. Oh, how it rains in modern poetry, my dear Verlaine, but as it never rains in Paris, only in London! Can English poetry by any chance have affected the situation?

"*O melancholy of umbrellas . . .*" (Pellerin.)

So here I outline a form of procedure and offer it for what it is worth. But how much more conclusive my experiment would have been if, instead of being limited to six pages for each poet, the graph had taken into account the whole of the poet's achievement! Yet possibly the results are even more revealing coming from so limited a source.

I have been particularly careful in noting colours. Nothing better reveals the "tropisms" of an organism than the colours that dominate it.

I have also put down shades of colour, and they will be found in the subsequent columns.

For instance, in a given number of cases the word Rose recurs 68 times (not to mention innumerable rose-bushes), Blue recurs 55 times, Moon 48 times, Star 44 times (planets and constellations omitted), Rain 33 times, Azure 29 times (and Yellow 18 times merely).

Poets during the last hundred years have not much cared for yellow: they prefer the colour rose. They are vowed to rose and blue. But with a nocturnal vocation also, for Night is mentioned 110 times.

I have not registered flowers, perfumes, odours, ether, nymphs, swans, grottoes, tombs, vaults: it would begin to look too much like an engraving of the Romantic period. But I have kept track of modes of transport, and the advent of a certain modernism in accessories can be detected. People do not get in out of the rain any more on three-masters, but in lifts, aeroplanes, steamers, bicycles, motor-cars, or pirogues, with saloon bodies no doubt.

I have picked out only the key-words revelatory of the subject's automatism, an inevitable procedure in any investigation into the unconscious. Nor, for instance, have I read amethyst for violet, nor the word " star " into the following lines:

> "The sky is all a-quiver with winking, unseen eyes . . ."
> (Cendrars.)
> " All the night long Heaven garners its marguerites." (Cocteau.)

It would seem that among the many poets I cite, very few indeed were concerned with what took place in daylight. Column 7 shows the extent to which Night is dominant in authors born after 1885. We must get up earlier. You know sunrise is a lovely moment. And noon. But the frost, the frost: it is always freezing hard. I spent my Christmas Eve in registering the fact that though it was warm in my studio, yet this kind of poetry froze me.

There was no reason for Radiguet to menace poetry with a rose as though it were a bomb: they have been raining down on us for a hundred years (Tristan Derème holds the record, roses quoted 8 times in six pages). Apollinaire ties with Soupault for that of Night, with Paul Morand a good second. As for flowers, Tristan Tzara has them 15 times (4 in the singular and 11 in the plural) in eleven poems. Even if we have lost all the aviation records in France, we still beat the world at poetry.

I have done enough commenting; the records are before you to consider. If you feel so inclined you can make a special graph for any particular poet.

I am not here judging whether the poet is good or bad, but I seek the outline of this age, and it does not displease me to see the individual curve so much in harmony with the main curve that results from them.

Greece built with marble, yesterday with quarried stone, today with cement and plaster; our poetry is made up of rose, blue, cemented with rain and frost, as statistics prove.

Is it the poet's soul that makes him use such handy colours as rose or blue? Surely it would be as easy to make his rhymes yellow; nevertheless, the co-efficient of blue is 55 per cent., whereas that of yellow is 18 per cent. only.

This enquiry is a sort of lead-bearing ore, but I must leave to others with more leisure the making of the wireless set which would convert it into a first-rate amplifier.

This galena can detect those powerful and secret motivations which make us write mist and not sun, grey and not gold, white in place of black, black in place of white, melancholy in place of gay, Maldoror in place of Maleine. Why should *ic* be rhymed with bucolic rather than with colic or colchic-um or pneumatic or melancholic or odalisque? Does anyone write what he wants to?

We write, we think, what our heredity and our lives have made us write or think at a given moment.

※

CONVENTIONAL MOTIFS

As indicated by five average pages from the work of fifty French poets from 1807 to today

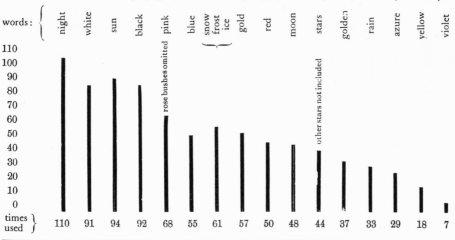

words:	night	white	sun	black	pink	blue	snow frost ice	gold	red	moon	stars	golden	rain	azure	yellow	violet

(pink: rose bushes omitted) (stars: other stars not included)

times used: 110 · 91 · 94 · 92 · 68 · 55 · 61 · 57 · 50 · 48 · 44 · 37 · 33 · 29 · 18 · 7

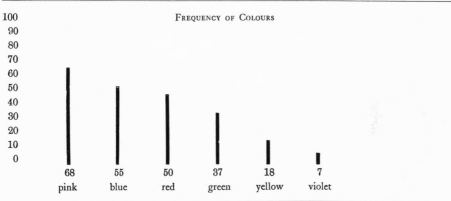

FREQUENCY OF COLOURS

68	55	50	37	18	7
pink	blue	red	green	yellow	violet

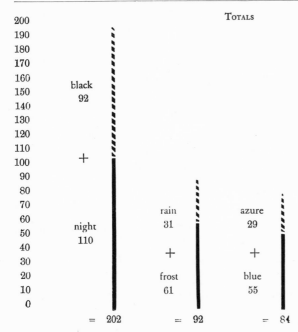

TOTALS

black 92

+

night 110

= 202

rain 31

+

frost 61

= 92

azure 29

+

blue 55

= 84

1 AUTHOR.	2 RAIN.	3 ICE, SNOW, FROST, ICICLES.	4 MOON.	5 STARS.	6 SUN.	7 NIGHT.	8 BLACK.	9 WHITE.	10 GREEN.
GÉRARD DE NERVAL, 1805-1855				* Con-stellated	S S S	N	b b b b	W W W W	G
CHARLES BAUDELAIRE, 1821-1867		O O		*	S S S S S	N N N N Nocturn-al	b b b b b b b		G
LAUTRÉAMONT, 1846-1870			(S	N N N Darkness	b		
ARTHUR RIMBAUD, 1854-1891	! Hail, rain beat-ing on win-dow pane	O O thaw	((* * *	S S	N N	b b b b b b b	W W W	G G
JULES LAFORGUE, 1860-1887	!! Sleet and drizzle		((S S S	N N		W W	G
STÉPHANE MALLARMÉ, 1842-1898	Mist. fog, fog	O O			S	N N	b b b	W White-ness	
PAUL VALÉRY, 1871		O O			S S S S S S	N N	b	W W W	
M. MAETERLINCK, 1862	!!	O O O	(((S	N Darkness			
ANDRÉ GIDE, 1869	! Fog	O O	((S S S S S S S S S			W	
MARCEL PROUST, 1871-1922	!		(S				
VALERY LARBAUD, 1881	!!	O	(S S	N N N N N	b b	W W	G G
JEAN COCTEAU, 1892		O O O O O O			S	N		W	
G. APOLLINAIRE, 1880-1918	!			* * ○	S S S S	N N N N N N N N	b b b	W W W W W	
BLAISE CENDRARS, 1887	Fog, fog, fog		(* * * * *	S	N N	b b b b	W W W	G
PAUL MORAND, 1888		O O O			S Sunless	N N N N N N N	b b b b b b b	W W	G
TRISTRAN TZARA, 1896		O O		*	S S S S S	Midnight N N	b	W	
RAYMOND RADIGUET, 1903-1923		O O			S				G G

The reader may find it an entertaining pastime to adapt this

11	12	13	14	15	16	17	18	19
BLUE.	VIOLET.	RED.	ROSE : COLOUR AND FLOWER.	GOLD.	AZURE.	YELLOW.	SHADES OF COLOUR.	MODES OF TRANSPORT.
B	V	R	r r r r r	G			Red, Livid.	
B B		R	r r r	G	A A A		Whiteness. Ebon Sea, Ruby Colour, Brown, Ebon, Coppery, Inky, Brown, Ambered, Livid Grey.	Sails, Vessels, Vessels, Balloons, Waggon, Rowers, Masts, Vessels, Chariots, Horses, Oxen. Vessels.
B					A (azured)		Mercury, Aluminium, Livid.	Vessel (through telescope), Vessel, Railway.
B B	V	R	r r	G G	A A	Y Y	Greyish, Ruddy, Orange, Verdigris.	Vessels, Brougham, Bark.
		R				Y Y	Grey.	Messageries du Levant, Waggons, Rails.
B B					A A A A A A A		Carmine, Sinople. Silver, Livid, Pale, Yellowish.	Steamer.
B		R	r r r	G G G G G G	A A		Wan, Colourless, Colour, Carmine, Amber, Grey, Colour of Falsehood, Gilt, Gilded, Purple, Gilt.	
				G				Ship, Ships.
		R R R	r	G G G	A	Y	Coppery, Colour. Colours, Colour of dead leaves.	
B B							Uniformly Sombre, Colourless, Grey.	Barks.
B	V	R R R	r r r	G G G G		Y Y Y	Gilded, Gilded, Blackened, Ashen, Milky.	Through Expresses, Trains, Trains de Luxe, Nord Express, Locomotives (2), Canoes of perfumed wood, Waggons, Tugs, Trains, Sud Express Train, Restaurant Car. Cunarder, Mail Boat, Waggon, Restaurant, Orient Express, Sud Brenner Bahn, Carriages. Ships.
B		R R		G				
B B		R	r r	G	A		Ginger, Scarlet, Colour of Oil, Gild, Grey, Ginger, Blond.	Ship, Vessel, Boats, Automobile. Airplane, Flying Machine, Autobus, Airplane, Gare St. Lazare, Bark.
B B B B	V V	R R R R R	r	G		Y	Inky, Tarry, Milky, Copper, Blond. Gilt, Bluish, Grey, Verdant.	"Ancient Hulk," Station, Ship, Embarkation.
			r	G G			Blond, Pear Grey.	Station, Tramway, Tramway, Station, Chassis, Elevated, Metro, Decauville, A Locomotive all in Gold, Travelling P.O., Tender, The W.C. in the Orient Express, Trolley Cars, Steamships.
				G			Colours (verb), "The ink of the sky," Crimson, Coloured, Scarlet.	Boat.
		R					Purple, Redden, Coral, Coral.	

table to selected English and American Poets. TRANS. NOTE.

3

LITERATURE

IN ITS INTELLECTUAL ASPECTS

DURING revolutions people revolutionise wholesale, whether it be needed or not. Poetry was bridled by its conventions, so they unbridled it. A similar attempt was made in respect to prose, which also received the kind attentions of the liberators; but the latter is an art which is basically free. . . .

Many modern writers think they are writing prose. But in fact their writing, liberated and lyricised, so nearly approaches the forms of liberated poetry that the difference is practically negligible. So much so, indeed, that the pretended reformation of prose led finally to its being no longer prose but poetry. If the function of pure poetry is, above all, to evoke feeling, that of prose is to make us think: revolutionary literature makes for feeling, not thought. Pure prose is first and foremost the language of definition: poetic glamour is no longer what counts most, but the intrinsic interest of the thought. Certainly the rhythm, the music of the words and their interactions, intensifies the thought: but the form is already adequate if the idea is clearly expressed, and, above all, if it is worth something.

The richness of prose lies in the richness of ideas; its freedom, in the freedom of its thought.

Two poles: PURE POETRY, the creation of states of feeling and emotion which escape definition; PURE PROSE, a language for the expression of thought in all its purity.

The prosaic is always in the thought and not in the form. "Please despatch, carriage paid, 5,000 tooth-brushes, No. 727." That is prose: prosaic.

Fine prose can never be prosaic, for a fine idea is always poetical: that is, indeed, why it is fine. Fine prose is a consequence of the reverberation of ideas through the medium of words, and not of the reverberation of words at the expense of thought. "Thought annoys the fools who strive vainly to understand it, for their literary custom is to admire only forms of style." (Stendhal.)

38

Modern texts have not always the purity of style of the writings of the seventeenth, eighteenth and beginning of the nineteenth centuries. When we have read them there is often some uncertainty as to what the author means. Some there are who attribute this obscurity to the form of the prose, accusing it of being unable to respond to every subtlety of our thought. To them it is the fault of the form if the conception happens to have no form. Is it true, then, that normal language has become so inadequate to the minds of today? Montaigne, Bossuet, Descartes, Pascal, Buffon, Voltaire, Barrés, Gide, Valéry even, seem when we read them to be extraordinarily subtle. We think we thoroughly understand them . . . has language, then, betrayed them? If their thought had been even more subtle, would language have gone bankrupt? Modern thought is subtle, and in order to find words for it, language is modified by rubbing off its edges, doubtless with the object of enabling the reader to enter fully into the thought and untie the knot. It is Gordian prose for instructed readers. Some there are who cut that knot by shutting up the book.

Assuredly the subtlety of the work depends to some extent on the subtlety of the language used, for that determines the depth to which a thought can penetrate; but have all the resources of French really been exhausted?

A foreign author writing in French lamented the poverty of that language to me: he praised instead the huge Russian dictionary. But several times he asked me to repeat the word "reciprocal," which he did not know.

No doubt what obliged certain authors to write well was that they were read and had to be understood. Their readers were both lettered and learned. Michelet and Taine, historians: Bossuet, Renan, exegetes: Buffon, naturalist: Berthelot, chemist: Fontenelle, physicist: Pascal and Henri Poincaré, mathematicians and physicists: Descartes, Condillac, philosophers: Montaigne, Montesquieu, Saint-Simon, historians or moralists: Voltaire, something of everything. This impressive list, though incomplete, should tend to prove that the value of the underlying thought may be of more importance than we seem to think.

Nowadays a special consideration seems to be reserved for those authors, painters, or musicians whose work is both diffuse and confused. Is this to be interpreted as a need for profundity in us, which, unable directly to gratify itself, finds in such obscurity its illusory substitute? Softening down has charm. And, after all, there is nothing much wrong with obscurity if the thought is of secondary importance. Lovers of real thinking sometimes read scientific works. But disillusion awaits them, for because they are so little read, thinkers have made less and less effort to be readable.

Thus they have got into the habit of using a special language, which renders their writing quite opaque to the majority of readers. The wisdom and authority of the scientist, the philosopher, hardly extend beyond the immediate circle of those who specialise in the same subject. They are like prisoners who communicate by the merest signs.

It is too bad that those who can think, often do not know how to write, and those who have that gift have forgotten how to think. Willingly they make themselves harps for every wind that blows. Impressionism. Certain prose writers are in the condition of M. Jourdain, but writing poetry without being aware of it.

Scientists ignore the art of writing, and practically the only prose writers left are those engaged in Criticism (where it is, of course, important to be readable) in journalism or in Academic literature; all the rest is either more or less conscious or unconscious poetry.

Giraudoux, Paul Morand, Delteil, Breton, Aragon, Drieu La Rochelle will soon be excommunicated by those who go in for feeling, for they in fact are turning towards thought, being no longer satisfied to rely on the impressionism, under any of its various names, which dominates nearly the whole of modern literature, and which in effect was but the general poetic attitude of the last hundred years: romantic individualism. Absence of thought has become so admired a quality that no written work is accepted as modern by the majority of extremists, unless it satisfies this particular condition. The greater part of so-called intellectual society shows hardly the least interest nowadays in matters of the intellect; all it asks is to feel. Thus the majority of writers have little by little put aside thinking, real thinking, in order to pour themselves out, which is also something, but a different something.

The present ambiguity between prose and poetry, or rather between the spirit of prose and that of lyricism, explains why this chapter, devoted to prose, often mentions poetry, and why the former chapter, consecrated to poetry, treats of prose.

Certain writers, very conscious that an impressionist and revolutionary attitude in the arts has no longer anything exciting about it, are trying to walk the political tight-rope. They proclaim their disgust with society, and its rulers: in fact of our civilisation. Exceedingly prone to use paradox and invective, they devote their very real talent to the propaganda of revolutionary ideas. There is every possibility that such a political literature may provide valuable results. Maurice Barrés, in *Leur figures,* which still remains one of his best books, was able to make something striking out of a pamphlet. Doubtless its ferocity will be difficult to surpass, as is that of Léon Bloy or Léon Daudet. The latter will recognise his pupils in Messieurs Breton, Aragon, Ribemont-Dessaignes, Eluard, Benjamin Peret.

In any case, Barrés and Gide, in spite of the shadow of the great Nietzsche in the background, preoccupy those who write well or ill. Even though many authors pretend to ignore or even deny them, they still reign.

But here is the important point so far as it concerns the spirit which has dictated the drawing-up of this Balance-Sheet: poets are perceiving the possibility of a literature in which thought has a place!

André Gide and Marc Allégret in the Congo.

PAINTING

I

From before the Flood to 1914

CUBISM

THERE are plenty of ways of drawing up a balance-sheet: as a book-keeper, or banker, or lawyer, or Public Prosecutor: as a biographer, ethno-grapher, archæologist, statistician, or merely as a pal. Only profitable operations can be disclosed, or disastrous ones, or both. Or even nothing at all can be disclosed, which is a usual proceeding enough.

Here I shall attempt to elucidate a particular attitude towards painting, one responsible for the present conflicting views on the subject. I shall indicate its growing ascendancy, and draw attention to the part played by those who, like Cézanne, made possible the vast movement begun some twenty years ago. There will be no question therefore of the various good painters who do not come into this category. And, like all good accountants, I shall add to my Balance-Sheet, a note as epilogue and warning, for the avoidance of further risky speculations.

The aspect of the arts changes, not because of fashion, as is often thought, but because the new conditions that affect society and the artist bring with them new demands. Which does not at all imply that ancient masterpieces are out of date, for certain demands within us happen to be permanent.

New epochs bring with them new aspirations. The best artists in return influence society anew. A great artist is a forerunner unconsciously impelled forward by a society in course of evolution: but often he adds the movement of his own genius to that impetus, and so much outstrips the impetus that he modifies the further evolution of that civilisation. One is oneself (which, by the way, only the great masters can most truly be), but at the same time we belong to our epoch, and we react upon it.

An art which merits or merited the appellation of " modern " is an

art that is precursive. " Advanced art " adds a living cell to the muscle of tradition. Academic forms of art are so much adipose tissue. A Syracuse medal is beautiful, but it is no good striking new ones from the disinterred mould, or trying to pass the old one off as new.

New demands, new art. The abruptness of pioneers is always considered outrageous. Under the influence of the Pharaoh Amenophis IV. the artists for a time broke with the tradition of hieratic forms, the art of the priests, in order to copy nature, and the result was a real political revolution : " modernism " was the rallying cry, and the very dynasty was shaken. (Our own time saw the cessation of the imitating of nature, and if the dynasty was not shaken it is because there are no dynasties now.)

In the fifth Greek century Phidias broke away from primitive academism, as later Giotto broke away from Byzantine influence. A similar movement took place in the nineteenth century, when the artists abandoned their studios for the open air.

But if it be believed that progress wipes out the creations of the past, what becomes of progress?

Do the Ægean marbles move us less since Michael Angelo, Rodin, Cézanne? No! New works, new modalities !*

There is progress in the evolution of technical equipment : a locomotive of the Pacific type is in advance of the Fulton Puffer since our need for speed is greater. A beautiful Egyptian statue was perfect in its epoch and remains so, since it appeals to all our " constants." A work of art that satisfies only a passing need, a changing fashion, wears itself out.

In the eyes of many, ancient works of art seem merely experiments, drafts, modest preparation for more recent works. Moderns imagine they often surpass their predecessors, and that in so doing they annihilate them. All mirage and fatuity. Actually, supposing every civilisation has something particularly individual to express, the function of Art is not merely to minister to needs recently born or ready to be born, but above all to satisfy those which are deep and unchanging in us.

It is time a firm stand was made against so elementary an idea of progress in art. It is perfectly silly to imagine that our most modern work testifies to any advance whatever on the great epoch of Egyptian sculpture. It would be like assuming Mallarmé to be in advance of Pindar, Bergson of Parmenides, Seurat of Poussin.

It may be comforting to regard oneself as a final achievement, but it would be better to forego that pleasure : by so doing we shall

* " Art does not itself repeat itself, it prolongs itself." (Léonce Rosenberg.)
 Henry Kahnweiler and Léonce Rosenberg were the first publishers of works on Cubism.

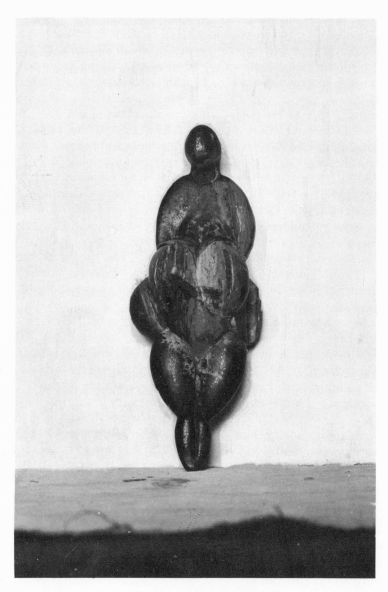

The Venus of Lespugne.
Prehistoric statuette found at Lespugne, France. (*Circa* 25000 B.C.)

take example by those scientists who, having elaborated some new conception of the universe, do not, in consequence, consider it final or perfect, but only a better working proposition, in the sense in which Henri Poincaré has said that the new conceptions of science are not more certain than the ancient, but only more " useful ": which is saying that they conform better to the demands of the spirit of today. So it is with modern art, which is better adapted to our needs than the work of the past, and that is all.

Cézanne, because he was the precursor of Cubism, is no less great than his successors. He in his potency is one vast aspect of art, the Cubists are another. Any creative effort is truly related to its epoch when it can satisfy the totality of needs of that epoch, including those which are still inarticulate and of which the greatest artists have as it were a presentiment. The needs of an epoch = eternal needs + recent needs + tomorrow's needs.

There have been very few precursors. The majority of the artists of every epoch (ancient Egypt, Greece, the Renaissance, etc.) produced only such works as were in conformity with the needs of their age. It is natural that the masses should turn to what they understand, which explains the tardy recognition accorded to true creative minds and the success of such as lag behind. The followers turn out the usual stuff. I am not concerned here with whether it is good or bad : I just say it is so.

Great individuals have always been rare. The history of Art is a few names only. The masters were those who said something new in their time. At first a nuisance, they succeeded later in inoculating the public with their own special needs, which eventually became everyone's heritage. The schools are the product of the paraphrasers whose affiliations, branches, colonies, and large-scale production exploit the " market " created by the masters. Thus even the Renaissance had a few great painters and crowds of lesser men. Yet schools have their uses, for they help to get the master accepted by toning him down, and when they exaggerate him they end by boring everybody, and thus deliver society from his tyranny.

Here I find some difficulty in knowing how to begin my account of modern painting. I ask myself whether it would not be better to begin with prehistoric times in order to demonstrate how living are certain works that date back millenniums, and by living I mean satisfying needs that exist in us today. For indeed this fresco, say what you will, is pretty "Surrealist."

Owing to our proximity to the schools of painting which at present interest us, we see the divergences only. I seek the main trends. And yet, if Delacroix, Seurat, Renoir, Segonzac, Léger, and Braque be compared with Phidias, what a close relationship appears! In a very few decades the great figures of 1840 to 1928 will all bear a strong family likeness to each other :

Prehistoric Fresco : La Pileta (Malaga).

Cézanne.

Albert Gleizes, 1910.

the weathering of a century is something very different from a summer's exposure.

The date chosen might be that when the Impressionists broke with every convention and looked out on the world with marvelling eyes, or when Ingres and Manet took such scandalous liberties with the human form, or even when Courbet affected to paint anything and everything, or when . . .

Nevertheless, one moment particularly pregnant with possibilities for

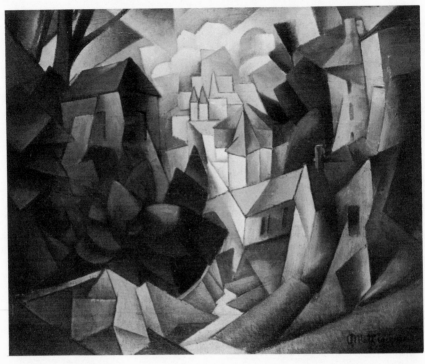

Metzinger, 1911.

the future was when CÉZANNE, deliberately and more ambitiously than ever before, dared break away from nature. That, I think, is the best moment to call a halt, for it was then at all events that the idea of an art independent of the external world originated, plus the deliberate intention that art should be as far as possible removed from nature.

I want the capacity for invention of certain modern artists to be appreciated at its true worth, as, for example, Cézanne abandoning the naturalism of Courbet and setting aside the appearance of reality, the better to scrutinise its image in his spirit. Yes, the point of departure must be Cézanne: without him there would be no meaning in Cubism. It is a movement of great importance, but Cézanne's originality was something even more fundamental, more startling, than the spirit behind Cubism, which served merely to carry further the discoveries of Cézanne. In fact, Gleizes and Metzinger in their book *Du Cubisme*, which appeared in 1912, that is, towards the end of the great Cubist epoch, say:

> " *Between ourselves and the Impressionists there is only the difference in intensity, and we do not wish there to be more. He*

*who understands Cézanne already has a presentiment of Cubism.
From now on we stipulate that the only difference between the
latter school and the art manifestations preceding it, is one of
intensity."*

I propose to define Cubism as super-Cézannism. Cézanne took terrific
liberties with nature, and so sometimes did the Cubists with regard to
Cézanne.

It was all a question of how to gain even more intensity, for that was
the need of the age.

But often something quite different was seen: some altogether unex-
pected and astonishing miracle.

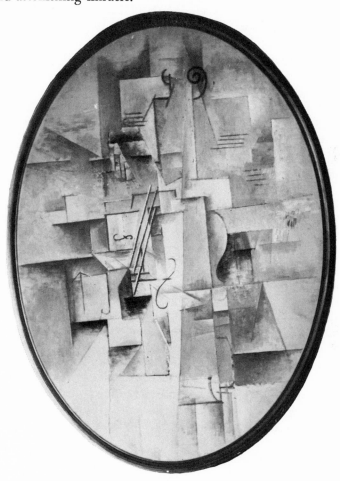

Picasso. 1912.

First, however, let me name the artificers of the first Cubism, as mentioned in Guillaume Apollinaire's *Les Peintres Cubistes* (1913). They were Derain, Pablo Picasso, Georges Braque, Robert Delaunay, Le Fauconnier, Jean Metzinger, Albert Gleizes, Juan Gris, Marie Laurencin, Fernand Léger, Louis Marcoussis, Francis Picabia, Marcel Duchamp, Duchamp-Villon, Archipenko.

By the difference in the illustrations that adorn *Les Peintres Cubistes* the individual direction of each of these artists can be traced, their paths in some cases being hardly discernible, but in others leading to blind alleys or broad avenues. Yet as early as 1914 Picasso had broken away from Cubism. Braque went to war and returned different, Marie Laurencin had never more than brushed Cubism with the tips of her pretty wings, and the best period of Juan Gris was between 1917 and 1922, though the painter had ceased to be a real Cubist. Fernand Léger, on demobilisation, did indeed for a while take up his art where, interrupted by war, he had left it; but the mechanical revelation of armaments was already modifying it, as was that new outlook which I had forecast in 1916 in *L'Élan* and elaborated in 1918 in *Après le Cubisme*.

Turning over the leaves of Apollinaire's book, the extreme diversity of the first Cubist productions appears. I have thought it best, therefore, before going into the question of origins, to express certain general opinions on this movement, which for the most part is not too clearly understood, owing to the difficulty in placing it. Cubism lasted little more than a moment.

{ If we wish to avoid unending confusion we must stop calling
{ Cubism what is not so. Cubism belongs to the period 1908-1914.

The word "Cubist" must be reserved solely for works painted earlier than 1914 by Picasso, Braque, Metzinger, Gleizes, and some of their friends. The trend was towards an extreme separation of nature and art.

Inextricable muddle. It was thought that under one designation both the Cubism deriving from Cézanne, and the manifestations of an attitude extremely different and perilously close to mere decoration, could be reconciled. The confusion necessarily created by such very disparate phenomena led to the most hilarious misconceptions. The same thing happens in academic æsthetics, where attempts are made to formulate laws which reconcile at one and the same time Giotto, Meissonier, Botrel and Rimbaud, Gustave Charpentier and Bach. It would be a similar misconception to class as Cubist, among the noble paintings of 1908 to 1914, certain pleasant compositions in form and colour painted after 1914: an error most generally perpetuated, and one which results in chaos and a mish-mash of ideas and opinions.

And if, exceptionally, certain truly Cubist works were painted after 1914, it must be realised that they in no way add to the primary concept of the movement. Painting went on to something else, at least that of the masters did. To be precise, Braque took up painting again in 1917, having returned from the war, and went on with it into 1921, always on pre-1914 lines. He is a long way from Cubism now and by so much the closer to nature. Picasso about the same epoch had a Cubist spasm, and that ended it: Gris grew less and less Cubist, Léger and Metzinger quickly ceased to be so, and Gleizes remains the only one of the founders of the movement to preserve the primary concept.

It is somewhat surprising that RODIN the revolutionary should almost systematically be ignored in works dealing with modern art.

Yet his liberating influence was tremendous. His fame was universal just when the Fauves of the new painting were banding together. Indubitably he was the first of them all. He was the model revolutionary. The drawings I give next deserve careful attention, and the reader can then decide whether the sculptor merited such burking. His influence was far earlier than that of Cézanne on the Jeunes. If Rodin inspired Fauvism, Cézanne's influence was of a different order. The geometrical approach meant nothing to the Fauves, but the two attitudes fused in the first Cubists.

Rodin.

Rodin.

The freedom with which Rodin treated nature and the human form, was added to that of Cézanne liberating himself from the subject. Fauves, Cubists, and all succeeding schools are indebted to these two masters.

{ The Cubist attitude: the effort to evoke emotion without resorting to representational forms.

Yet from antiquity onwards the classical attitude has been to consider painting a representational art. Theoretically, that is. The lack of

agreement between the theoreticians of painting and painters, is not par-
ticular to this age, for painting has never been, except to a few odd cretins,

altogether a matter of pure imitation. A few dreary Dutchmen, the insi-
pidities of Meissonier, the Daguerreotype : all these were steps towards the
ideal propounded by the philosophers.

All thanks to Daguerre; he revealed clearly that exact imitation, item for item, cannot reproduce nature, but that only EQUIVALENTS can. It is not by making volcanoes that sulphur is produced. Retorts are better. Nature is

not reconstituted by imitating animal cries or natural noises, but by writing pastoral symphonies. To imitate something is merely to stuff it.

The painters of the past respected nature when it did not interfere with what they wanted to express. But the art of the Egyptians, Greeks, Byzantines, of certain artists of the Renaissance, of Michael Angelo and French primitives, of Jean Goujon, Puget, Poussin, Delacroix, Ingres; of savage art, and in fact of all great artists, was often very remote from nature. And in permitting themselves very wide divergences from nature or even the human body, they claimed to be " enhancing its specific attributes."

When the Moderns discovered El Greco his audacity amazed them. His eminently mural achievement, hung on the line in museums, made them take him for a forerunner of the distorting modern extremists. Doubtless he did consciously make use of dominant verticals to create the particular effect they have on us, but always with a certain moderation: hardly more exaggerated even than Tintoretto, his master. Has it been remarked that such of El Greco's painting as remains where it was painted, generally above some altar, even though elongated, hardly gives this drawn-out impression at all? El Greco lengthened his forms in proportion as their position above eye-level made them seem to recede. If his picture " The Interment of Count Orgaz " is seen in its place in Toledo, the proportions will be seen to be those of nature. Actually, the only figures to be extremely elongated are those situated in the sky, and in consequence the most fore-shortened by perspective. This painting has remained in the situation it was meant to fill, and no distortion appears when it is looked at. El Greco's easel pictures, the portraits, are a trifle elongated, but nothing in comparison with the mural paintings. Except, of course, those small paintings which served as sketches for larger ones, for in these the distortions are worked out. El Greco distorted above all to defeat distortion.

An interesting historical observation is that the photographic reproductions of El Greco at his best, taught Cézanne the power of expression that lay in extreme distortion. The dominant verticals inspired the forms with a nobility to which Cézanne responded. He made use of them. El Greco's influence on modern painting is considerable. But he was a forerunner by accident.

"DISTORTION"

NOWADAYS the word " distortion " is very much used. It is understood loosely because it is used loosely. It is meant to stand for the transfiguration which artists impose on the exterior world so as to give a more intense version of it.

Sir Austen Chamberlain as seen in a Distorting Mirror.

The Portrait of the Crown Prince's Horse, or the Fable of Apelles.

The distortion sanctioned by the Classical period allowed certain elements to dominate, though never to the point of seeming unnatural: but the distortion of the Romantic era allowed for a violent exaggeration very near to caricature.

The search for intensity dominates the whole of modern painting. There can be no intensity without simplification, and, to some degree, no intensity without distortion: the distortion of what is seen, naturally. Simplification, distortion of forms, and modification of natural appearances, are ways of arriving at an intense expressiveness of form. All such means are analogous because they succeed in establishing certain dominants. In this respect the most important influences on Cézanne were El Greco in regard to distortion, Corot for simplification, and doubtless Manet for colour.

Corot and Manet take nature as their point of departure, simplifying it, using it sparingly, inventing equivalents. Against this method a Meissonier imagines he is rendering nature by reproducing every grass blade, every leaf, every possible detail. He wants to show us everything, and only the inadequacy of the finest brushes prevents him from including even more.

But the only purpose of Corot and Manet is to create in us the emotion they themselves felt in contact with something objective or imagined. Frenchmen, they did not go beyond what was indispensable, which is one way of submitting without servility to the natural laws that govern our sensibility. One of those lovely Italian views, or Manet's " Olympia," says economically and comprehensively what Meissonier, with all his simian imitativeness, would have said incompletely with utmost prolixity.

This capacity for simplifying is common to all great French painters: as, for instance, Fouquet, Poussin, Corot, Manet, Cézanne, Seurat, and to every great artist of every school, every age, everywhere. Inspiring synthesis! Magnificent prose (from which the lyrical is not excluded), concentration on definition, but only to the degree necessary. Conception bounded by clear outlines, nothing overlapping, exactly limited, but how pregnant! The egg's impeccable parabola contains more energy than a barrel of froth.

No doubt Michael Angelo, the Egyptians, the greatest artists, have always practised something analogous to the method of Cézanne: but there is one historic reality which must be emphasised, and that is that the Impressionists, who were his contemporaries, were, taking them all in all, confirmed imitators of nature or of what seemed to them so. They were individualists who had accepted a conventional mode of expression. While the Impressionists were translating the sensations that came to them from without, Cézanne was seeking in nature's vocabulary the means of expressing his interior world: something very different therefore. The contribution of this great master lies in his fundamental determination to subject nature to his tutelage, which resulted not only in his simplifying it after the manner of Corot, but in reducing it to a repertory of forms and colours.

For actually, to Corot, the exterior world was something visual, and if it moved him he simplified it in his painting, to make it convey as much as possible. When Corot is being imaginative it is always realistically. Cézanne has no interest in doing this, and if he does it it is never intentionally. Cézanne's problem is always how to find in nature communicable formulas adequate to the expression of interior concepts. Fundamental divergence! Nature considered as a theatre, where the tableau is what matters most, or, like a simple vocabulary: the difference in fact between an author who adapts the reality of some tragic event and one who altogether invents it. Trends!

Corot imitates, and in imitating seeks to translate what he, Corot, experiences. Cézanne chooses from nature what best expresses Cézanne.

The history of painting and sculpture is more than anything a record of varying interpretations of the human form.

In the painting of the past, the principal rôle is enacted by people, and a landscape's only significance is as background. But Nicolas Poussin and Claude Lorrain succeeded in allotting the most important rôle to the landscape.

It is easy enough to tyrannise over a tree, the concept "tree" being so very elastic. A poplar, an oak, are also trees, however much they differ. But it is a different matter with the human form, for a man is a man, ourselves. The disciplined trees of Le Nôtre remain trees: but hacked about in the same way a human form would look butchered, or like those mutilated soldiers that people hide away during wars. All the same, the eye little by little accustoms itself to accept trees, houses, clouds, and all nature, utterly transformed, and the re-education of the organ leads to an indulgence that is extended to the human form. The painters of landscape, to which living figures lent animation (Poussin, Lorrain), found themselves obliged to consider the relation between such figures and their background, and to this end they found it necessary to distort masses. Thus the human form came to be no more sacrosanct than the next thing. In order to relate the human form and its background, the forms themselves had to be modified to make them fit into a background which had been modified already. Anybody who truly comprehends the enhancement of effect brought about by increasing the height of a yew tree, let us say, and how adapted such stature is to architectural forms, will more naturally accept the modifications of the human form made necessary in the interests of good composition. Thus it was that after Claude Lorrain and Poussin and the landscape painters of 1840, Corot, Manet, and the Impressionists, Cézanne could conceive himself justified in treating human forms with extreme freedom. The road had been marked out. Ingres and Delacroix had already permitted themselves every licence that their own epoch permitted (as interpreted by themselves, not by the public) with a view to expression. Once such distortions of the human form were accepted, an even bolder attack could be made on inanimate objects, with the result that all these new liberties went cannoning off each other in ever widening circles of influence. Cézanne as a result dared paint forms the characteristics of which were the most violently accentuated of his century (the nineteenth).

He was the innovator also of a sort of stasis, no longer inert like that of buildings of hewn stone, but sustained by flying-buttresses, the balancing of opposing, compensating forces: a stasis founded on an admirable dynamism: walls that would have crumbled to pieces if the painter had not re-established the equilibrium of his picture by introducing an inverted tree, for example.

Daring liberties, it may be, but the subject still prevailed: houses,

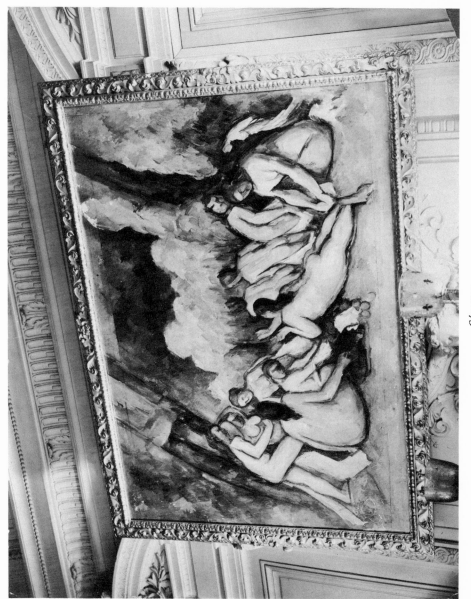

Cézanne.

mountains, flowers, fruits, human forms. It was only after Cézanne's
death that the Cubists, with no uncertain finger, pointed nature to the door.

*

CONCURRENTLY with landscape painting, still-life helped to bring
about the release from prosaic exactitude. Only the truest connoisseur can
adequately appreciate the relations of tones and forms in a still-life, for
the intrinsic interest of such a subject is practically nil. A real peach or
pear are beautiful things, but the aspect lent to them by Chardin, say, or
Cézanne, is something utterly different from their imitation: symphonies
of forms and colours, of which the subject is but the ultra-modest theme.
The same is true of the fugue, which also is not the theme, but the
modalities of that theme. The subject in painting and in music must be
taken merely as a cause, important not in itself but in its consequences:
expression, intensity, quality. Modern painting is to the theatrical-scene
what the sonata is to the opera-comique.
 If the artist's attitude to the human form be truly humble, it may move
us very deeply. But what has a still-life to say to us other than what we
make it say? Yet by its means artists accustom themselves to appreciate
works whose only value is their poetical content, a poetry derived from
the relation of forms and colours independent of what is imitated. The
lesson thus taught largely determined the Cézannian emancipation and,
following on it, the Cubist.
 The subject matters so little in a still-life that a trifling shock was to
prove sufficient to inaugurate an attempt to dispense with it entirely.
 Cubism therefore, in my opinion, can be considered as the " still-life "
entirely liberated from the subject.

*

NEARLY all the Cubists, before becoming so, belonged to the Fauves,
who had already profited by the teachings of Rodin, Cézanne, El Greco
(through Cézanne), Gauguin, and particularly the impetuous Van Gogh.
Savage art was an additional emphasis of dominants. Matisse, Braque,
Derain, Vlaminck, Picasso, Van Dongen, Rouault, Friesz, Dufy, Fauves,
were the origin of the ensuing Cubism.
 Fauvism was expression in revolt, swashbuckling, slightly faunesque.
 The very real value of certain of its productions justified its excesses.
 Form became less and less dependent on exterior reality: the expression
justified the means.
 Coincidentally, colour too emancipated itself, and here as elsewhere,
freedom was interpreted as " no quarter." But actually, painting in the past
was extremely open-minded as regards the colour of nature: Masaccio,

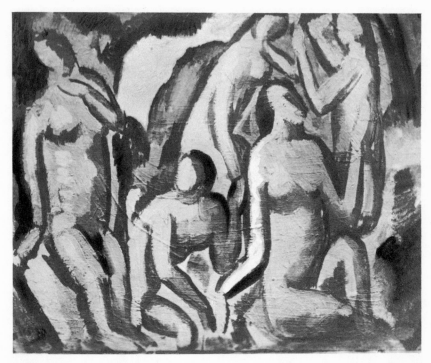

Derain. 1908.

Signorelli, Michael Angelo modified the intensity of colour in nature by toning it down. The neutral colour of the earliest phase of Cubism approximates to the same attitude, and helped to conceive noble works. On the other hand, the Byzantines, the Italian, Flemish, French primitives, the Persians, and Venetians, and nearly all the artists of the sixteenth, seventeenth, and eighteenth centuries, exalted the colours of nature in all their vividness.*

Yet a certain logic determines this enhancement of tones in the work of the masters. And except in the case of the Byzantines and Primitives of the Renaissance, who translated every sort of thing into gold, and the decorative painters, colour is simply keyed up or toned down.

Not till our own times were the norms voluntarily subverted: trees became red and flesh-green, prussian-blue or lemon-yellow. Van Gogh and

* Certain portions of Tintoretto's " Great Crucifixion" in Venice have been discovered under the protecting wood of the frame : the colours are intensely vivid and uncompromising. It is these good pictures that ought to be cleaned, not the second-rate ones, which derive so much benefit from age. Death can make the dullest features majestic. A little dirt can modify so much screaming colour. Advice to paint with pure colours is the undoing of the mediocre.

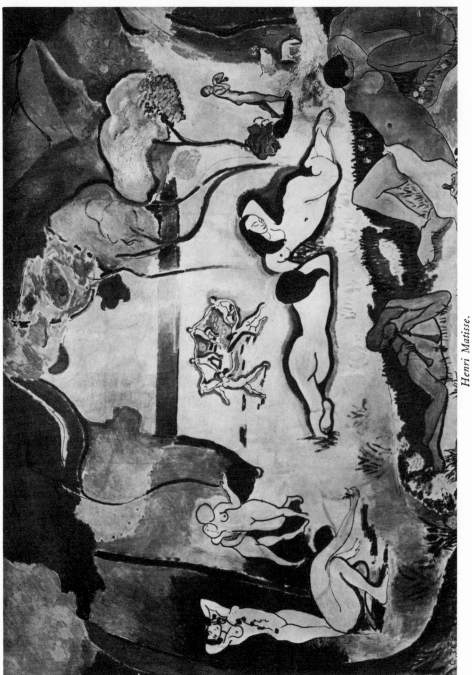

Henri Matisse.

Cézanne.

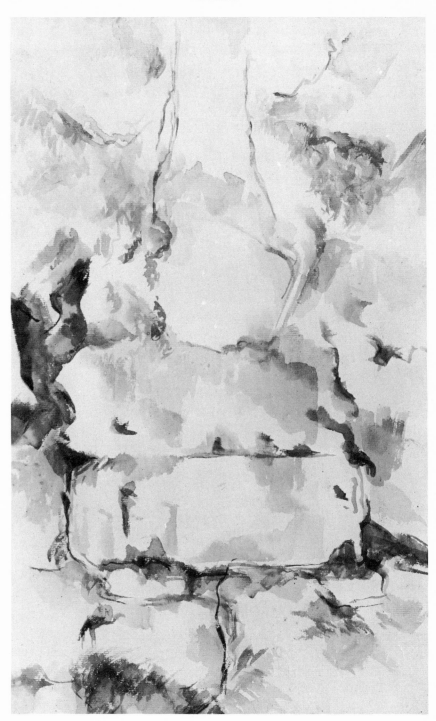

the Fauves took up the job gaily. The painters splashed around in floods of
retributive colour.

It is clear that Cézanne towards the end of his life conceived painting as
approximate to an effort of pure creation. His last water-colours witness to
an astonishing detachment from objectivity. It was an art of related forms
and colours adequate in themselves yet almost without any recognisable links
with a subject. But actually, as always, no work of art absolutely attains the
ideal sought for.

It was the Cubists who realised Cézanne's ambition: upon them
devolved the task of working out his trends to their final, extremest conse-
quences. Yet the future Cubists did not at their first efforts succeed in sur-
passing him. For them it sufficed to eliminate just a little more nature than
Cézanne, in his middle period, had done. Actually, the last water-colours
of the master are more Cubist than the Cubists' first paintings. Look at
this painting by Cézanne with the sky cut out.

Cézanne.

The inventive originality of Cézanne will be appreciated when it is
remembered that his friends were Monet, Renoir, Sisley, and not Picasso.

All who were present at the first exhibition of Cubist painting will re-
member the astonishment and bewilderment caused by it. The picture en-
titled " Moulin à huile " reminds us that the painting in question repre-
sented cubic houses, rather less cubic than the Provençal ones painted by

Cézanne.

Cézanne, the windows which he sometimes included being omitted. Fundamentally, these manifestations, so prematurely called Cubist, were only its earliest symptoms, derived entirely from Cézanne. The "protests"

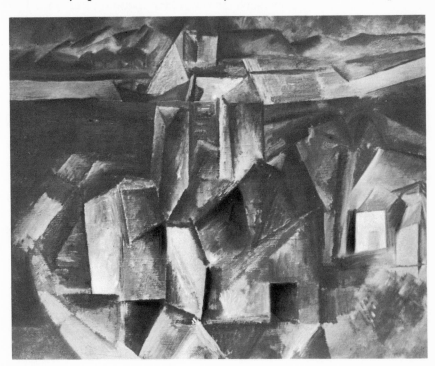

Picasso. 1910.

which at that time were its immediate consequence, reveal the degree to which our minds are representational, for merely to eliminate odd details from these houses, easily recognisable as they were, was enough to make the public furious. Most vehement of all were the panegyrists of Cézanne. Yet they had seen plenty of pictures of the same kind. It was forgotten how much more revolutionary the master himself had been. Could they really have looked at Cézanne? One is not always understood by one's friends.

In short, Cézanne supplied the spirit and the method, and that spirit was so rich that every artist since has been in his debt. A conception new to the twentieth century: painting as independent of exterior reality. It is clear now why I have suggested calling Cubism super-cézannism.

Had the Cubists called a halt at this point, their school of painting would have been an indefensible imposture, a case of substitution, infringement of trade-mark, or, simply, pure Cézannism.

But the Cubists were to slacken the bridle of Nature still more. Many painters, and Cézanne above all, as we have seen, treated exterior reality very casually: but what had never been achieved was a painting *altogether* independent of it. Those who took part in the experiments of this period have not informed us how such an extremist notion came into being. Methodical search is only undertaken for something which, so to speak, has been discovered virtually already. I shall produce evidence. It will help, I believe, to a clearer vision of that mysterious epoch.

Nothing is born spontaneously. If it occurred to Braque or Picasso that painting could ignore all exterior reality, the reason was because the seekers were getting further and further from it, yet the Rubicon had to be crossed. I render unto Cézanne what has been attributed to Picasso. But he is about to appear on the scene. Let us seize the precious moment.

At the point they had reached any accident might have proved fruitful. Was it Braque or Picasso who realised that a canvas standing upside down against a studio wall sometimes looked better than when right way up? . . .

Whereupon, the last link, worn to nothing, suddenly snapped. Result: landscapes are turned upside down, camouflaged with some ornament or object to deceive the eye, furnished with bizarre titles to put the onlooker on the wrong track: " non-representational " painting is born into the world. Nature, hitherto the intermediary, has been suppressed. The mine, sapped for ages and rammed hard with revolt, explodes at last.

I am exaggerating. What happened was that a virtual thread had snapped.

" Ouf!" cried the painters.

" Boo!" said the public. (But why?)

If the development of Cubism be traced from the time of Cézanne, the inevitable and logical development of a painter like Braque becomes obvious.

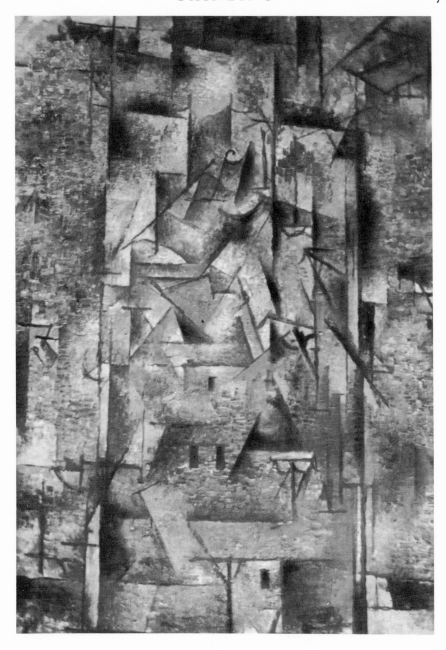

Georges Braque: A Window in Céret. 1911.

This very Cubist painting has a perfectly straightforward title. It reveals the extent to which Cubism derives from the landscape of Cézanne.

"The subject of a picture," says he, "is its poetical (lyrical) quality," which explains everything. Yet all the same, some sort of form had to be discovered that would make such a conception objective. Possibly it was Picasso who took the shortest cut.

The subject picture can be very fine, but often the painter, satisfied with

Top.

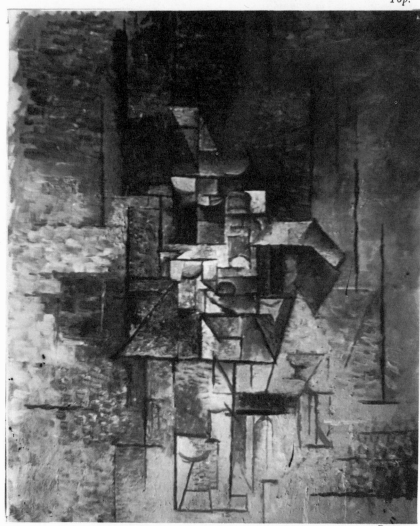

Bottom.

Picasso: *Woman with Guitar*, 1911.

Here the title is ambiguous, for if you turn the book round . . .

his scenario, neglects feeling. In the battle against subject painting it was necessary at all costs, and by every means, to make feeling more dominant than vision. Now there is one method familiar to every painter, which is, that when a canvas is turned upside down, it loses almost all its imitative effect, and reveals its " plastic " qualities. Toeppfer's design on the next page maliciously illustrates this useful practice.

But to maintain a canvas thus inverted, the lyrical and inventive spirit of a Picasso was needed. Chance is only propitious to those who can take advantage of it : to turn a canvas bottom up is a perfectly commonplace proceeding. But to enrich an æsthetic, create a technic (a mode of expression) by realising, no doubt first among men, the profound consequences of this traditional practice, required what was, in effect, a stroke of genius.

I remember that at the outbreak of the Great War, Picasso was putting the finishing touches to certain pictures in the position in which they seemed best to him, deciding which should be top and which bottom, rather in the manner in which, after various attempts, one arranges some decorative object as it at last looks best.

Invention has a thousand resources. Some, like Cézanne, Derain, or Braque, intuit, reason, deduce, and only proceed when equipped with everything they need. They work out a plan, and having executed it decide its fate : they relate instinct and intellect. Others, like Picasso, are able to discover treasure that literally hit one in the eye, though no one saw it.

You remember how the public sniffed and snorted in those days : " You call that painting ! But it doesn't look like anything."

Accustomed to judge painting by what it imitated, the public vociferated or split its sides, in front of canvases in which it could recognise nothing : wonderful discussions took place in the Press, and the most asinine views were exchanged. The astonished public was unable to recognise the extraordinary talent to which these surfaces, painted in so remarkably novel a manner, bore witness : or that, solely as a result of form and colour in no wise representational, unprejudiced minds could derive very real gratification from them.

It is probable that the reason for so violent a reaction in the public mind to a mode of painting so much more " sensory " than any other, was due to the manner of its education : it had been dosed so very thoroughly. Because painting is a representational art and descriptive, the public expects to have representation and description handed to it. Finding it withheld, it begins to growl. The public is very punctilious where art is concerned : it prides itself on knowing all about it. But though such homage to art is very touching, it is also very dangerous. Yet it would not have been difficult to say :

" You are able to feel satisfaction in looking at a negro rug, which

Page 2

Monsieur Pencil, who is an artist, is making a drawing from nature.

M. Pencil, who is an artist, looks at what he has done with pleasure, and remarks he is pleased with it.

M. Pencil, who is an artist, remarks that pleasure down it pleases him too.

And even if he looks at it over his shoulder.

And having tried to see it from behind, M. Pencil, who is an artist, remarks with pleasure that he is still pleased with it.

Rodolphe Toepffer (Mr. Pencil), 1830.

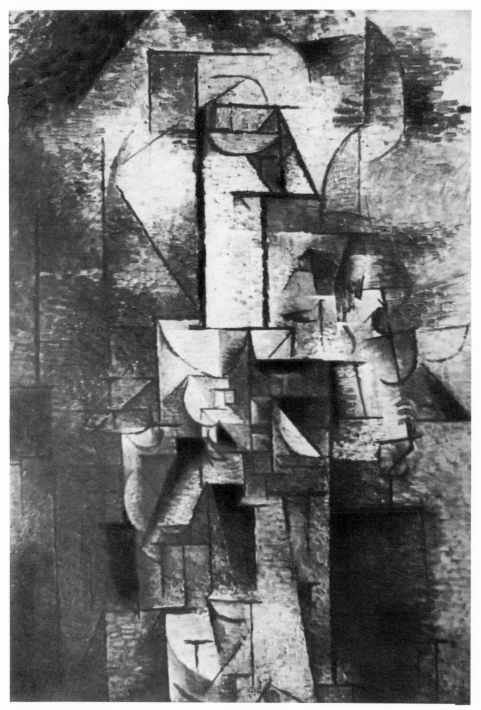

Picasso: Woman with Violin. Here we are in the heyday of non-representational Cubism. 1911.

represents nothing: why not feel similarly in front of a Cubist work, and allow the form and colour to affect your sensibility, without demanding anything more from it? For that is all there is." And, in effect, that is all, to begin with. But no one said this to the public, and instead, everybody went on and on arguing about it, until it was enough to send you to sleep as you stood, or waken the dead, or destroy the living and the dead too. In those days the public (as it does today) wanted to understand. So the newspapers explained everything: but generally with hostility, and always abstrusely. They invented a Heaven knows what extraordinary fourth dimension of painting. Cubism as a topic of conversation was on a par with table-turning. Writers, instead of explaining these works as intended to evoke feeling, used all sorts of metaphors, like occultists of the past, or fortune-tellers by cards. Yet in spite of all, the public would probably have grown accustomed to like this kind of painting (some of the stuff it likes today is pretty revolting), when suddenly there was no further need to make the effort. The seekers were already evolving further. The heroic age of Cubism lasted a few months only. Soon came the war, and few are now those workers of the first period, who, like Gleizes, continue the researches begun in that pure period. In any case, the majority went off to the real war. And at a later date we find Cubism much changed. It is a substitute Cubism only that is tolerated or appreciated: a Cubism in name only, with no right to bear it.

Let us be clear as to what the Cubist spirit was. I am not justifying it. I am trying to show what its contribution was. One definition would be: "Cubism is painting conceived as related forms which are not determined by any reality external to those related forms."

When a painter was faced with the problem of executing some trifle "after nature," nature was in fact duly executed. To hope to imitate sunlight with splodgy colours, or translate into actual colour the vibration of light, was inevitably (at least theoretically) to come to grief. Representation, they said, was never anything but a wretched *ersatz*: light from paint tubes, questionable flesh-tints, nature falsified: and the closer representation was to the object in question, the more flagrant was its deceptiveness, for what could be more false than *trompe-l'œil*; and, at bottom, what vainer than the theatre, when it would have us believe in its reality?

The Cubist painter no longer sought to imitate. His object was to evoke emotions by the exhibition of coloured forms, which, not being comparable with aspects of reality, evaded the falsities inherent in *trompe-l'œil* painting. Representational painting is like music that would claim to give us the illusion of a storm on a gramophone record: all the instrument could do would be to make questionable noises, which, by sufficiently reminding us of the real sounds, would make us realise how false they were. A copy is

all the time confessing its artifice and glorying in it. To paint true, is to evoke in the observer exact sensations and appropriate feelings, and not fallaciously to imitate. A profound difference. And here we have one of the most important aspects of the modern attitude towards art, and to the Cubist goes the merit of having clearly stated it.

At all events, the proof by *reductio ad absurdum* has been made: it is not Meissonier who is in the right, nor, at the opposite pole, those truly extremest painters who, outbidding the Cubists, depict a sort of squaring-up; which instead of being forms of pure construction, as these gentlemen think, is, on the contrary, a very exact and innocent imitation of tiled surfaces and other building materials (the Neoplasticists: Mondrian, van Doesburg, etc.).

Had Cézanne reached his final conclusions at an earlier age, possibly he might have been the first of all Cubists. Very little indeed was needed to make him so. Would he then have broken completely with nature? But he died.

What remains is the fact that the clear conception of an art independent of a subject exterior to itself is new, and this we owe to the Cubists. (New for painting, that is, for in music it was generally so, as indeed for geometric ornament also.)

※

IF a painting retains nothing that is imitative, are we so made that we can avoid trying to find familiar forms in it? To make us seek them where they do not exist, is not that to set a trap for us and, in violation of the terms, bring us back to nature? At first view it would seem that pure Cubism is painting at its most lyrical. In intention, yes! But on reflection it appears to me that our minds, in spite of every arguable intention, must strive to comprehend the structural reason for arrangements that represent nothing, for the disposition of these elements must, in some respects at least, evoke those of nature. Too much or too little reality? Question of degree! But states of revolution take little stock of degrees. Then who is to decide? All the great painters!

Nature moves us when it approximates to art: but art suffers when it approaches too close to nature (servile imitativeness) or recedes too far. It is impossible theoretically to define wherein virtue lies. It must be felt. I am not sure that the problem "too much or too little reality" has ever found a perfectly satisfactory answer. That is natural enough. But little by little we are drawing nearer to its precise solution. In music, what was false and so forbidden, had been determined, as also what was true, and so permissible. False and true in relation to what? "False" notes, like "true," have different properties, and so are legitimately employable

if they can be united in some enduring work. At this point we must admit that every combination of sounds is valid so long as they evoke in the hearer only the feelings it was intended he should feel. For a century now musicians have been trying to legalise certain arrangements of sounds which had been declared unlawful. Beethoven, Berlioz, Wagner, Debussy, Schoenberg, Stravinsky, Milhaud, Honegger, etc., all took liberties with harmony, static at that particular moment, because they had new things to say, and the new technic was of use to them. Today Jazz is in-separable from the extreme " Right " of the conservatoires, but the result is " harmonious," true. Massenet wrote true, but the result was often false. By false I mean without interest. In the section dealing with Literature, a parallel effort is dealt with. And another will be seen in the section on Science.

So in painting we do not now wish to ascertain whether the thing painted is true in relation to nature, but rather if it is true in relation to us. If it can " truly " convey the sense of its excellence, then it is justified.

> Every means is justified if the work has power and nobility. Which is not saying that all means are favourable. We have absolute liberty, it is true, but yet it is conditional on . . . and conditioned by . . . quality.

From 1908 to 1912 Cubism was both a " heroic " and " collective " movement. Heroic, because the problem these young painters had set them-selves was an arduous one, and loftiness of spirit was needed to affront it. It also meant incurring public enmity. Collective, because each profited by the researches of all : to such an extent, in fact, that it is not possible now to identify the separate contributions. This does not mean that Cubism was clearly outlined or could be learnt; but that it was a trend. That is why there never has been an orthodox Cubism, save for us who have tried to show what Cubism might have been, had it realised clearly that its originality should have lain in its capacity to evoke emotion through utter and systematic absence of imitation.

Unhappily, as I have shown, Cubism had no well-defined theory.*

* I have sometimes been reproached for making Cubism say things it never even thought of. Well, explanations of some sort had to be found for it, and if I did somewhat lend my ideas to a movement I never belonged to, can it be a cause of complaint to say that I helped to establish its doctrine . . . since the reasons put forward by me are now generally accepted, and its recognition is in some degree due to my efforts? Certainly it deserved them. But in 1921, at the Kahnweiler sales, Cubism sold for the most trivial prices, whereas after the appearance of " L'Esprit Nouveau " it was quoted very high: proof that the effort had not been vain, nor the desire to systematise that I bring to defining it. The works were rich in meaning,

Albert Gleizes himself, one of the first of all Cubists, wrote in 1920: *

> "*When this movement first found its wings, the painters themselves, in spite of all their efforts to explain their experiments on a rational basis, could, it must be confessed, establish no fixed rules or valid system. At most, there was an aspiration towards more solid construction, a vague impulse towards different relations of forms than those officially admitted, and a profound boredom with smart painting.*"

*

Great manifestations have always something extravagant in them: and they never become mighty unless philosophic minds lend them power. (Renan.)

*

CRITICS AND CRITICISM

APOLLINAIRE and André Salmon encouraged the young movement to take to its wings on the breath of their lyricism.

Maurice Raynal was one of its supporters from the beginning. Breaking away from subjective criticism, which writes poems and personal confessions about pictures it hardly looks at, Raynal began to interpret the point of view of the painting itself, and found ingenious philosophical justifications for the works of his friends, the painters in the vanguard.

Waldemar-George, somewhat later, brought to Cubism his generous enthusiasm and passionate courage.

Louis Vauxcelles adopted the rôle of getting round the opposition: his irony was witty. Fels and Clarensol were of the same school.

Today, in the *Cahiers d'Art*, Zervos and Tériade have the ungrateful task of discovering something original twelve times a year. They cannot be blamed for the fact that the months have but thirty days.

Literary indeed is the manner in which Jean Cassou writes what he feels and thinks about painting: but he uses his eyes, and thus his writings illustrate both the objective and subjective attitudes.

Numerous are the younger critics: but we must wait until their work has assumed some definite shape before we can speak of them.

the explanations are less so, and, in any case, confused. But Cubism is now defined. My only concern with Cubism was to do justice to certain works and to enquire into my own reasons for debating this stimulating subject.

* "*Du Cubisme*" (*Povolozky, 1920*).

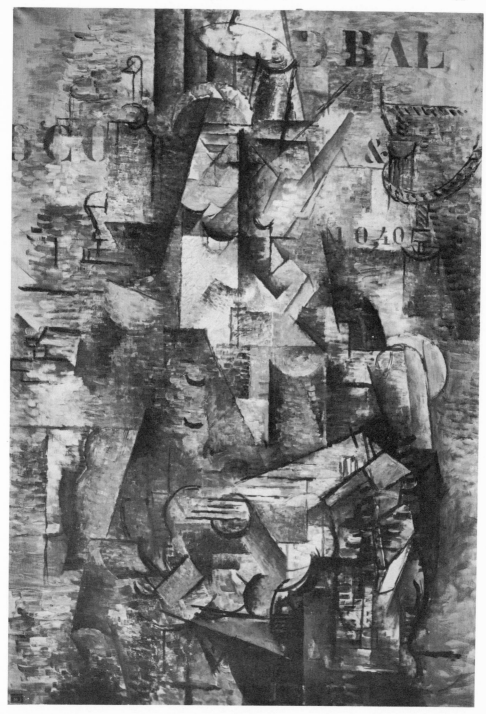

Georges Braque. *" Bal."*

ART MINUS EROTICS

POSSIBLY the most frequent reproach against the Cubists is of having dared to break away from the kind of picture that tells a stimulating story. They have left out woman!

The sexual situation weighs on art as it does on letters; the public wants the picture to be thrilling. The sage calls it " the zest of living": more precisely it ought to be called " the zest for high-kicking." This kind of zest has been with us since the days of Boucher, and long before that too.

Cézanne gave us pears and apples that owed nothing to Eve: it was a brutal interruption to a flesh diet. Matisse, Derain, Picasso, Braque, Gris, Léger, Gleizes and others, produced austere compositions in which there was nothing for the enquiring eye. No more slices of life, or women intriguingly unveiled, or breasts bursting with sap like ripe fruits. The Cubist terror, like all terrors, created an unholy respect for itself.

There has always been an art of gallantry: as, for example, the Korós of the fifth Greek century, painted and made up to the life; Tanagras, Pompeii, Coreggio, Boucher, Titian, Renoir, etc.

" But you are only citing masterpieces, and I really cannot see in what way the subject prejudices the perfection of the works you mention."

" I do not say that the subject necessarily prejudices the painting.* I am not even saying that at all. I say that such works please most people, precisely in proportion to their salacity. Very few know the Baptistery in Florence, but everyone dreams of having a replica of the famous little ' Temple de l'Amour' in their gardens. For they want ' love,' in hewn stone, or, failing that, in plaster. And if they have no garden, then it must be as a mantelpiece ornament. And if they have no mantelpiece, then in painting. And if they have no painting, then in music. And no music, in a novel. And no novel, then in butter."

When I turn over the pages of the history of Art, I realise that every epoch has its painters and sculptors of backs, of breasts, of loins, often magnificent (but more often charming). Assuredly, no art exists in which our senses do not have some part: through them our souls, our hearts, can be moved: but these delicate, mysterious impulses, released in the deepest regions of ourselves by forms and colours, these ineffable emotions which the heart itself is surprised by, must not be localised in one only of our senses.

Planing over the art of Eve is the art of Apollo, which Venus has nothing to do with. It is none the less significant for that. Descartes hardly mentioned love. And if Ingres, late in life, did so rather too often, that is not why we go to him for instruction.

* See p. 277.

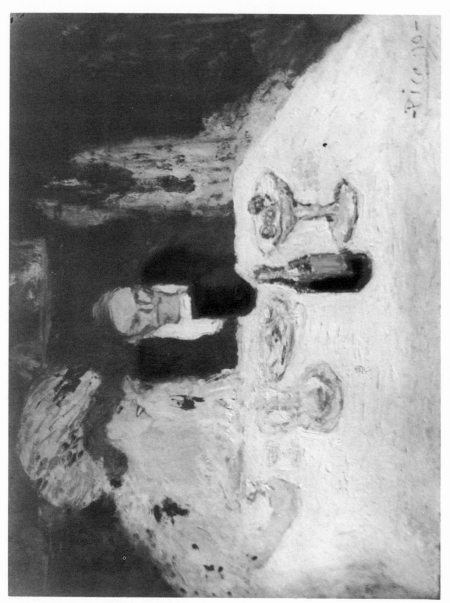

Picasso about 1900 makes his bow. Banal but talented, and that's how it should be. A beginner is not a master.

PAINTING

(continued)

PICASSOISM

(1914–1928)

A GOOD many of the years of my life were consecrated to defending and explaining Cubism, and the campaigns of " L'ESPRIT NOUVEAU " played no mean part in winning justice for such works as merited it, in particular the masterly creations of Picasso. This enquiry into the particular effort of the age must necessarily glide over the failures in order to exalt the successes, the researches. I am drawing up a balance-sheet: profits and losses. We come now to the debit.*

From the very origin of Cubism, Guillaume Apollinaire, leader of the orchestra, made his friend Picasso soloist. The others, even Matisse, even Braque, and above all Derain, were relegated to the position of third violins. Apollinaire's preferences ran to the sort of virtuosity best exhibited by gipsies. There are precedents. Admirers turned Monet into the " greatest of all the Impressionists," and Renoir, Pissarro, Cézanne into mere walkers-on. That is nearly always the way.

There is no point in falsifying the history of Cubism, even to glorify a historian-poet. Are we to go on showing the remaining great painters as feeding on the scraps that fall from Picasso's table? The modern movement is certainly in his debt, and in particular, since 1914, to his " clowneries ": but great art must learn to do without them.

To "Ideal" beauty Stendhal opposed what he maliciously termed "Ideal" ugliness. We know that this writer was the first to speak of Romanticism. In his day poets and artists were tired of Academism and out of patience with conventional " beauty," so they took up the task of integrating into art new ideas and forms, which seemed shocking to the eyes and mind of the "bourgeois." This effort of " rehabilitation " went on all through the nine-teenth century, and today Cubism is one of the aspects of that " Hundred Years' War." I have already demonstrated the very real importance of Picasso, and how with his friends he contributed towards the new liberation. With his masterpieces he justified a manner of painting that owed much to Cézanne, but almost nothing to nature.

Picasso's influence was fruitful down to 1914. The first period of

* For illustrations refer : Maurice Raynal's " Picasso " (Crès); and Maurice Raynal's " Picasso " (" L'Effort Moderne "); Pierre Reverdy, " Picasso " (N.R.F.). For the period 1920-1926 refer Christian Zervos, " Picasso " (editions " Cahier d'Art ").

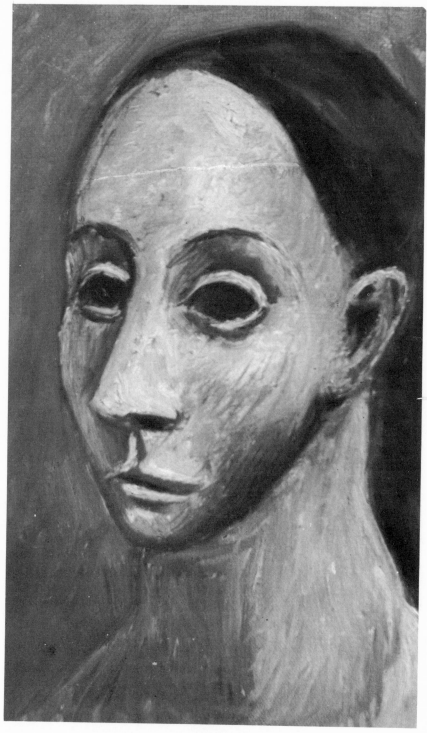

When Picasso was the equal of the greatest. (1906.)

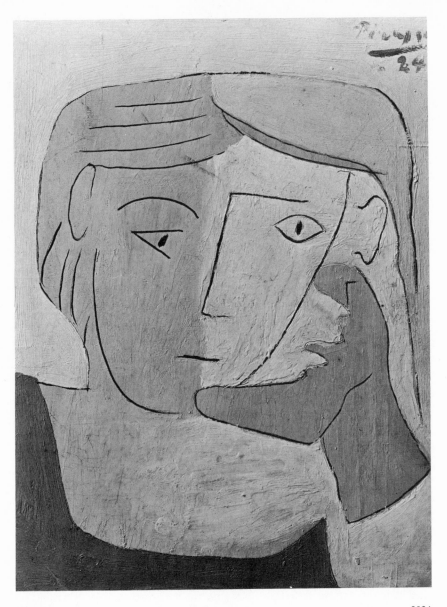

Picasso. 1924.

Cubism is inspiring, because it testifies to a high and noble aim. But from
the outbreak of war, the work of the master began to reveal a preference for
the standards of the embroiderer and the lacemaker : it was besprinkled with
dots, spots, squiggles, charmingly pretty or aggressive colour, and para-
doxical forms. His grand manner degenerates into intriguing mannerisms.

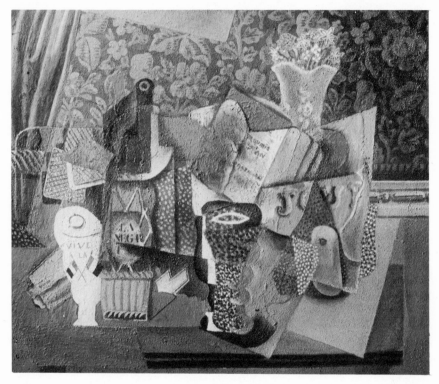

Picasso. 1915-1916.

His inventions are at times charming and ingenious, but they are the ex-
pression of a trivial ideal of sensation and feeling : they stop short suddenly.
Everything in this book is investigated from the point of view of the
nobility of its aim. From that angle we must, alas ! admit, that even if
the majority of Picasso's works after 1914 are extraordinary, they are also
not important. It is true, of course, that they do not claim to be the great
art certain Cubists found so very entertaining. But there is nothing that
compels us to admire their irresponsibility, or to reduce painting to a matter
of skew-eyed faces or patterns for neck-ties and jerseys.

Picasso, as a painter, is eloquent : indeed, that quality preponderates over
everything else. But it is the sort of eloquence that mistakes a " bull " for

wit, the *quiproquo* for balance, and confounds the beautiful with the agreeable, and the bizarre with originality.

One of the results of a fear of ridicule is that the artist himself ridicules beauty: this attitude comes from the cabarets of Montmartre.

Parody, malicious art, the unpleasing arts of pleasure: Picasso with extraordinary talent makes them valid in painting. Yet it is an art of titivation, just as peppered cocktails for tired palates do not cease to be alcohol. The fashionable journals continue to announce the installation of cocktail bars in private houses, with the mistress of the house disguised as bar-tender. A decadent Picasso adorns the sanctuary.

So long as the cocktail remains the province of the worn-out spark, little harm is done: but when the élite gets to the point of asking from art what only a cocktail can give it, then the situation becomes perilous.

Princess Murat, writing in *L'Intransigeant* for May 7, 1928, said: "*The painter projects upon the canvas the transposition of his imaginings . . . a vegetable marrow, a woman who obsesses him, the Eiffel Tower, a coal-scuttle, a geometric problem whose lines stimulate the eye . . . all we demand from the artist is a passing emotion.*"

What severity, madam! And so we have the painters relegated to the pantry!

This intelligent woman with much exactness expresses the contemporary attitude towards art.

And the public, in effect, only looks at pictures nowadays for their agreeable colours and remarkable forms.

Let us have the courage to admit it: at every fashion-show you will see charming or bizarre contrasts of colours and forms. That is what is demanded of artists. Surprises! A little while ago hats were big, then the fashionable modiste decided they were to be tiny-tiny; it is charming, but tomorrow will seem ridiculous. The basis of fashion is surprise, not art!

Picasso has always sought to surprise. But astonishment only works once. The sparrows soon get used to the scarecrow. Great paintings are those to which we always come back, because they do not depend on the element of surprise. In any case, the wish to surprise implies a concession to the public, as does a desire to please: for how can one surprise oneself? Surprise is only an element in art, it should not be its aim. Too frequently nowadays the means is taken for the end.

Yes, Picasso and the rest paint as no one else ever painted: but was it necessary?

I can imagine a house, which would be a sort of ship standing on its sails, its masts the columns. But no one has ever constructed it. Ought it therefore to be built? Have we got to engender two-headed babies?

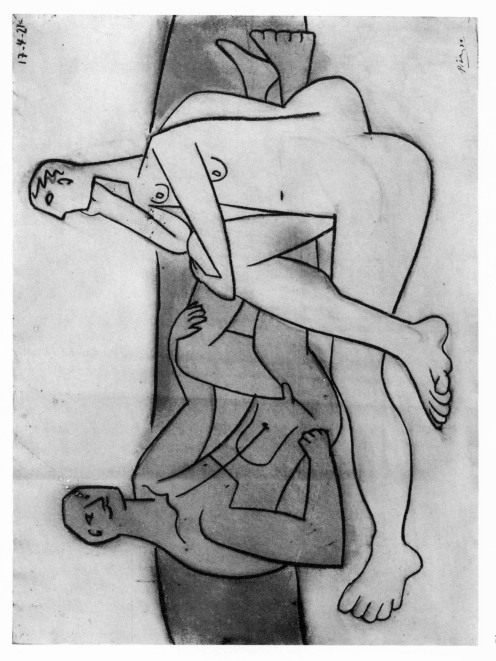

1921.

Picasso.

But let the admirers of Picasso speak. Give ear to the why and where-fore of their praises. Off with your blinkers, clean up your spectacles, and consider well their works.

GUILLAUME APOLLINAIRE

"Would that not therefore be the most considerable æsthetic achievement known to us? He has enormously extended the domain of art and in the most unexpected directions, even to the point where surprise functions like a cotton-wool rabbit beating a drum right in our path."

*

JEAN COCTEAU

"Why should not the impulse to mystify serve to originate new discoveries in art? . . ."*

*

"He was content to go on painting, acquire an incomparable technic, and put it at the service of chance. . . ."*

*

"Where in Picasso does excess cease? At what point does it link up with what is essential? We cannot tell. . . ."*

*

"He knows that that sepia girl, of the colour of transparent barley-sugar, that tin guitar, that table at the window, are as significant as each other; that in themselves they have no significance, because he is the mould through which they pass; that their significance is immense because the mould never casts the same result twice; that they deserve first place in the Louvre and some day will have it; and that that fact proves nothing whatsoever."*

*

"In the collection of Mme. Errâzuriz there is a canvas in which a young man sitting in a garden disappeared between 1914 and 1918, to give place to a splendid metaphor of lines, masses, and colour."†

* " Picasso," by Jean Cocteau (Stock).

† Delacroix said : " Poussin at least was not the man to paint and repaint the same picture an infinite number of times, for he knew exactly what he intended and his resources were adequate to achieve it."

1926.

Picasso.

"*Because Picasso, nourished by the best masters, and breaking new ground on their own territory, was well aware how pitiful was the prestige of spots and scribble. Those he left to the decorators.*"

Jean Cocteau : " Le Secret Professionnel."

PIERRE REVERDY

"What Descartes had done for philosophy, Picasso, without realising the extraordinary thing that was happening, repeated in the realm of art."*

<div align="center">*</div>

"Actually, it would not be sufficient to consider Picasso merely as a great painter and incredible draughtsman : what must be emphasised, in my opinion, is that *par excellence* he is a great artist, doubtless the greatest and most accomplished of this age."*

JEAN COCTEAU

"Can I foretell the kind of revelation that after thirty years of silence a canvas by Picasso may reserve for us?

"It may be the wealthy amateur will be overheard saying to those round him : 'You know that Picasso of mine? Well, this morning it suddenly began to speak.' "†

JEAN COCTEAU (PANEGYRIST)

"It is the function of the last-comer to clear the ground and litter it with obstacles. The succession to Picasso is complicated by the fact that he excels not only in the most elaborate inventions but also in innocent games of every kind. Thus the only way to improve upon his findings would be by the application of a simplicity very different from his own. Since the days of Cubism I see a surprise-packet emptied over Europe : hypnotic trances, delicious enchantments, lace that walks, impudence, scarecrows, aerogynes, smoke-rings, snow-ploughs, jack-in-the-boxes, and Bengal lights.

"But shall I be capable of realising it when the clean sweep comes?

"At least, should my sight fail, I shall have had the good fortune to have saluted Pablo Picasso when I could see."‡

A most mysterious flourish that!

<div align="center">*</div>

WHAT does death matter to the panegyrist if only he can indulge his eloquence? What will he not do for a fine phrase? How many

* " *Picasso.*" *Preface by Reverdy.*
† *All we need to complete this religion is a real miracle.*　　‡ " *Picasso* " (*Stock*).

sentences have not become altogether negative because "not" sounds so much better than an affirmative?

Writers find a particular charm in writing up Picasso, for that painter provides a pretext for writing. The best subjects are never anything but modest themes to the creative artist: he uses them as a spring board. Well, it shows that the Picasso diving board has plenty of spring. But here is what is wrong with panegyrists. More interested in their own creation than in what they treat of, they annihilate what they so inordinately praise.

When I was little someone gave me a rubber lion. It occurred to me to blow it up with an air pump. It swelled, then burst and subsided flabbily. Thus it is with too zealous friends. Everything has a limit to its capacity: even genius.

A writer, a man of wit, said to me once: "Picasso is a phenomenon who has nothing to do with painting, and is intensely interesting because of that very fact." I do not go so far.

But actually, what matters to the writers in question, is less Picasso's *œuvre* than Picasso the phenomenon. We will not enlarge further on the "drama" of this painter, who it is said is never content (and sometimes with reason), and digs his own grave daily: for here we are dealing with painting.

The early youth of a man marked out for greatness reveals his later quality. His middle age is often characterised by work that is not truly representative, for self-criticism often obscures his natural virtues. Often works of this period, when technically he is most accomplished, mirror a malaise due to the fact that his intellect has not yet established full harmony with his instincts. The greatest works of art are those produced in the fifties. By then the master has drawn from his intellect all it can give, and is reaping the reward of his experiments. He discovers or rediscovers his own well-springs. Michael Angelo, Tintoretto, Renoir, Cézanne.

Picasso, one of the most vital intelligences of this epoch, is capable of realising certain verities. He said himself recently that to combat the disease from which contemporary art suffers (and he therefore himself realises it) a David is needed. But the needed David is not one of Picasso's bastard Greeks or quavering Socrates, the dreary reminiscences of indifferent plaster-casts of art schools.

It would be splendid to see Picasso, in his ripe age, give us works, different certainly, but worthy of his "Toreador" and so many other fine things, some of which I have reproduced here, but to which the public prefers his parodies. What would matter then the having absorbed a thousand influences, swallowed everything, followed hundreds of false routes, if in the end he succeeded in discovering the hidden path that led to his summit?

✳

Cigar Saleswoman in Cuba.

Picasso.

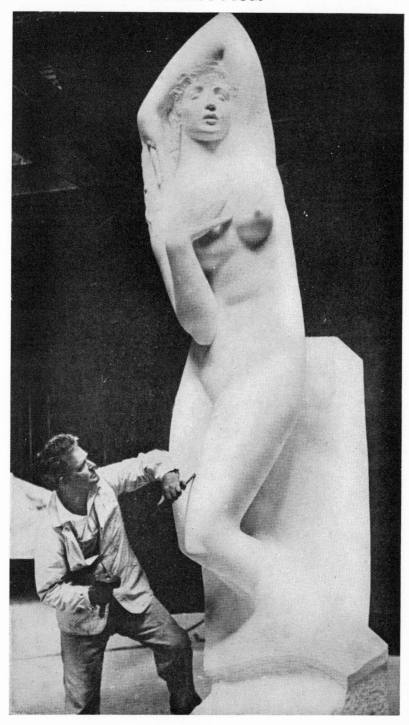

An American Sculptor.

1926.

Picasso.

ACADEMISTS

and

PICASSOIDS

AS FOR Picasso's imitators, they are a nightmare. Picasso very opportunely made war on imitative art, but his followers have exalted imitation into a sacrament. Religiously they imitate Picasso.

Most astonishing of all is that these parasites have their own infinitesimal counterfeiters. And they call it " school of Picasso "! My poor Picasso! What is sought is the agreeable, the bizarre, the amusing, and nothing else. To have succeeded in pleasing seems to them enough. They think themselves something great, fearfully refined! What talent I have! How easily it comes! (And those who do it with difficulty, what talent they lack!)

My advice to some of them, not by any means the worst, was to abandon all they had learnt and put the indicator back to zero. I proposed there should be a weeding out of art which Picasso wittily designated as " hygienics." Let us " hygienise " and realise the dangers of Picassoism, cunning art, " the art of trickery," as Apollinaire said, praising Picasso as its innovator.*

Let us rid ourselves of all the Academists. In Memoriam, all honour where it is due, artists of France, Academists! Historic reconstructions, the forging of ancient patinas, ready-made phrases, mouldy scenarios, anatomies pickled in alcohol: Cain, Abel, and Adam at the current rates for models: 1789, 1815, 1870, 1914, epic events suitable for dioramas, casinos de Paris, and cinematographic sets. Portraits of women, titled or otherwise, lovely enough to eat. And dissolve out the " moderns " to " extract the good from all that mess." We others, " inheritors of the great tradition," etc. . . . But the " Artistes Français " have no monopoly of Academists.

Advance guards are conservative. Even today there exist painters who with bristling moustaches will take up arms against any contrary opinion, and not half-heartedly either. At the École des Beaux Arts and at the big seasonal exhibitions a certain number of young or aged folk can always be found who imagine themselves veritable Genghis-Khans because they still use violet shadows: their comrades call them " terrific." Beware of advance guards in pickle, and aged lunatics with white hair.

* And Cocteau: " Picasso, in laying these snares, shows a poacher's cunning."

For fifty years now the most exciting rôle has been to be considered outrageous. Think of the efforts to achieve it, and the number of fine works aborted, because the kernel of the effort was a determination to appear inspired. For fifty years all literary small-talk went to show that Delacroix, that most methodical person, was wild and fanatical, and trusted entirely to inspiration. (Read his diary.)* A phrase like " immense destructive force " is claimed by many. How well one understands the screams of those simple, healthy souls, who have a new kind of hideousness presented to them time after time, with the pretext that the newest form of genius demands it! This new hideousness casts the previous one into oblivion, and it is then said that the public has at last understood.

Our epoch seems to have decided that genius must necessarily be heterodox to our own fundamental make-up. But we have had enough of this " something apart ": the opposite of common sense has been too much exploited, too much abused. We are tired of it.

The romantic style, too, has made its hecatombs. Instead of concentrating on what is significant, it attributed significance to what has none. What is significant is that which moves us. To compel us to take seriously events in which the variations, largely magnified, are reflected in the aberrant mirror of the individual, can only importune us. Do Bach's colics affect us? No, that serene genius ignored them.

> Mankind's desire is to take pleasure in the beautiful, and not in all these lucubrations. For example, what moves us in Chateaubriand is only the legacy from the seventeenth century: we respond to what is eternal in us, and not to incidental calamities. The by-product of Romanticism is a dreary and foul naturalism, in which everything becomes hideous. This school battens on old carious walls and loves filth. Stendhal wrote:
> *" I learn that when the barbarians built a bas-relief into a wall, finding the plane surface much more beautiful than the other, it was their invariable custom to turn the stone to the wall in such a manner as to hide the carving."*

Alas! many modern paintings are hideous even from the back. What can be done?

<p style="text-align:center">*</p>

SWARMING Rubenses, swollen to bursting. Art seen as a process of gourmandising. Lovely girls like underdone veal or half-cooked fowl. A gluttonous art.

* *Madame Jaubert in her diaries writes that Delacroix had his mufflers, waistcoats, and hats numbered to correspond with variations in the weather.*

PAINTERS who will garlicise any tiny Riviera port for you with the seven brutal and overwhelming colours that are the speciality of Messrs. Lefranc, artists and colour-men : cookery according to international picture-postcard receipts, in which nature is represented (from Venice to Pekin) always with the same outrageous colours (not in the least outrageous). What has happened to first-rate technic, the product of a hand faithfully interpreting the brain's conception? What a sight to see these gentlemen beneath their sun umbrellas, putting out their tongues at each other the while they quickly oil an honest canvas! Monet's fine pictures were anyhow livelier than these sub-Impressionists, who turn any decent view into something revolting. These painters in castor oil almost make us appreciate certain groping artists, whose productions, being on a small scale, reduce nature but leave it decent, even though a trifle moth-eaten.

*

FALSE primitives. Simplicity, the moment it becomes an attitude, ceases to exist. The " simple " do not act simply : they make all the effort of which they are capable. An art, pretending to be that of the masses, more stupid than nature : an art of imitation Daguerrotypes, popular prints, mausoleums made from hair, painting by heart, but heartless. People mislead themselves purposely, ingenuously : a ROUSSEAU or a BAUCHANT,* because they are real primitives, move us. But the majority remind us of certain ancient ruins restored to look like sixteen-year-olds, which is not without a certain speculative interest, but I prefer the old Michael Angelo, or the old Cézanne, or the old Renoir. Imitation mummers, imitation simpletons, decadence, debility.

The new pietism. I shall convert myself. Become a cherubim. Almost crazy with love and kindness. Compared with me, St. Francis of Assisi was a bumpkin. My birds can swim and my little fish fly. O Fioretti of public-bars! And holy water stoups! I am, as Joan of Arc was, inspired. My frail virgins look like mimosas dying of drought, bowing before the blasts of an irresistible shrimp-coloured mysticism. Factories for turning out deluges of angels.

I have already dealt with pimping art.

The Neo-classicists do badly what has been well done.

Art à la japonaise : Madame Tussauds, wax figures, microscopic art of the leisurely waster, the perfection of screens and fans, so much an inch, etc.

*

PLAGUE is contagious : rats transport it; when the death's-head of

* For " Bauchant jeune," see the article I wrote in " L'Esprit Nouveau," No. 17, 1922. Diaghilev discovered this painter in 1928.

plague appears on a ship, the law of May 4, 1906, decrees the rats are to be exterminated. Art must be de-ratted.

There are 30,000 painters in Paris. Counting one per thousand, there are thirty geniuses among them. I must have made a mistake somewhere!

✳

PAINTING

(continued)

(1914–1918)

*

JUAN GRIS, JACQUES LIPCHITZ, BRANCUSI, LAURENS, DELAUNAY, MARCOUSSIS

AFTER 1914 all the founders of Cubism abandoned non-representational Cubism (except Albert Gleizes, who went on experimenting in various directions).

In this period began Picasso's apotheosis.

New figures appear or consolidate themselves.

JUAN GRIS for part of the war seeks himself perpetually: as it nears its end his work grows austere, penetrating, sober. A result of his close friendship with the poet Reverdy is that each man's work reveals reciprocal technic and æsthetic.

A specialist in museums, logically minded, Juan Gris found himself attracted by Fouquet's "Man Holding a Glass of Wine," and by Zurbaran, as is very natural for a Castilian. He was building up a technic for himself in which French lucidity was made to serve his dark racial instincts.

Of all the Cubists, Gris's achievement, being the least agreeable, was the last to be recognised. With no ingratiating qualities, it yet has that somewhat distant nobility one learns to appreciate once one has pushed through the heavy door that leads to it. The deserts of Toledo: far from the joys of Seville, Malaga, or Valencia. Towards the end of his life, nevertheless, the inimitable eloquence of Georges Braque seemed dangerously on the point of affecting him, but energetically he took himself in hand again. Death robbed him of the success that came too late to soften an existence only too cruel to him, as to nearly all the great.

*

JACQUES LIPCHITZ, familiar with every great achievement in art, is a phenomenon rare in these days. He found himself in the perilous

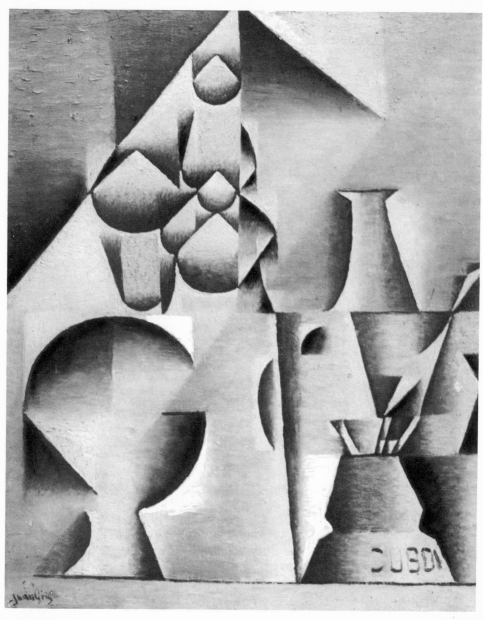

Juan Gris. 1911.

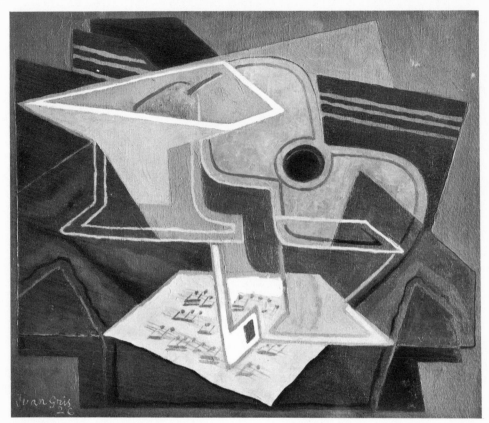

Juan Gris. 1926.

position of being a sculptor. He had not at his service that palette by which painters, for good or ill, are able to gloss over the poverty of their forms. Fortunate sculptors! Form must be conceived by them as interrelated masses conveying emotion by that fact: not dependent on the superficial stimulus of pigment. Fortunate necessity, in fact, since the sculptor has his problem of colour automatically resolved for him. His colour is that of his medium, which very fact endows it with the inevitability of a natural event with nothing of the dangerous charm of colour. Will modern painters ever really understand that they can never attain the nobility which is the special quality of sculpture (and desirable in all the arts) unless they can conceive colour as a component part of form, and not as super-added pigment? The study of Lipchitz's work reveals that a respect for the deepest natural laws, which are not those of passing aspects, need in no wise shackle lyricism.

Lipchitz is awake to every calculable possibility. His ideal is perfection. Is there any need to bring up BRAQUE and DERAIN again?

We have already dealt with them among those great leaders of the various schools that have succeeded to each other.

Each continues to experiment, and each has quality, as has their every gesture.

*

CONSTANTIN BRANCUSI is respected by true connoisseurs. His art is all finesse and love of his implacably polished materials. Imperceptible variations endow the simple surfaces of his forms with serenest life. What he does can never be popular. It demands an initiation, like everything that does not talk a commonplace or usual language.

The American Customs lately brought suit against Brancusi. They claimed that, in order to avoid the duty payable on raw materials, he had made a false declaration by designating his bronzes as works of art. One of the arguments used by the Customs officials was: " M. Brancusi claims that this object represents a bird. If you met such a bird out shooting, would you fire?"

*

LAURENS, who for a time was influenced by the still-life paintings of Braque and Picasso, later approximated more nearly to the tradition of the masters of the French Renaissance. Foe to all publicity, he, with the conscientiousness of a splendid workman, created profound sculptures whose charm was the fruit of a poetical imagination, solidly grounded in the splendid materials which it transfigured.

*

ROBERT DELAUNAY was one of the first Cubists. Even as far back as 1907 he was influenced by Cézanne, as witness the " Vues de Saint-Severin," the structural lines of which testify to so eminent a plastic sense. Some of his more recent work reveals rare accomplishment. Pure colours richly related according to what he calls the simultaneous contrast of colours. He profits by one of those errors of our epoch which would seem astonishing, were it necessary to feel astonished by injustice. His influence, generally ignored, was considerable on painters using vivid dissonant colour.

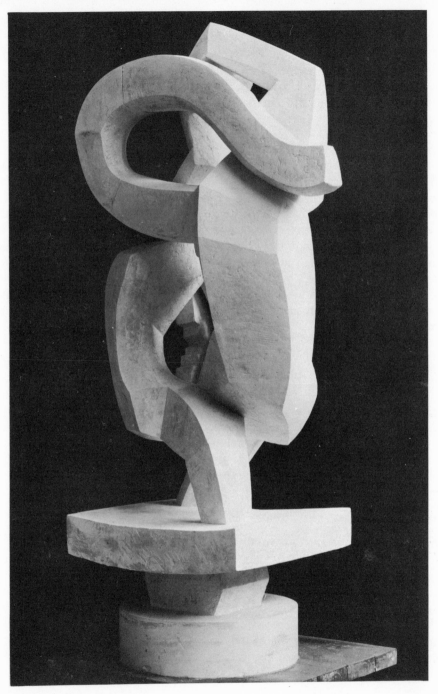

Jacques Lipchitz. 1927.

A garden figure in the possession of the Vicomte de Noailles.

LOUIS MARCOUSSIS joined up with Cubism from the very start. Apollinaire refers to him in his book on its origins. Learned composition, a questing spirit, a critical and keen intelligence characterise his work. He hides behind the glittering reflections of the paintings on glass that made him successful, like someone taking refuge behind the gleam of his spectacles. He is a living reproach to the daubers. The care he devotes to his work indicates the degree to which his intentions are premeditated. These will no doubt express themselves even more adequately when he has worked through a certain conventionalism.

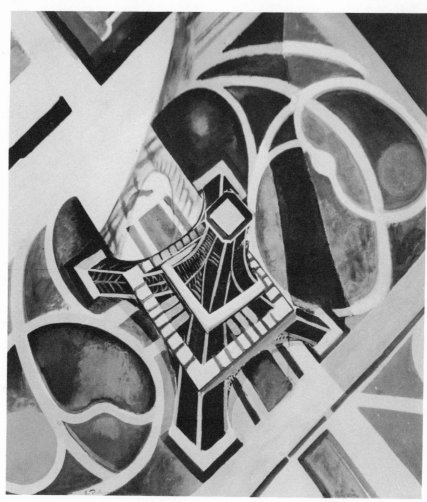

Robert Delaunay.

1925.

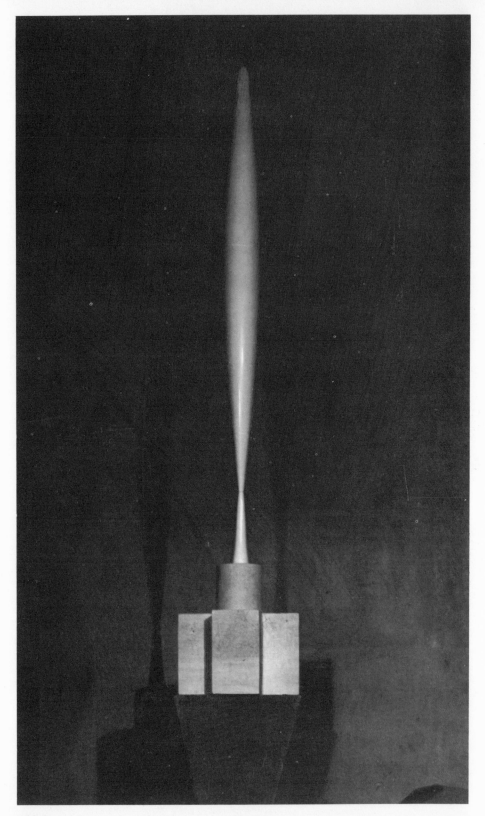

Brancusi. *The Bird.* 1925.

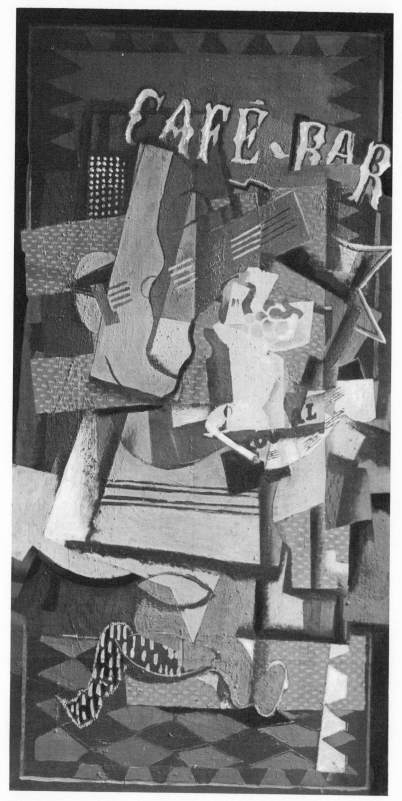

Georges Braque, 1918. *(Collection La Roche.)*

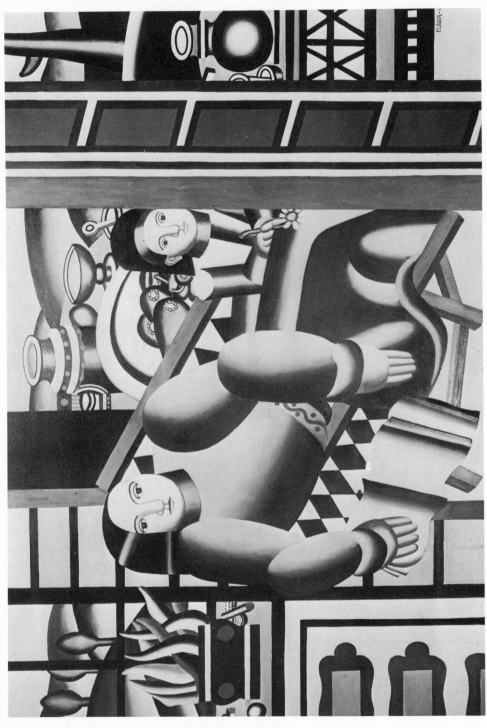

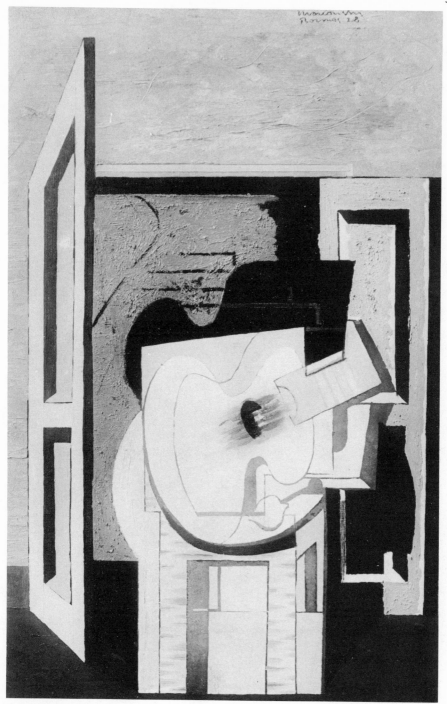

Marcoussis. 1928.

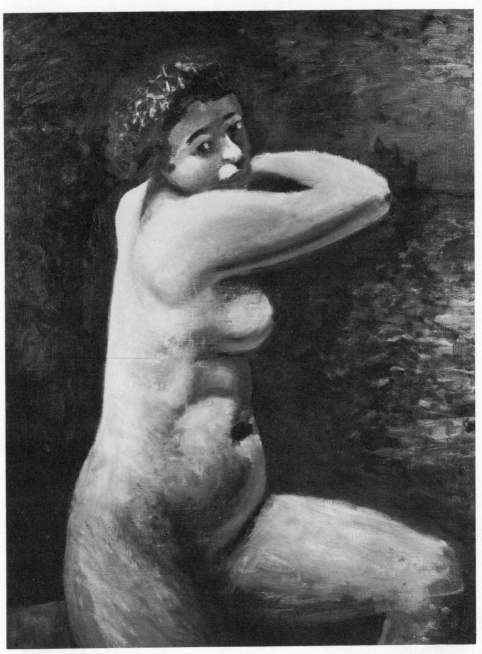

André Derain.

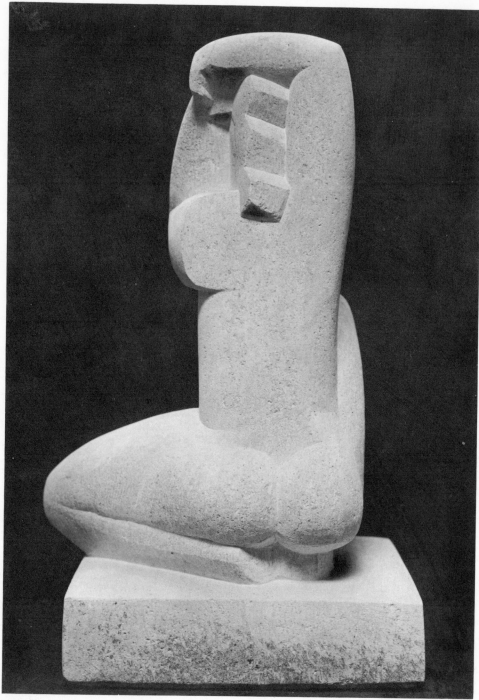

Laurens.

4

PAINTING

(continued)

DADAISM: PURISM: SURREALISM

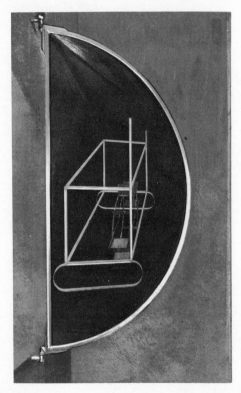

*Object in Glass
and Zinc.*

Marcel Duchamp, 1914.

IT will be perceived at some future date, that from 1914 on, all artistic activity falls into two living *collective* trends, Dadaism and Purism. These two movements, though apparently in opposition to each other, were equally sickened by the glib and stale productions of art, and sought to restore it to health: the former by ridiculing time-worn formulas, the latter by emphasising the need for discipline.

116

In the war period MARCEL DUCHAMP, who even in 1912 was highly individual in his manner, as may be seen from Apollinaire's book, became an important influence, through Picabia, on the Dadaism of Tzara, then in Zurich. Marcel Duchamp, Picabia, Crotti, etc., drew public attention to the plastic values inherent in "contraptions" and machines. Though rational enough as a point of view, for them they served as a nihilistic protest against art (the negative attitude of Dadaism). Nevertheless, it did not prevent those artists from giving us works of positive significance.

But after 1916 I felt that Cubism was slipping into decorative art. That is why, in my review *L'Élan,* I tried to take stock of the situation. My attitude will be understood better now than then. But then I made it clear that from the very origin of the Cubistic deviation I foresaw those perils which by now have all the force of an inundation.

Then in 1918, having induced Charles Edouard Jeanneret to collaborate in my campaign for the reconstitution of a healthy art, an association began that was to last till 1925.

We began by issuing our book "APRÈS LE CUBISME," and that same year arranged an exhibition of paintings in the now defunct "*Galerie Thomas.*" We affirmed that art must tend always to precision, and that the epoch of every sort of Impressionism was done with, even such as remained in Cubism. We laid down the foundations for a Purism that would bring order into the æsthetic imbroglio, and inoculate artists with the new spirit of the age misapprehended by so many of them.

It was from the union of the two attitudes DADA and PURISM that the passion for modern objects issued, exaggerated though it became in certain cases.

In *Après le Cubisme,* which has been out of print for years, we attach especial importance to the lessons inherent in the precision of machinery and the imminent metamorphoses that must result therefrom. The age seemed to us a noble one, destined for a glorious future.

We were taken for H. G. Wells's. Yet our vision was true.

Life progresses as we had foreseen it would. We drew attention to the presence of a new spirit. The severity of competition made it imperative to call machinery to our aid. The result of its collaboration was more and more intensely to accentuate the desire for the well made, the exact, the swift, the precise.

What ten years ago seemed hypothetical in our writings has now come to realisation: or, more truly, is not even realised, so accustomed have we grown to it. So much so, indeed, that what I wrote in 1918 for the first time, if read now, would seem something that had already been read elsewhere, so much comment having been passed on it even in the most reactionary newspapers and in books the world over.

The necessity for order, the only efficiency, has brought about a begin-

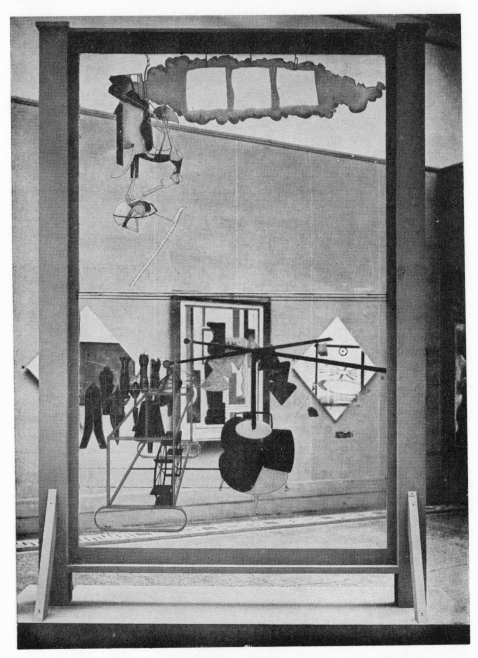

*Object painted on transparent glass. Through it can be seen pictures by
Léger and Mondrian.*

CANTER

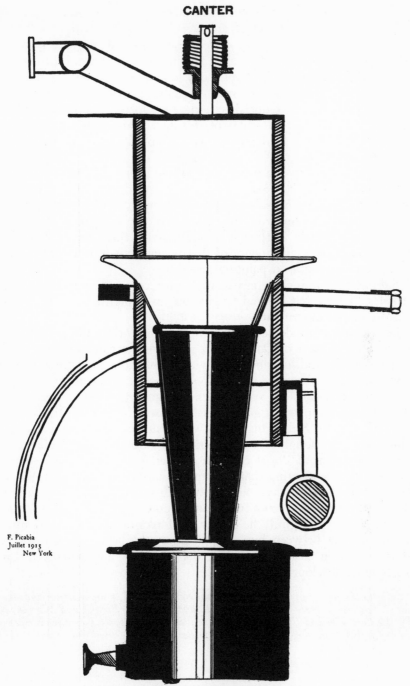

F. Picabia
Juillet 1915
New York

LE SAINT DES SAINTS
C'EST DE MOI QU'IL S'AGIT DANS CE PORTRAIT

ning of that geometrisation of the spirit which more and more enters into all our activities. The aspect of any street proves it. Only think of the higgledy-piggledy shop windows of ten years ago and compare them with the geometric masterpieces of today. Geometry is sovereign mistress of our industry. The best butcher's shops today look like surgeries! An architecture adapted to such ends becomes inevitable. Trams, railways, motorcars, equipment: all are reduced to a rigorous form. None but the blind could ignore the changed features of this age. And that rupture will be more brutal still, when favourable economic conditions make the modernising of equipment less costly.

In order to develop the ideas put forth in *Après le Cubisme,* the synthesising review " L'ESPRIT NOUVEAU " was founded in 1920 and continued until 1925 under the joint editorship of " Ozenfant and Jeanneret." Our book, " LA PEINTURE MODERNE," is a résumé of the *L'Esprit Nouveau* campaigns in regard to the particular applications of this chapter.* It is not for me to weigh up the influence of that review, nor of our paintings, nor of the influence of both on painting generally.

I did not wish to include any of my own recent paintings in this book : nevertheless, I have felt obliged to give one example in order to complete the history of the movement.

The reproductions demonstrate different interpretations of the subject from the point of view of Dadaism, Purism, and Fernand Léger.

Machines are healthy, and possess an implacable something that stirs us. FERNAND LÉGER was moved by the terrific mechanism of modern war and the precision of objects such as cannon, bombs, weapons : he realised the chronometric rigorousness that sets in motion the thousand cogs of war. In 1918-1919 his work, which still lagged behind his understanding, began to slough off the last traces of Impressionism. He was ripe for the appreciation of Purist conceptions, being one of the first to realise that we were not suggesting that painting should imitate our own, but were advocating vigour, honesty, objectivity. From 1920 on, his paintings, vivid in colour, have grown more and more into valiant odes to the " modern object." Mightily he chants the forces of our time. At times it occurs to me that between him and Cendrars the poet certain links exist. Of those who won recognition before the war he is undoubtedly the artist who has most developed since.

* *Refer to the works of Le Corbusier-Jeanneret in regard to architecture and decorative art, " Towards a New Architecture " (Rodker, London; Brewer and Warren, New York). Le Corbusier and Ch. Ed. Jeanneret are the same person. Pierre Jeanneret is the cousin of Ch. Ed. Jeanneret, styled " Le Corbusier."*

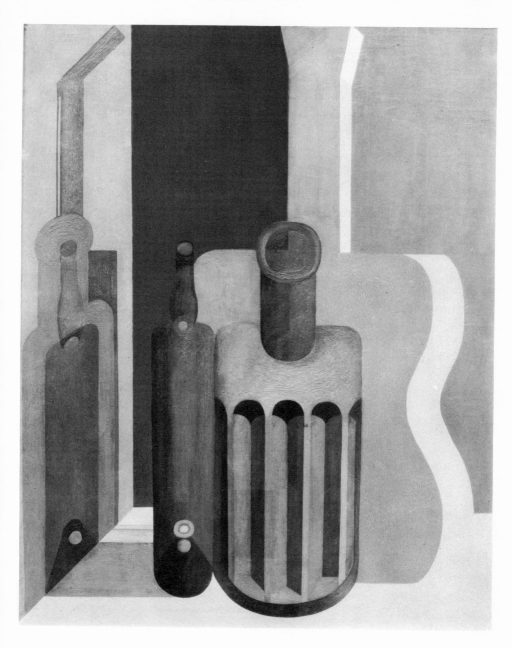

Ozenfant. 1919.

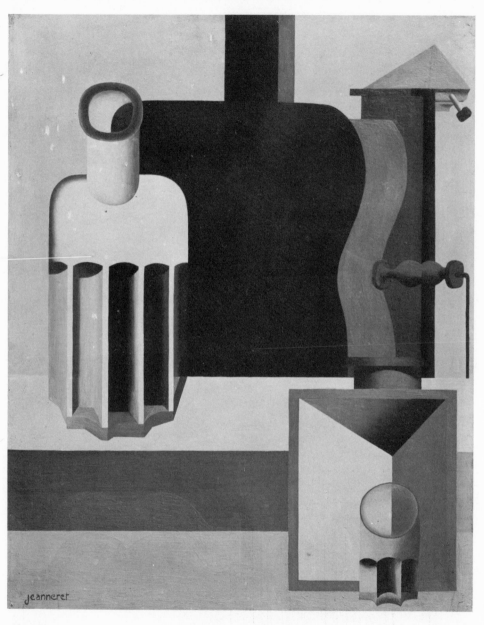

Ch. E. Jeanneret. 1920.

Fernand Léger, 1926. *(Collection La Roche.)*

NEOPLASTICISM

NEOPLASTICISM thought it ought to go one better than Cubism in the direction of the non-representational. In Cubist or Purist paintings, despite their non-representational bias, there were always elements of objects or objects themselves, which could be recognised; introduced because of their formal or chromatic significance; but in Neoplasticism the forms that make the picture are systematically and entirely non-representational, coloured forms that reveal no link with exterior reality: Mondrian, Théo Van Doesburg, Van Tongerloo, etc.

The tendency of certain Cubist works towards the decorative, already disquieting enough, was pushed to such extremes as finally to make merely ornamental objects of them with no ornamental finality.

*

CONSTRUCTIVISM

AFFECTED by the mechanistic manifestations of our machine age, and influenced by Dadaism, Léger, Purism, and ancient memories of Archipenko, the Constructivists contrived " constructed " paintings reminiscent of mechanism. Certain gifted artists at times succeeded in being interesting. This school, which for a time enjoyed a certain vogue in Central Europe and Russia, today influences scene painting, and, like all modern schools save Purism, which is too little decorative, came to fruition with Gabo and Pevsner in the Russian ballets of Diaghilev.

*

SURREALISM

CHIRICO is Italian. For a long time he lived in France, but did not subscribe to the Cubist movement. While Cubists were seeking a new form totally different from anything that had gone before, adequate to the transcription of their conception of painting, Chirico began by drawing the elements of his formula from the Italian Renaissance. A humanist, his first works made a singular impression, because of an extraordinary dramatic quality in them, due to a curious approximation of antique backgrounds and certain aspects of modernity: long arcades in small Italian towns and factory chimneys reacting on the statue of some warrior in a light of glory. A

Chirico.

Paolo and Francesca. *Hans Arp.* *(Collection Hoffmann.)*

Jean Lurçat.

Diagrams from the " Traité des Passions" of René Descartes.

Paul Klée. 1918.

poetry lofty, silent, poignant, and distinguished, emanates from his work. He is one of the fathers of Surrealism.

Of PAUL KLÉE was made, justifiably or not, the St. Peter of the Symbolist paradise, and it must be admitted by anyone who is not blind, that Klée's work is often touching and at times deeply moving.

The man himself the Surrealists took to their bosoms; they also admired Odilon Redon and the aged James Ensor. The art they desired was to be perceptible subliminally. And indeed: mystic spiders, the most esoteric fishes in the Prince of Monaco's collections, the enchanted or " macabre " islands of Boecklin, ancient and naïve treatises on anatomy dating from the Renaissance or Descartes, strange flowers, crawling and parasitic creatures, butterfly-fish, even Wagnerian flower-females, illumine a universe less

ethereal than may seem from the reading of their theories. Dreams which, above all at the inception of the movement, bordered on nightmare. It is to be feared that an art of the "indefinable" may prove somewhat too elastic.

Two very distinct attitudes have so far shared the universe of art between them : the trend towards objectivity and the trend towards symbolism. Symbolism affects us through its symbols, objectivity through our senses. Symbolism would seem the quicker way, but is unreliable : it depends on accepted conventions for its interpretations, and in painting more than anything, on the imagination of the observer or reader.

> "When prophetic images are sought for in coffee-grounds, splashes of candle grease, clouds : or any other shape which, having no definite form, is capable of evoking all that is demanded of it, it is clear that it is only an imaginary world that is being discovered, one which issues entirely from the unconscious. For that reason each observer will, faced with the same object, interpret the matter differently ! Indeed, certain psycho-analysts methodically utilise this technique in drawing the attention of their patients to accidental stains, so that concentration upon them may people them with definite images." (Dr. R. Allendy, Le Problème de la Destinée.)

But simultaneously with categorical art, which imposes its imperious edicts upon us, another form of art can be conceived, passive, accommodating, rubbery, coffee-groundish : not like the other, moulding us to its shape, but ready to take on ours. A web of art governed by ourselves, instead of governing us. The danger is that not every spectator is necessarily creative. In short, however the future of Surrealism may turn out, so far as its theories go, its poetical intentions are in principle entirely praiseworthy. Those who have taken the trouble to read what I have written since 1916 will remember that I have always defined the object of art as the easing of the pain of reality, the helping us to EVADE reality. It is that same aim and terminology which the doctrinaires of Surrealism have adopted as their own.

An extraordinarily limited outlook, not, unfortunately, very rare, is implied in the conception that different modes of art, even when they claim identical aims, necessarily appear the same. What has been accepted as the Surrealist school presents itself at first sight, and above all on reading André Breton, the theorist of the movement, as a striving for entirely new ends. We must thank this writer for his desire to elevate art above the usual platitudes; how indeed could I not praise it?

Nevertheless, to release ourselves from the accustomed things of the

Mirò.

world, in so far as they are in our way, has always been the aim of all great art, ancient or modern. The impulse towards lyricism is one common to all great artists. There are many ways of ministering to this desire. Yet "dreams" are not a panacea. DREAMS ARE ANOTHER REALITY: a reality with its beauty and ugliness. And the proof is that nightmares are intolerable.

The Surrealist technic has nevertheless something remarkable about it, at least in theory: it strives towards an unconscious exploitation of the unconscious, something like the automatic writing of mediums. Materialistic minds affirm that it is all rot, but others (myself among them), less convinced by the transcendental virtues of common sense, cannot help having a certain degree of feeling about the matter. Nevertheless, the danger of letting your hand wander, is that the shapes traced by it, depend much more frequently on the conformation of the bones and muscles than on that of the soul. It has been observed in drawing schools, picture exhibitions, museums, that the forms which recur most frequently are those which can most easily be drawn, and this is also true for colour. Still, we do not feel we have a right to pass judgment on this technic. For it is a technic. Do the best Surrealist painters follow it? I doubt it.

And here is Diderot to aid the defenders of dreams. *"And another, though he wakes like a fool, may dream like a man of sense."*

POSTSCRIPT

While correcting this book, a catalogue of an exhibition of pictures by the painter Arp is sent me. André Breton supplies a preface, in which he talks of this painter's simplified forms.

> *"These harsh or tender flourishes truly seem to me to offer the greatest possibility of generalisation from particulars, thus allowing an appreciation of the most infinitesimal variations. . . ."*

Here we have a thought particularly Purist.

In any case, the Surrealists Arp and Max Ernst mature day by day, as the photographs I reproduce demonstrate. Arp, purist: Ernst, lyricist. As for Mirò, I predict an early detachment from the mists of his oils, and the adoption of a highly objective form. I shall not therefore pin him to a definition like some butterfly. None of the three has yet said his all. Chirico, Ernst, Arp, Mirò provide us with rich mirages, works which border on anxiety and myth.

※

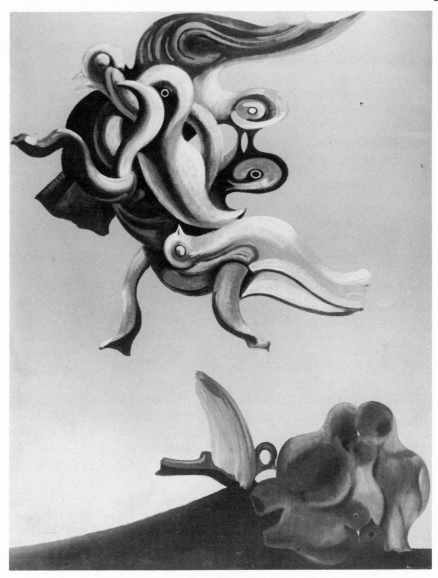

Max Ernst.

THE SCHOOL OF PARIS

GENTLEMEN, from the four quarters of the earth, which in these days have become at least a thousand, you have come to absorb the sublime lesson of French Art. Paris is the melting-pot into which have been perpetually

flung the precious metals of foreign mines. France is method and continuity, impassioned and patient experimentation. Patience in view of a clear end. A tenacity permanent as the ages : restlessness and modesty under an imperturbable and honest mask. Fouquet teaches the lessons of a thoughtful precision : Poussin, to a renascent Italy which was often sham, adds his own artisan's conscientiousness placed at the service of a most profound mind : Chardin teaches the art of making even nuances eternal : David teaches the scorn of compromise : Ingres and Delacroix, passion ardent but controlled : Courbet, audacity : Manet, communicated intelligence : Seurat, lucid intelligence : Cézanne, unremitting experimentation : Matisse, perpetual invention : Derain, restlessness : Braque proves the persistence of the spirit that made Chardin and Corot : Segonzac is own brother to Courbet : Léger shows what robustness can do. I cite but a few names, for this is no French Pantheon.

I do not hide from myself the fact that our school fears what is startling. I have already borne witness in this book to the prudence, the repeated experimenting that preceded Cézanne's liberation of painting, and to the degree in which he himself trembled at the necessity of making the step, and to the great hesitation of the French Cubists before they too, jumped. Such infinite precautions might, in the eyes of certain impulsive strangers, thrilled by the last successes won, seem timidity; but if tradition has made us prudent, is the absence of tradition or of scruples any guarantee of quality? Take heed; revolutions can only come about, and above all be opportune, when they follow on long premeditation. We know it by experience, having passed through 1789, that slowly ripened revolution which had nothing of a bomb about it. The fecundating rôle of the stranger as regards the French school is the infusion of his blood into it, a prompt catalyser, because he is less often hobbled by a past. And often the stimulus is a happy one, as witness the effects of Picasso's waywardness on budding Cubism.

Yes, for many centuries the School of Paris has existed, and among those who today come under this head, strangers or Frenchmen, many are true artists and in no wise to be confounded with those others, too numerous, alas!, who cannot tell the difference between the Art of France and a *Present from Paris*.

Not a great national art, but one great universal art which, beginning in prehistoric caves and passing through a thousand aspects, still lives among us.

No Græco-Latin culture to oppose to that of the North, when the latter has given us Goethe, Shakespeare, Rembrandt, Bach, Beethoven; no Latin or Germanic or Slav spirit if we think of Mozart, Moussorgsky, and Schubert.

The "specialities" of certain foreign countries have universal signifi-
cance: nobility of Spain, profundity of understanding and gravity of Anglo-
Saxons, lyricism that is both Slav and Jewish, Italian fire, love of perfection
and patience of Chinese and Japanese, purity of Mediterranean peoples,
American order and method, Swiss and Flemish vigour: all these virtues,
which are particularly the appanage of certain peoples, fecundate those who
paint in Paris and whose ambition it is to synthesise all these eminent
qualities.

What divides races is not opposing capacities, but local customs
of no importance, infractions against universality. National defects
are local ones, but racial virtues are of universal significance.

And now:

TOOTHING STONES

I HAVE made Cubism the kernel of this chapter on painting and cited
but few names. I have brought in a few outsiders, but only because they
belong to the discussions of the past. We cannot turn into adults, merely
by naming them, all the young painters who are but tuning up, and who
are changing all the time.

Others I have consciously left waiting; we must not compromise them,
for if in the second part of this book I define a general attitude favourable
to them, there is no particular creative effort which can at the moment
altogether illustrate it. Let us beware of too soon picturing our ideal: the
Jews were wise not to image their gods. My next book will attempt the
adventure.

❊

ARCHITECTURE

free : evocative

GREAT ART is art which ministers to our moral, affectional, and intellectual needs: the "useful" arts minister to needs that are purely practical. They must not be confounded. Despite their different modes of expression, Poetry, Painting, Music, Architecture have identical aims: to inspire us with lofty emotions.

Architecture has been wrongfully called "The Mistress Art." Bombast! Masterpieces in every art are all first, and as good as each other. The lion is first among beasts. Which is saying what? That a fine lion is better than a fine tiger? Why, a splendid cock is better than a moth-eaten lion. Mozart, Phidias, Montaigne salute each other as equals in the Elysian fields. There was an antiquated notion that paintings were to serve to decorate walls, so nowadays people still say that Painting is subservient to Architecture. Do you think Shakespeare or Mozart bothered about the architecture of the place they would be played in? Certainly they had to obey the spirit of architecture, but their work was not limited by architecture. Which is to say that construction is the basis of every art, including architecture. All the arts are equal, given perfection as the standard.

More exactly: nowadays everything is confounded. A building that serves its purpose, a monument worthy of the name, a rabbit-hutch and Notre-Dame. Result: no one knows where he is. This confusion is aggravated by those to whose interest it is to encourage it. It must be delicious for the specialist to believe himself the equal of Phidias; he thinks Phidias was an artificer like him. Alas! one word should never have defined both the artist and the specialist who designs the boxes we live in; for the latter is functioning as engineer and not as artist, or at any rate his function should have been that of engineer, and not of artist.

"But still, the turning of a utilitarian building into something pleasant is surely an art?"

"Yes indeed, there is an art in making buildings attractive. But it is a lesser art, and should be considered so."

It is better to be a first-class engineer than a second-class artist. Engineers

can be, after all, important personages. Ettore Bugatti is greater than his brother, the late sculptor Rembrandt Bugatti. But his motor-cars, though perfection today, will be old junk in twenty years, whereas the shattered Parthenon will serenely throne over the ages.

Let us call Architects, such as conceive edifices in the essential aim to create beauty: votive monuments, temples, triumphal arches, tombs, etc. For here they are as free as the poet, the musician, or the painter: and their chief function, too, is to evoke emotion in us. Every means is good and lawful if it succeeds in stimulating us to lofty sentiments.

ARCHITECTURE FREE IS SCULPTURE

PHIDIAS, was he sculptor or architect? Both at once. Chalgrin, creator of the Arc de Triomphe, is a sculptor like Rude or, if you prefer, Rude is an architect like Chalgrin. What great art true architecture is!

Had its only object been utility, the sumptuous Parthenon would have been a sort of hall for the faithful: a strong box for treasure would have taken the place of the exquisite *cella*. But what was wanted was a work of art that would move men, so fabulous sums were expended. The Greeks knew that beauty is beyond price, and that a building is not a temple.

The house, the box for living in, must before everything be serviceable: it is a machine that functions, a tool.

Between the two poles of an architecture purely lyrical and one which is utilitarian, all types of hybrids can be found: architectures in which the lyricism dominates, yet where utility plays a certain part (such as palaces and luxurious residences). And according as the useful is more present or more absent, so these constructions relate to one or other type.

Lean kine of architecture. Lyric architecture slumbers, not because our epoch lacks great " plasticians," but because the demand is, so to speak, nil. All that is needed to be a Rembrandt or Stravinsky is genius, a bit of pencil and some paper: but no one can be an Ictinos at such small cost. Our age is first and foremost utilitarian: it has reduced its architects to the rôle of specialists. These wretches, lacking the demand for art, succeed in finding some pasture for their art by introducing it into their houses, factories, utilitarian edifices. Somewhat as a sardine-vending poet might publish his verses on his tins.

Much better would it be for them to be content with being entirely useful, doing honest work, and allowing natural grace to blossom from objects adequate to their function, and therefore perfect.

But what am I saying? What an error I am falling into! From the day we " won the war " thousands of splendid opportunities have arisen:

votive monuments to the fallen, Verdun. And what has been made of them? Lyric creations, yes: but what sort of lyricism? Poverty-stricken! In exoneration of the "moderns," they were not given a chance.

For the first time, doubtless, two eminent architects of the younger school dared "enter" for an official contest, the Palace of the League of Nations. The firm of Le Corbusier-Jeanneret had that courage.

A lofty problem was submitted to them: the construction of a monument which would symbolise to humanity the immense idea of organised Peace, war against war. Magnificent programme! Versailles was raised to the glory of one man, one sovereign, one nation: and at Geneva there was to be one great conception, universal, modern.

Official architects sent in their projects for ready-made palaces, ill-conceived, stupid, ugly. Le Corbusier and Pierre Jeanneret put forward a highly ingenious solution, sincere and striking. In rejecting their suggestions the jury covered itself with ridicule.

Nevertheless, was Le Corbusier's conception sufficiently lyrical for the Palace of Peace? His solution was a group of office buildings, harmoniously conceived and formal, rational administration units. But it was not yet Architecture!

※

THE ENGINEER'S ÆSTHETIC (?)

ARCHITECTURE

domestic and industrial: service!

"WHAT fine houses are being built all over the place! Architecture really is the mistress art."

"We are grateful to the architects for having given us airy houses. They have conquered light for us: large windows, glittering eyes. Bravo, and thanks again."

For reasons whereof the understanding knoweth not nature causes us to be born, as it were, like hermit crabs, naked as worms.

Man, however, is differentiated from them by just a touch of phantasy in what affects his dwelling. The hermit crab seeks for a shell left vacant by the death of its proprietor (which it sometimes provokes: the housing crisis, in fact). Preferably it chooses some comfortable shell, and since there is nothing that better suits its needs, it generally takes up a temporary residence in elaborate whelk-shells, which must be terribly uncomfortable. Mankind chooses its houses as women do their motor-cars, for the sake of the fittings. The architect's client, when he dreams of his future house, has a whole poem in his bosom. He rocks himself with dreams of the perfect symphony he will dwell in. He unburdens himself to some architect. And the ordinary architect is all fire to be a second Michael Angelo. Under pressure, he puts up an ode in concrete and plaster that generally turns out very different from what the client brooded over: whence arise conflicts: for poems, particularly those engendered by others, are uninhabitable. Oh, those fugues in the form of bath-rooms, those sonnets of bed-chambers, the melody of boudoirs and dramas of water-closets!

A private house (everything is in these words). Its cardinal virtues: as being impervious to cold and water, warm in winter, cool in summer, open to light, easy to keep clean and convenient to live in, are in no wise poetic unless common sense and utility be such.

(A few rare factories have merited the interest taken in them, for they are good factories, whereas most of the utilitarian structures of this age which claim to be remarkable are hideous: and there are quantities of them.)

Confusing "art" with artistic, too many architects design charming façades and leave to "ghosts" the problem of working out the rest of a house, with difficulty inhabitable. The façade, architecture's spoilt child, should never be a mask. The architect's genius is in relating all the internal organs of the house, with a view to their most efficient functioning : and in conceiving the structure as an organism to which every part of it is both necessary and subservient. Is that some particular trend of our minds? Certainly we have a very special satisfaction in observing, that in all respects a minimum of effort, has produced a maximum result. In fact, I believe that therein lies the whole secret of power, for power that is not controlled is merely brutality. No trimmings! Does a hard, strong hand tolerate jewels?

An antipathy to cosmetics would make the architect's problem, if he desires to attain the ease of power, and the grace which emanates from what is true, infinitely more difficult. What an arduous inventor's task! Each square centimetre must yield its maximum, and the rooms must be exactly related if they are to be pleasant to live in : a perfect harmony which though much to be desired, is rarely attained.

In such an architecture it would be impossible to say that the plan had determined the elevation or *vice versa* : their interrelation is harmonious and organic. To be true, I said : (and a habitation can be true, be it humble or sumptuous : for instance, the Petit Trianon).

In that definition all fine utilitarian architecture lies; in the breathing unity of masses entirely adequate to their function. Decoration can be revolting, but a naked body moves us by the harmony of its form. Thanks to certain of our architects, we have some houses that are splendidly naked.

THE LIBERATION OF TECHNIC

THE rational application of iron to the construction of utilitarian buildings enabled them more and more to develop according to the function for which they were intended (Crystal Palace, Labrouste's Gare du Nord, Eiffel's Viaduct at Garabit, La Galerie des Machines at the Exhibition of 1889, and Tower).

Then reinforced concrete, invented by Hennebique, came into being somewhere round 1886, and immediately gave proofs of its admirable facility as a medium.

The extreme adaptiveness of this new material at once tempted the architects. Right up to today, stone has been very much of an obstacle to the builder : (Roman cupolas took revenge on experiments too daring by

falling to earth). But concrete, which could be run into moulds, and made
to overcome every obstacle, at first inspired the most disarming cement
fantasias.

The annals of reinforced concrete demonstrate clearly the misunder-
standing between the æsthetic of the material and the technic of handling it.
The engineer's office, which, with its large windows, absence of ornaments,
filing cabinets, etc., has become so sympathetic to us since 1900, gives birth

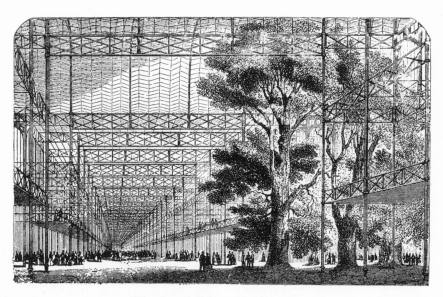

The Crystal Palace. London. 1851.

to the most dreadful things the moment it goes outside its job to dabble
in art. The torpedo station at Hyères reveals one of the earliest aspects
of true specialist architecture in reinforced concrete : there is something
moving in this prototype of contemporary houses, completed in 1908.

Architects like Loos realised that after the debauches of the " modernity "
of 1900 the most elementary good taste demanded more restraint.

The Perret brothers, before the war, professed similar ideas, and in
certain of their constructions they used the new medium with great in-
genuity, elegance, and intelligence. (Witness the garage in the rue de
Ponthieu, the skeleton of the Théâtre des Champs Élysées, the Casablanca
wharfs, etc.) The Perrets were originators, and from their work has
issued that school of architecture which has solved certain problems of
efficiency, lighting and heating. Among the precursors must, for various
reasons, be counted also Sauvage, Sarrazin, Tony Garnier, Lloyd Wright,

Berlage, Van de Velde, Gropius, Mallet-Stevens, and Le Corbusier, who, seconded by Pierre Jeanneret, vastly extended, familiarised, and purified the movement.

Many others could be named, for the architects of the modern school are by now innumerable. Let us praise them all, for to them we owe our

QUELQUES APPLICATIONS DU SYSTÈME HENNEBIQUE

Immeuble du Bureau technique central, 1, Rue Danton, Paris. - Construit en 1899.

Villa Hennebique, à Bourg-la-Reine. - Construite en 1900.

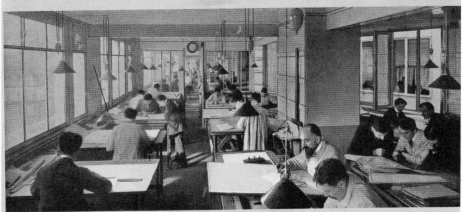

Vue intérieure d'un des bureaux d'études de la rue Danton.

A page from a publication by Hennebique. "For careful consideration."

Among young architects the problem of who first invented modern architecture is discussed with passion. This construction, dating back twenty years, ought to reconcile everyone. Render unto Hennebique. . . .

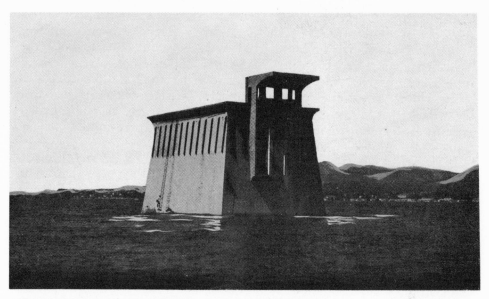

Shuttering of the Artificial Islet by Hennebique, destined to serve as skeleton for the Torpedo Station at Hyères, 1908.

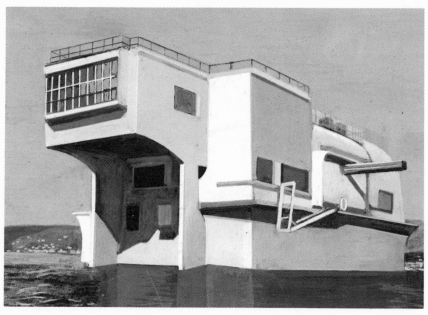

The Torpedo Station Completed, 1908.

pleasant houses: houses more than pleasant, significant, because of their impulse towards more convenience, and so more elegance.

Seven years ago *L'Esprit Nouveau* started a campaign to rationalise the dwelling, the problem being how to strip off all that was unnecessary. The majority of modern architects have rallied to the ideas then expressed. Their praiseworthy desire is to create what is useful only, and yet the sensational much tempts them. Many, and not the least, invent feigned utilities for the pleasure of rationally solving the problems thus raised, as witness those balconies for urban haranguings. Have they forgotten that everything that is not organic is ornament, and notably that an affected severity is more false than frank decoration, and that pure form is not the same as the absence of any form?

The great undertakings of the Department of Roads and Bridges, utilitarian constructions, appear as impressive technical achievements. The aeroplane hangars at Orly (Freyssinet), the immense dams of the Panama Canal, the automobile track at Montlhéry, are the latest masterpieces of this specialised art which is in no wise inferior to the great achievements of the Romans. In some ways it is purer, more sensitive, more intellectual also: for it fulfils our ideals of efficiency and thereby provides a gratification that answers to the new intellectual needs of our epoch. The magnificent Pont du Gard, Coliseum, and other utilitarian structures of antiquity had power, but not this majestic elegance. We have our own Romans and our Negroes too. What we are waiting for are our Greeks!

❈

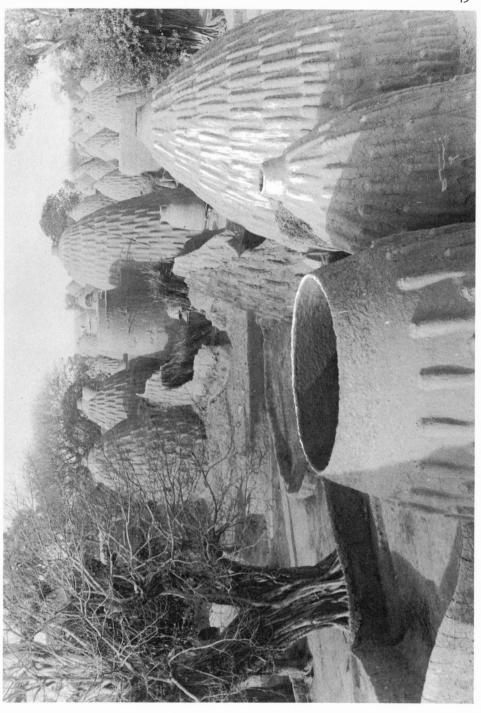

Negro " egg-shell " architecture.

(Photo Marc Allégret.)

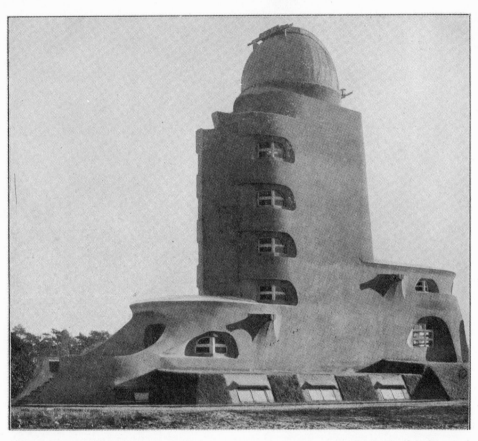

Einstein Tower, Potsdam, 1920-21. *Erich Mendelsohn, Arch.*

Interior of the Dome, Einstein Tower. *Erich Mendelsohn, Arch.*

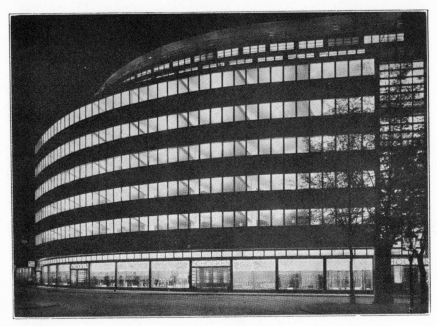

The Schocken Stores by Night, Chemnitz, 1928-29. *Erich Mendelsohn, Arch.*

Palm Beach, Florida.

The Bugatti of Egypt (circa 1500 B.C.).

Wheel of my Touring Bugatti, 1928.

THE ENGINEER'S ÆSTHETIC (?)

MACHINERY

the object in relation to function

NATURAL forms are mechanistic, for they are the product of universal forces. And these very forces are in their turn transformed by mechanism. The honey-bee is a relay that nature uses: mankind, too, is a relay like the bee: machines are relays created by man, and the collaboration of men and machines creates natural objects which artificially we call artificial. Doubtless the bee itself considers its honey artificial. But does anything exist that can be called unnatural?

A machine that turns out good work is a healthy machine: its organs rigorously satisfy mechanical, therefore natural, laws. Its products by degrees become stereotyped because the play of forces is unchanging and their effect is to compel such products into certain shapes, their optimum. But all this does not happen at once. Mechanical evolution is comparable with natural evolution, the law of mechanical selection is comparable with the law of natural selection. I went into these questions in *L'Esprit Nouveau,* and formulated this principle under the name of "mechanical selection."

*

THE GENESIS OF THE MACHINE-MADE PRODUCT IS NOT ÆSTHETIC

THE POWERS of imagination and the intuition of great engineers cannot truly be called æsthetic.

Their products are predetermined, for the natural laws to which, with ever-increasing efficiency, we respond, by degrees bring about their definitive form.

Ten years ago every electric-light bulb had a point, through which the air was drawn to make the vacuum: a point which interrupted light. Someone thought of evacuating the air through the base, and so the point

vanished and the bulb became spherical. Thus we like it better and it
serves us better : but was there any æsthetic impulse behind all this? No !
it was solely due to the automatic functioning of evolution !

Every substance is subject to laws that determine the form of its product.
As an instance, a connecting-rod of steel, having to transmit a given
quantity of energy, must have its shape and size determined by mathematical
calculation, based on the known resistances of the metal : a connecting-rod
of bronze cannot possibly be identical with one of wood, steel, cast-iron, or
any other substance. Mechanical shapes thus illustrate the properties of
certain bodies under given conditions. The engineer cannot give free
rein to his imagination, otherwise his connecting-rod will break. This does
not disprove the fact that artists do sometimes intuit what the form should
be, though personally I prefer a good ready reckoner. Think of the crazy
coachwork invented by æsthetic body-builders when engineers were content
merely to construct chassis ! Even nowadays coachwork is not free from
the same reproach, when the engineer has been apeing the artist, and
designing bodies.

Æsthetics, introduced into the sphere of mechanics, is always an indica-
tion of inadequacy somewhere. Old-fashioned telescopes are æsthetic, but
up-to-date ones whose capacity is infinitely vaster are in no wise so : and,
what is even better, there is practically nothing to be seen. A modern
telescope is frequently a well, at the bottom of which there is a mirror,
neither more nor less exciting to look at than water in a puddle, while in
the air somewhere, you have an insignificant eyepiece.

Motors, as in the Bugatti or the Voisin,* bear witness to incontestable
artistic taste, but the engineer's freedom in this respect will become more
and more restricted. The motor, starting from a certain principle, inevit-
ably gets stereotyped, and the most efficient unit is the one that will
inevitably be adopted everywhere. When that time comes there will be no
place for æsthetic invention, which serves to hide the absence of knowledge.

HOW THE MACHINE AFFECTS US

A MECHANICAL object can in certain cases affect us, because manufac-
tured forms are geometric, and we respond to geometry. No doubt that
is so, because intuitively geometry communicates to us a feeling that some
higher dispensation is being subserved, which thus becomes a pleasure of
the mind, and a feeling that we are satisfying the laws that govern our being.
All the same, its capacity for stimulating emotion is pretty limited.

* M. Ettore Bugatti as well as MM. Voisin, Farman, and the brothers Michelin
were art students.

Function creates the organ: an armoured airplane carrier with the funnels and turrets at the side of the ship to allow more room for taking off.

Temple or Machine? The First Sulzer Compressor.

But first of all we must be clear. Mechanisms often have a certain obvious beauty, because the substances employed by us happen to be governed by relatively simple laws, and, much in the manner of graphs, they exemplify those laws.

The tendency towards electrification is creating machines that are practically formless, " castings " containing insignificant spools. By the time we have got to disintegrating the atom, it may be there will be nothing at all worth looking at. Our mechanism is primitive, and that is why it still looks gratifyingly geometric.

Besides, certain substances like rubber, whose use is being widely

extended, are difficult to apply with precision: thus their " forms " are hardly " interesting," for they bear objective witness to the imprecision of the calculations that dictated them.

There are beautiful objects (not to be too difficult over the significance of the word " beauty "). But there is no object, or factory, or mechanism, or piece of furniture, capable of inspiring in us emotions comparable with those evoked by Art. Has the most beautiful motor-car or the finest house an effect upon us equal to, parallel with, or equivalent to, some masterpiece of Art? When the Beethoven centenary was celebrated at Vienna, during the performance of *Fidelio* there was hardly a dry eye in the audience. The Parthenon takes even the most insensitive by the throat. Has anyone ever seen a factory or piece of machinery that could move men to tears? The most elegant bicycle would be quite incapable of it.

And besides, it is really very striking how lovers of machinery by preference collect ancient implements long out of date. Imagining they worship mechanism, in reality they offer sacrifice to a taste for antiques . . . and the æsthetic imperfections resulting from the primitive technic employed.

All that can be said is that a really efficient machine is more intriguing than one that is a failure, and a polished pebble more than a mere scrap of stone. For certain forms are pleasant, others painful, and everything the intellect produces must be of interest to us. But starting from this point, to place the machine on the pedestal of great sculpture, seems to me blindness, silly snobbishness, and ridiculous also.

※

*A Cyclist Thirty Years Ago. Fashion has changed, but the bicycle-type is
already established.*

So long as the type is not stabilised, mechanisms go quickly out of date.
(The Santos Dumont, 1904.)

A great work of art is never out of date. (Egypt.)

DECORATIVE

"ART"

THE cult of the machine is responsible for the mechanistic-decorative schools. They do not decorate, but the dentist's chair to them is chair to the nth degree, and of course art too. There was some mention lately of a certain study armchair, rather similar to those made for the mutilated. It was worked by an electric motor, and would conduct the reader to the

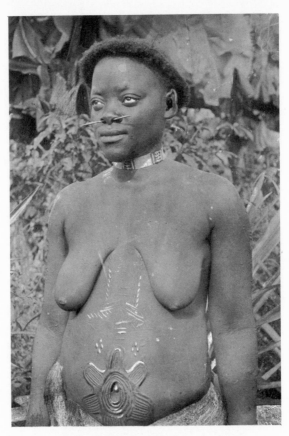

desired book, while articulated arms reached a cigar out of the box, struck lights, and eventually played a tune. This ingenious arrangement perished one spring evening. A badly adjusted cam caused the machine to fling itself out of the window with its fortunate owner, who came to no great harm. Now he uses the sort of armchair that everybody uses, like everybody else!

We hear also of some genius who has invented cushions of sheet aluminium for up-to-date boudoirs, the place for the head being specially indented. On the same principle a certain furniture maker, if asked to make chairs or armchairs for you, sits you in a heap of wax, takes the shape of your seat, and from the model thus procured makes them to your measure. The most honest among them invent suites of furniture in armour-plate, faithfully linked by immense rivets. It is the tinsmith's lyricism, near relation to the *delicatessen* shop, which builds its temples out of butter. I have even seen a design for a chair composed of glass, metal, and marble.

Loud-speakers are camouflaged as landscape paintings or missals, but, in revenge, hospital furniture is the correct thing for the drawing-room. Telephones modestly hide their nudity in a doll's petticoats, antique furniture is transformed into receiving-sets: but on the table you will find a large ball-bearing. Writing is done either with a fountain pen or an enormous gilded goose quill. A love for nature and mechanism is indicated by a crystal ball in which chalky rain trickles over an Eiffel Tower. Bizarre bazaar.

But . . . where are the chair-chairs, the table-tables, the lamps that illuminate? Yet they exist, and in quantities, everywhere: but unperceived because of their polite neutrality, decent and worthy though they are of any interior.

Nevertheless, we can, and should, create furnishings more and more closely adapted to our needs of poverty or luxury: but they can never be the products of unbridled imagination. First therefore, we should ask ourselves if there is any need for a chair to be remarkable, and if such excess be an embellishment or defect. Art furniture is but too often a utensil for showing off.

"Decorative art" in its charming way does its best to minister to our needs for Art, but it can do very little, and above all goes about it in the wrong way.

Let us be clear. I accept fine furniture, fine stuffs, but on condition that they are beautiful. Certain interior decorators like Groult, Francis Jourdain, Pierre Chareau, and a few others, at times succeed in creating acceptable objects.

In reality architects, mechanicians, decorators, are all stretching out towards Great Art. But their professions do not provide the opportunity

A Fine Wireless Receiving Set.

The same set can be had beautified thus ⟩⟩⟩——————————————⟶

"The Pulpit," pure Gothic style, containing a receiving set complete in every detail. The music book is the loud speaker.

for attaining it. The evil lies in the inevitably sterile ambition. Lure of Beauty! It is deeply moving to see the striving of these authentic artists, so superior to the occupations into which they have side-tracked themselves. But one has to live, and this age is particularly willing to pay dear for cheap amusements. Thus we pay through the nose to Mine Host of Ye Olde Inne, as for all sorts of odds and ends, though we try to scrounge free tickets for concerts, canvases from painters, and *de luxe* editions from publishers.

We must observe our distances. If we go on allowing the minor arts to think themselves the equals of Great Art, we shall soon be hail fellow with all sorts of domestic furniture. Each to his place! The decorators to the big shops, the artists on the next floor up, several floors up, as high as possible, on the pinnacle, higher even. For the time being, however, they sometimes do meet on the landings, the decorators having mounted at their heels, and numerous artists having come down on their hunkers.

Decorative objects are like those eminent retired personages with all sorts of decorations, who are hired out by agencies to lend distinction to ceremonies that have none.

WINDOW-DRESSING

FOR a long time the Viennese, through Hoffmann, have cultivated their shop windows.

Among those who contributed to reorganise window-dressing, mention must be made of Paul Iribe (whose influence was very great round 1908), Fauconnet, etc. Nowadays the window-dressing of small or great shops is very agreeable to see. A sane geometry derived from Purism and Léger directs the composition: dresses, boots, casseroles, all play their eager parts in the equations to which they provide a solution.

The art of window-dressing is an important factor in that town-planning to which Le Corbusier brought so much clear vision and power.

✳

Window-Dressing.

MUSIC

IN SO MUCH as it concerned painting, a prolonged effort was needed to shake off the compulsion to imitate appearances : but musicians were in no way obliged to curb themselves similarly, for music is autonomous, independent of surrounding reality. And though, exceptionally, certain sounds or arrangements of sounds recall the noises of nature, speaking generally, notes or arrangements of notes are in no wise reminiscent of reality (apart from states of being and feeling). A fugue by Bach is a fugue by Bach, a universe of sound, and nothing more.

Haydn said : " Music can no more exactly paint a tempest than it can say that I, Haydn, live near the Schoenbrunn Gate."

The painter's difficulty is how not to imitate, and that of the musician how to imitate.

Has modern music invented new formulæ, conquered new technics? No! music, like the other arts, has fluctuated because new needs and new tastes have come into being, and not because newer basic freedoms have been won. Are dissonance and complicated rhythms a new invention? Native traditions : Arab, Moorish, Russian, Chinese, Negro, used them constantly. Therefore, in spite of appearances, there has been no innovation in technic, but only a very systematic exploitation of elements considered exotic, by composers like Debussy, Dukas, Stravinsky, Schönberg, the super-Schönberg Berg, and a number of others. Note, however, by way of memento, the attempt to integrate noise and jazz as part of musical technic by Savinio, Russolo, Antheil, etc., which in effect only comes down to a development in percussion.

The struggle by musicians against usage and custom was active and valuable, for the legislators of the Auricular code had, with great severity, prohibited any departure whatever from the standards laid down by the dead Great Masters, " harmony " being the " sacred acts of the masters." Thus in *conservatoires* of music was born that music of selected pieces, odds and ends from the best musicians, the recipe for which they offer to teach prize pupils, and which annually gives us so many thousands of pages of scraped catgut. No auditor could stand it if his patience was anything but resignation. But sometimes he does wear through his breeches, for the resigned melomaniac is always shifting in his seat, as if his train were

late. Still a time comes, when it does slow down, and at last the station comes in sight. Station? Ah! but the little train drags off on its seemingly unending journey again. Occasionally he cocks his ear: something is happening, "it holds together," but, but, but we seem to have heard it before somewhere. And so we have. Massenet's, Beethoven's giblets in fact, swiftly swallowed up again by the orthodox drone, interrupted only by the inspired sobbing of twopenny-ha'penny gipsies, romantic boum-bouming and forest murmurings à la Wagner or Debussy.

The moderns have at times been able to express themselves otherwise than through the mouths of the masters: but here, as elsewhere, some of the more gifted have somewhat too much frequented native tradition. It is tempting to go bargain hunting, and all the more so since composers, in all good faith, believe they are improving and advantaging the native art by adding their own authoritative imprimatur. Albeniz "arranges" the music of tradition, Granados improves Albeniz, Falla is "interested" in Granados, the composer of Valencia "edits" Granados, Smet and Mario Cazes "arrange" Falla (and how!). Similar "exercises" are seen in the other arts, especially literature.

Jean Cocteau is about to publish his *Œdipus-Rex*, followed by *Romeo and Juliet*. His publisher, in a circular to the bookshops, explains a few matters.

> "*With the utmost respect for Shakespeare and Sophocles, he has rejuvenated 'Romeo and Juliet' and 'Œdipus-Rex,' and adapted them to our epoch. The dead branches have been pruned from these masterpieces, which thus brings them more closely into touch with the most modern outlook and those who most disdain the past. The operation to which they have been subjected, resembles somewhat that of the draughtsman, copying in pencil the canvas of some master.*"

"Do not derive your art from art," said once very sensibly Jean Cocteau-Voronoff.

Modern music has tendencies which in general are similar to those of the other arts: a seeking for intensity, polyvalence, and the utilisation of every means to such ends, and there are very few works today that do not possess this richness in some degree. If modern poetry is monotonous, yet it generally possesses a resonance which makes it, in spite of everything, more seductive than the regular uninspired verse of the past. So with painting and music. Often it is just this seeking for intensity and complexity that interests us in them: Nevertheless, the love for what is strange drives out the love of quality. Does that mean we are no longer able to

appreciate it? Certainly not, but our effort is concentrated elsewhere.
But where?

Ever since the war this quest for sensational sensation has been the
principal objective everywhere: everything has been to please, intrigue,
surprise, charm. No one seems any longer to have a very clear idea what
that Great Art is which has so generously been relegated to the boring
dodderers of the art schools.

With Picasso and Cocteau, Satie is to some extent responsible for the
jocular trend. He was often purposely stupid, and so was liked. He
behaved so, he said, in order to compel people's attention, and to get them
to listen to him. Then he wrote 'Socrate,' a grave, pure work. He was
lucky, for the snobbery which rewarded the aged musician's charming
acrobatics, decreed he could not openly be designated tedious. But it thought
so all the same: to such an extent has frivolity taken the place of beauty,
nobility, profundity.

The precious devotees of the frivolous excommunicated Darius Milhaud
and Honegger, when they dared confess to ambitions to greatness, and,
what was more serious, achieve it!

Rimbaud had a predilection for objects out of fashion. Under the sign
of shooting-galleries, inadvertent noises, and romance; painting, music, and
literature all fraternised together. While the painters were rehabilitating
popular prints, the lore of the gipsy, the charming decoration of side-shows,
the circus, clowns spangled like night, street acrobats or those in tinsel,

A Trade Card.

musicians woke suddenly to the savour of hurdy-gurdies whose melodies interminably turn upon themselves like gold-fish in a jar.

It was charming. And, as far as I am concerned, it delights me when year after year at Pentecost, I see a delightful 1830-ish roundabout instal itself in a certain street I know. It has Renaissance hangings, most gracefully draped, gold on red naturally, and twelve scarlet lions with seals' tails, and five sirens: a blond, a brunette, a negress, a red skin and green skin who have gone on chasing each other through a whole century. The painter in me delights in the negress siren whose face is painted once a year at the sign of the " Lion Noir " of generations of caravanners: and whose white eyes with their strange squint hold yours. A round of little horses in carved wood, dappled most delightfully, and four pink little cows complete the romantic family. A negro Zouave protects them on the west, a superbly silvered odalisque on the east, and a ghost of a mechanical organ with thirty-seven pipes, all more or less out of service, susurrates or coughs cracked noises that are flaccid, raucous, harsh, or crystalline in turn. The little organ has only one music-roll, but the cadence can be varied, and the tunes are always new; for they depend on the entirely fantastic and most modernist decisions of ancient cogs with broken teeth that sometimes engage and sometimes miss.

One thing leads to another, and having discovered charm where it lay

Outside a Fair Booth in Paris. (Photo Scholten.)

hidden, the end was that charm was attributed to things entirely lacking it, and in this way the general stultification began. Skittish forms and sour colour began to dominate Picassoist painting.

Jazz is the most perfect of free technics. All the same, there is nothing *new* as medium in jazz, only certain systematic usages, miraculous execution, and artist executants.

Whether we like it or not, it is jazz which best answers to the conception we have made for ourselves of a new music that shall be untraditional and living. Berlioz, Wagner. What emotion they would feel if they could but hear it! They would delight in the things they themselves strove for: intensity, infinite richness of timbre, its possibilities, the power and density of sound-volume, the purity of voices. The hypnotic potency of jazz has never been equalled. I mean certain jazz bands only, and not the rowdies of whom there are legion: not yet the refined Wagnerism of Paul Whiteman, an advance on Wagner, but a retrogression as regards jazz. In jazz music, where the instruments do not merely reinforce each other, but are complementary: where every element has been made organic to combine with every other, and where the melodies spring from the meeting-points of their curves, you have a presentiment of what modern music might be, if you can imagine a Gluck adding a dash of Poussin and Descartes to the rich dust-bin of super-rhythm and super-melody, which would have issued from that artist himself, and not from potted " native tradition."

The Athenian baton of Bruno Walter conducting, Stravinsky plays his " Concerto for Piano and Wind Instruments," and from the piano issues percussive and repercussive sounds. The senses are stirred, the soul is exalted by an ingenuity without parallel. Stravinsky has remarkable nerves. Mankind is an instrument with three registers: senses, head, and heart. What modern musician will compose a concerto for that instrument? Nowadays most of them elaborately move our senses and our heads, but the heart is neglected.

END OF PART I.

※

THE

ARTS

OF

FAITH

SCIENCE: RELIGION: PHILOSOPHY

WE HAVE strayed from the splendid wide road of faith. It is all overgrown, like the best Roman roads. Our behaviour is no longer automatically dictated, our instincts lack the vitality to direct us, we are going mad. Death alone sets a term to those sterile colloquies with the soul that demand an answer. Those who went before are much to be envied: they had faith. God was God, and under His severe but magnanimous dominion man was man. The sun gloriously shone for him, beauty was beauty, good good, and two and two made four on earth, in heaven, and every possible universe. Religion had a ready answer for every fundamental problem as to man's origin, his why and wherefore, and his future. Life was the antechamber to a happiness as of the *Thousand and One Nights,* and religions indicated the itinerary. But whatever happened, on no account were the royal prescripts to be infringed, and the blows of Fate earned good marks in that heaven to which they surely led.*

* *Nothing is more remarkable than the manner in which men behave: there are believers whose firm conviction it is that life is a preliminary examination eliminating the unfit from paradise. How, then, is it possible for them to do otherwise than rigorously and as though mechanically bow to the Divine law? How can anything other than obedience to what is decreed, or how to make the most of it, matter seriously to them?*

How, too, can Art have any significance for them, other than, in view of its futility, as an onerous and very laborious pastime? Do they realise how lucky they are? But some there are who cannot believe, and for them it is no joke. Art offers them its dreams.

How far we have moved on from that convenient orthodoxy! Yet rare philosophers in every age have asked their indiscreet questions of Fate. The abscess of scepticism ripens little by little. It comes to fruit in Montaigne, Montesquieu*, and bursts with d'Alembert: and the infection, so far confined to a few, flows out among the people. The free-thinkers become legion. Reason put the Heavenly Father on trial. The critical attitude began to strip Holy Writ with the most childish rapture, " proving " that nature could not have performed miracles merely for the Children of Israel and allowed the Red Sea to be crossed, etc. As for the logic of the " schools," it puts its arguments at the service of doubt in phrases like " How is it possible for a good God to create evil?" etc.

As a result, the only possible attitude became an ironic atheism. To be anything but a free-thinker was to seem hide-bound: town and country gaped in astonishment at the almightiness of human logic, and abandoned its hereditary beliefs. People felt, as it were, grown up, and gaily they gave themselves up to the joy of existence, like a terrier off the leash. It is thrilling to tease God, and delightful to give the senses rein. Free-thinking and open-speaking! The human intellect, suddenly finding itself in a position to treat as incredible Jonah's submarine holiday, has no longer any doubts about its own amazing capacities, and lulls itself with thoughts of its own clear-sightedness. In that joyous springtide marquises and commoners transform their houses into chemical laboratories . . . and expect that all of a sudden, out of a retort, " the prime cause of all " will issue, or the devil.

* *Twenty-two editions in eighteen months.*

Scientific and philosophic discoveries hasten on each other, thinkers and scientists lend wings to the soul. All the public realises is that Volta has succeeded in inducing movement in dead frogs. That is enough to rob it of its faith. Magnetised trays speak oracles!

THE NINETEENTH CENTURY: SCIENTIFIC OPTIMISM

RENAN inherited the outlook of the eighteenth century. A sceptic where faith was concerned, science found him credulous. His *L'Avenir de la Science* is a long ode to the infinite extensibility of human knowledge, upon which he pins all his hopes. Religion is lost, but another takes its place. Taken as a whole, the nineteenth century is an era given up to experiment. Everything that instruments can register is analysed: the results accumulate. There is a certainty in the air, that so remarkable a collection of facts must inevitably end by revealing the secret of the profoundest human problems, the why and wherefore, the beginnings, the nature of existence, and, above all, throw light on what may be beyond the grave. Miracles, above all, serve as the rallying-point; the investigation of miracles is the *leit-motiv* of free-thinking in the first part of the nineteenth century, as it is of the second-rate minds of today. According to them the repetition of a

African Pygmies.

phenomenon is a necessary condition of its scientific investigation : yet miracles are by definition unique. They cannot therefore be scientific. Well and good, they are not so, clearly, because they cannot be verified. But does that imply that they do not therefore exist? (Yet, on the contrary, miracles, sad as it may appear, do not prove the existence of God.)

In any case, our new graven images are constantly creating miracles : marvellous mechanical triumphs : photography, steam, electricity. And then there is the triumph of agnosticism : Darwin's *Theory of Evolution,* Haeckel and the genealogy of the cell evolving into man. Youthful science seemed, to the onlooker, to be redeeming its promise sooner than could be hoped for.

" What is Man? "

" The evolution of an ape, which was itself a stage in the slow evolution of a first cell."

" What created that first cell? "

" Chance."*

Thanks to such hypotheses of genius, the nineteenth century experienced very little of the torment of the physicist Pascal, who forced himself to have faith, realising the terrible snares that lay in wait for man in that sterile solitude where science awaited him.

Today the deepest, most earnest men of science no longer attempt to explain. They realise they are only observing the world outside them, the world inside them, and perfecting means for doing so. Newton saw all bodies subject to the laws of gravity which he had formulated : Henri Poincaré worked over these laws and adapted them to modern findings, and asserted only that the universe appeared to be subject to them. Einstein introduces new modifications into a theory which tomorrow may prove untenable.

What, in fact, are the resources of science? And by what *détours* is it able to supplement our limited senses? By arming them with more responsive, more penetrating instruments? Yet the deeper world into which we thus penetrate is still perceived sensorially.

In the last resort, our reason, our logic, are human too. Science is incapable, therefore, of discovering anything irrational in our universe. And anything which should be so would pass unperceived by us, for we are so made as to be capable of perceiving only what is perceptible to us, which is the same as saying that our brains are rational. For that reason the universe must appear to us determined by definite laws, and thus science becomes possible. But all it does is to write the word " thousand " over an already existent hole.

* *Juan Gris, rationalist, remarked : " What astonishes me most is that series of accidents that made me into a man. . . ."*

(Life doubtless is that non-rational factor which we are positively unable to grasp.)

The ancients and the Renans believed that only a mist, as it were, separated us from the reality of the universe: but we know now that this cloud cannot be resolved, and that, far from being a vapour to be dispersed

by enlightenment, it is the armour plating of the unknowable. Armour plating? Every use of language is inappropriate, for we know nothing, and we but dupe ourselves with images. Metaphors all!

Our ineluctable darkness is but too apparent: neither science nor philosophy are able to give us any absolute certainty. They can register the relation between apparent facts, and schematically group those which recur often, and only those: but never can they seize Reality as it is, and still less satisfy our ardent curiosity as to the nature of things or ourselves.

You hear people talk of the dramatic night of the Middle Ages, and compare it with the daylight that shines in our own age: but we know now that we know nothing: or yes, we know that we can know nothing with certainty. The conception of the universe as something absolute has disappeared.

A COMPARISON IN THE FORM OF A BALANCE-SHEET.

Nineteenth Century.	*Twentieth Century.*
RENAN,	EMILE PICARD,
of the Académie Française, wrote in 1871: "Science has only one object really worthy of it, and that is the solution of the enigma of things: the communicating to mankind the secret of the universe and his own destiny."	of the Académie des Sciences, wrote in 1924: "Scientists, at least the majority of them, no longer seek to discover the secret of things as Renan so naïvely hoped. They are no longer even very sure they understand what such an expression means."

RELIGION

As a last resort certain scholars seek to revivify religion. They apply the "exact" methods of modern history to it and investigate sources. From later deposits they sift out ancient events, like a geologist tabulating his deposits against a scale that relates them. Others seek to reconcile different dogmas with the conclusions of modern criticism and scientific findings.

Others, again, invoke metaphysics, a labour that is interesting in itself, but which must inevitably be indeterminate like everything in the universe, outside feeling and believing. Neo-Thomism, neo-Scholasticism, art for art, and sometimes very fine art: Maritain.

But no discussion of dogma can be of any practical value unless reason itself is accepted as a proof.

There are many who continue to think of themselves as belonging to some religion. Dogma is by nature rigid. It is difficult for some to accommodate themselves to it, and the majority avoid its implications by thinking about it as little as they can. Religions are accepted in the degree to which men can accommodate themselves to them. Some go to Mass lacking true faith, but in reverence to the unfathomable mysteries of existence.

Religion itself, faced with the collapse of every certitude, has passed on everything to science excepting only dogma. Actually it has renounced the part it once played, that of being Science itself, in order to become a Credo only. A position which nothing could have impugned if, by an extraordinary twist, the Church, to prove its dogma, had not made use of just that implement that in these matters is so out of date, Reason. Reason can convince us of the impossibility of knowing, but it cannot give us reasons for faith.

Nevertheless, faith is in the air.

Be as ironical as you like about Theosophy, yet since, as nothing in the universe can help us truly to prove anything whatever, and consequently to demonstrate the falsity of a religious belief, silence is best. Believe who can, that is all that can be said. Faith is impervious to all criticism. To believe is to feel there is an absolute, and he who believes knows. It is a question of Grace. The Jansenists were right. That is why on Sundays I often turn my 5 h.p. in the direction of Port-Royal-des-Champs (the high plateau of which serves as an aerodrome for the Farman Company), in the vague hope of somehow finding faith, or, failing which, its illusion, among the wings that float about the sky, miraculously almost.

The unbeliever asks: " Why should there be a God?" And I reply: " Why should there not?" Bossuet said everything when he said that! Then why does he discuss it so much elsewhere? His eloquence is so divine that you forget he argues like an eagle. Yet what more could he prove if he argued like a scientist? Rationalism, too, is a form of credulity.

Science: Doubting. Religion: Knowledge. Art: Self-delusion.

SCHEMA

" . . . all perceptions, as well of the sense as of the mind, are according to the measure of the individual and not according to the measure of the universe."—BACON.

CONSEQUENCES

1. The impossibility of knowing anything certain as to the universe about us.
2. To believe in such a transcendental reality, one must:

 (*a*) Avoid thinking (is that possible?).
 (*b*) Stultify oneself (Pascal's way out).
 (*c*) Be capable of believing in the veracity of the senses and intellect (in which case our sentiment of causality compels us to admit God).
 (*d*) Be capable of believing our psyche integrates a portion of revealed truth in harmony with the universe (Leibnitz's pre-established harmony).
 (*e*) Knowing how inadequate reason is as proof, and doubting also of doubt, be able to accept therefore as possible what is acceptable to us: as, for instance, that the universe, such as it appears, is real; and that causality and finality are transcendental.

3. For the agnostic, science, like religion, is an art like other arts.
4. Art is:

 (*a*) A pastime where the true believer is concerned.
 (*b*) A palliative and liberating hypnotic for the sceptic.

CATEGORIES OF BELIEVERS

(CATEGORIES AMENABLE TO COMBINATION IN VARYING DEGREES)

1. THE BELIEVER:

 (*a*) Passive.
 (*b*) Convinced.
 (*c*) Active: propagandist.

2. THE MYSTIC WHO STRIVES TO BELIEVE (Pascal).

3. HE WHO WILL NOT ENQUIRE DEEPLY:

 (*a*) Through indifference.
 (*b*) For fear of disturbing his tranquillity (the ostrich's wing).

4. THE CONVENTIONAL FREE-THINKER:

 (*a*) Too "intellectual" to believe.
 (*b*) Propagandist: his ideal being to prevent others believing.

5. THE BORN AGNOSTIC: Whose nature will not let him believe.

6. THE VACILLATING SCEPTIC: Reason proves to him the uncertainty of reason. Aware then that he can know nothing for certain, he finds it impossible to decide one way or another (Montaigne).

7. THE POLITICAL BELIEVER: He uses religion as a form of State (Moses?).

8. THE BELIEVING SCEPTIC: Who knows he can *know* nothing, and in consequence is able to believe what he *feels*.

SCIENCE

1. THE SCIENTIST TRUSTING IN THE POWER OF ALMIGHTY SCIENCE: Believing that reality transcends all and that science will explain everything.

 (*a*) Tolerant, through innate kindliness.
 (*b*) Intolerant, anti-religious: religion opposing the advance of science (Homais).

2. THE SCEPTICAL SCIENTIST: Aware that knowledge is relative.

 (*a*) Despairing: practising art.
 (*b*) Giving its due to religion as outside the domain of science (Pasteur, Branly).

*The world outside us: revelations of our senses. (This landscape is
photographed with the invisible rays of the sun.)*

ART

OF

LIVING

PHILOSOPHY OF DOUBT

ON the façade of the house at Tréguier in which Renan was born, there was, before it was burnt down, a little niche to the right for the Holy Virgin, and to the left the plate of an insurance company. . . . For the same reason this book oscillates between two poles, like our distress in face of the supernatural and our sense of reality.

Everything great that has ever been made by man, has been made by him to win oblivion from the fact that his destiny is a sealed book : but if his destiny is a matter of indifference to him, then he creates trivially.

NOTICE!

Let us be quite clear. Below, I shall carry scepticism to its furthest limits. Not that I wish to encourage a complacent indulgence in doubt : on the contrary, in order that it may wreak its own destruction. In the annihilation of rational certitude we shall discover a justification for faith, and in relativity, a Certitude.

THE LIVING MOMENT : supreme instant, the one truly certain reality.

Is it certain that phenomena exactly repeat themselves? We cannot know, and there is a good reason why. It is by means of our senses (through the instruments which intensify them) that we perceive. Thus, assuming that some systematic distortion in the universe should take place, as, for instance, if everything diminished or increased in the same ratio; nothing would indicate the variation to us. (Henri Poincaré.)

Yet science admits the identity in time and space of two events, one in the present, the other in the past. It designates them similar. In that respect it reveals itself as accepting " the practical point of view," which

contents itself with approximations (and even errors). How much mis-
leading evidence there has been, which makes us *a priori* doubt all evidence!
Experience is but an operation of memory and intellect, both of which have
given us sufficient justification for doubting them. What is not present is
specifically questionable: experience is questionable, and questionable also
Science that builds on experience. Even if science revealed the truth to us,
we could not know that it truly was so. The only absolute reality is the
sensating of the present. I FEEL, THEREFORE I AM. The past and future
are probabilities, possibilities, ineffabilities.

There is no heat but that which warms us, no happiness but what we
experience. Everything else is substitute, hypothetical, illusory.

And yet, nothing is so precious as certitude, and that we have lost.
Anxiety has possession of us.

A Freudian analysis would reveal the fact, that the repression of this
anxiety is the virus of the contemporary neurosis. Few men dare go to the
limit of their thoughts. One problem only preoccupies us, and that is
Death. The skull in the cell of the monk counteracts this repression: the
result is serenity. Less wise, we have sought to escape that thought, and
the abscess has burst internally. We are all the more ill because we do not
know it, for the unconscious goes on working despite us and unknown to
us, and what is always repressed preoccupies and oppresses us, even while
we feign not to think of it. The popes who stuck fig-leaves on their
statues, drew attention to what they would have liked to be non-existent.
Like those popes, some gipsies I met one day, had nailed clouts over the
hips of the lovely women that adorned their roundabout, too nude
for the mayor of that district: but little boys were lifting the rags up
to peep beneath. So it is with us, when we play hide-and-seek with the
mysteries, and with our tragic curiosities.

In the need to escape their obsessions, some men fling themselves into
activity, others consciously create needs for themselves, in order to be able
to minister to them and forget themselves in their service. These needs
have augmented with such speed, that mankind, overwhelmed by them, has
had to invent mechanism.

Today therefore, we are swallowed up by our furious existence: but
the time is near, when by some strange twist, mechanism is to restore leisure
to us.

But for some time yet, humanity will be absorbed in creating its equip-
ment, so that its anxiety will find relief. For activity distracts and
inhibits.

"*The further I advance on the path of life, the more do I find
toil necessary. And in the end it becomes the greatest pleasure of
all: a substitute for all one's lost illusions.*" (Corneille.)

Then the saturation point will come for those new demands, since the possibilities of mechanism augment much more rapidly than our needs. Already even certain automobiles demand less labour than was needed to make the cheeses of fifty years ago.

How many years would it take for a mechanic to make a motor-car by hand? Ford with 50,000 workmen produces 5,000 cars a day: therefore with the aid of machinery ten workmen can entirely manufacture one car in one day: therefore one workman one car in ten days. Observe, that in his plant, a large part of the staff is employed making the mechanical equipment, the steel, the castings, sheet metal, fabrics, glass, etc., for only raw material enters the Ford shops. Reflect! When we were children the working day was fourteen hours. Now it is eight. In the United States (1927) 5 per cent. of the workers worked a five-hour day five days a week. Over-production. The working day will diminish even more. Mankind will soon be better served by its slave machines than was any overlord of feudal ages by his serfs. A few chosen engineers will suffice to work out such new mechanisms as "progress" makes necessary, and machines will put them together under the supervision of a few mechanics. What will the rest of humanity do? Have holidays: immense periods of leisure in which to think? But thinking means inevitably seeing Death face to face.

Conceive the frightful emotional and intellectual situation of future humanity, with nothing to do and brains more questioning than ever before. The masses will find themselves in the frightful waste that Nero knew, despite the succour of science, which no longer attempts to explain: and with no help from faith. Possibly there will be attempts to believe. But can the wish suffice? Will they stultify themselves to believe? It becomes difficult to do so when one has time to think. Did Pascal succeed? He died, rather mad, of terror and despair.

THE PHILOSOPHY OF ILLUSION, THE SERVICE OF ART

LIFE! That Fact is lost, the moment it no longer operates within us: a mosquito sting is more important than the memory of the most agonising pain. The might of the present! That is certitude itself. Art is actual, it is a reality intercepting that other reality, pain. A narcotic, but a salubrious one. Beneficent euphoria!

Science, like other arts, is an art of illusion: its crystal-clear apparatus is so diaphanous, that through it the beholder imagines he grasps the image of the universe. That illusion is beneficent. The aim of both science and art is to create fantasies which solace us for reality. For an instant of time we can be wholly occupied by them: evasion.

It is said, idiotically enough, that science has gone bankrupt, whereas what went bankrupt was the faith we had in it. We demand reality, but all science can give is reality's illusion, and that is a good deal. It is the best we can expect from Science as from Art.

Nevertheless, it is to be regretted that the art of pure speculation should, as an art, be somewhat blank. Certitude is in our hearts and senses, and these science attacks but feebly, for which reason it inhibits them less than do the arts of sensation. And then, abstract delights leave us grasping at empty air, as in those wonderful dreams from which we wake to find ourselves alone. Also, a thesis refuted is a pretty anæmic business. It is always Newton that is refuted, never Phidias, Mozart, or Rimbaud. Euclid is based on certain postulates, but painting, music, poetry dispense with hypotheses; they construct upon irrefutable sensation.

Of all the arts, music and the plastic arts are most efficacious, because they evoke intense feeling, though that is not the full extent of their influence. They affect our consciousness, our unconsciousness, our affectional attitudes, and also our intellects (that intellect which has some slight special interest in science). The senses being held in hypnotic check, the spirit is led to the joys of speculation. These arts are nowise inferior to those of science, as far as intellectual value goes.

Thus, as a result of art, illusion substitutes itself for reality and creates its imperative mirages: we see signs and wonders. We become creatures less unhappy, and at times even happy. The fable of the blind and halt!

ART IS IMPORTANT TO SOCIETY, FOR IT MINISTERS TO THE INDIVIDUAL'S FUNDAMENTAL NEEDS*

RENAN tended at times to think that an age would come in which art would be a thing of the past: that even Great Art would disappear, and that a great artist would be something out of date, almost useless, whereas the scientist would become more and more important. Beauty, he thought, would give precedence to science.

Condorcet said: " *Science will conquer Death.*" (In the meantime it is Art that has vanquished it, or at least its obsession.)

And Jean Jacques Rousseau said: " *The movement of water enthralled my senses, driving all other agitation from my soul, so that I was plunged into a delicious revery.*"

* *Some people have said that this notion of "Art as liberator" smells of Surrealism. Even if this were true there would be nothing to be ashamed of, for I esteem certain of the concepts of that movement. This chapter is the development of the ideas I have already formulated in those articles entitled " Certitudes" which appeared in " L'Esprit Nouveau," Nos. 22 and 27, April and November, 1924.*

And Stendhal said: "*It was a great surprise to find, when studying painting solely as an escape from boredom, that it held a balm against the most painful deceptions. For our nervous fluid has, if I might so express myself, only a limited amount of sensitivity to expend day by day, so that if it be employed in appreciating thirty fine pictures, it will not be used to mourn the death of an adored mistress.*"

It overwhelms one to see Art treated generally as *hors-d'œuvres* or dessert: yet a large part of all activity, even nowadays, is expended on æsthetic aims. We all spend a good deal of money, *i.e.*, effort, in embellishing our homes (even if it does mean Gothic buffets or so-called modern pieces). Women make sacrifices for their toilets, some say because love is at the bottom of it. Well, suppose it is? What then? It only proves how profoundly mankind is susceptible to art. . . .

Why, even in the *Cavernes du Lot*, prehistoric man was making beautiful objects. No doubt he counted on some magical result from them. So also, temples were everywhere constructed to a religious, and therefore interested, end: as with most art. Nevertheless, it is not absolutely necessary for a church to be fine in order to be a church, or for a crucifix to be a masterpiece in order to symbolise Christ. The efficacy of symbols in the minds of believers is not their action upon us but upon God. The incised engravings of the Magdalenian epoch may be *talismans,* but they are *also* works of art. A talisman is a sacred implement. And if we wish it to be beautiful, it is because through it we offer our homage of beauty to the gods. We offer up to them what seems most precious to us, a temple, plain-song, a Christ, a portal, a mask of Beauty. Even shops that sell religious objects, however execrable their taste, try to sell as much beauty as they can.

(What I have just said should reconcile Messrs. Salomon Reinach and Marcelin Boule: the former favours a totemistic magical origin for art, the latter art for its own sake.)

In the days of faith, art is generally at the service of religion. But the conception of lay art, individual and at the disposition of all, is relatively very recent. 'At the service of man,' means unrestricted service to our need for fantasy.

In the past, God and this need in us, could find their gratification in the same observances: nowadays it is ourselves we serve.

The artist is no longer the servitor of God, but a poet, a magician . . . since the true function of art is to surround us with illusions. More than ever before do we need magicians and their spells, for Religions were created to soften the fear of death, Art to enable us to forget it. The kind of buoy that rescues us is hardly relevant!

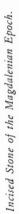

(Limeuil, Dordogne.)

Incised Stone of the Magdalenian Epoch.

The Jaeger Speedometer.

Lindbergh's Instrument Board.

B

THE TECHNIC OF HAPPINESS

THUS the artist's activity is of great importance, but the art created by him is a consequence of his life. Let us now deal with life.

> *"During a conversation with Bert Acosta after his memorable flight across the Atlantic, a distinguished engineer asked: 'How were you able to pilot your plane for such long hours, in fog so thick that sometimes portions of your plane were invisible?' Without the slightest hesitation the American replied: 'By relying entirely on my instruments.' 'Do you think,' then asked the engineer, 'that it would have been possible for you, under the same conditions, to pilot your plane without such instruments?' It appears that the expression*

188

of consternation which then appeared on the pilot of 'America's' face was intensely funny; he threw his arms up, and, speaking to the interpreter, said: 'I can't understand how anybody could ask such a question.' A French flier once said to another engineer who had specialised in the construction of aeroplane instruments from the very birth of flying: 'Instruments! I should like, when I start off somewhere, to cut circles of black paper and paste them over all the dials in my cabin, so as to avoid the risk of even looking at them.' " (From L'Intransigeant.)

It is, alas! only too true that most of our attempts on records fail. (Perhaps, though, it is reassuring, after all.)

So it is with life, if we start off blindly. Every project would be vain were we not free; but are we? Many deny it: they believe in determinism: according to them, life is not amenable to our wills.

Determinism implies causality. Causality and determinism are mere words. Words often deceive us. They lead us to suppose they must stand for reality, when they often merely adorn lay figures. As peremptory as a fiat from the Vatican, they go back to a time when Man believed he knew something, and that, some day, he would know all: they are the moulds in which faith is stored. Take, for instance, the word " solve," which so duped the philologist Renan when he said " science will solve the enigma of the universe," thus insinuating that a solution existed. But the statement itself is a " problem." The problem of causality quite simply leads back to the existence of causality.

Our logic cannot admit any effect without a cause, either remote or immediate. It reasons thus: " The universe exists, there must therefore have been some first cause, some impulsion." This is how that God was discovered, explained, or invented who is so variously denominated Prime Cause, Self-Created, the Sublime Architect of the Universe, the Prime Motor. But must God necessarily exist because we should like Him to?

We might just as reasonably think that the conception of causality depends entirely on the construction of man's spirit. In effect, transcendentally it may be that events behave so impolitely as to dispense with causes. God, in such an event, would be a creation of mankind, a dressing for a perpetual wound, a stop-gap for a hole in our souls.

All of which does not mean that God is non-existent.

From the logical point of view, the theistic solution and the atheistic negation have equal significance. Is either entirely satisfactory?

No, since we cannot logically make up our minds that God does or does not exist!

We can therefore reasonably take it that Reason has no validity in such

matters. Yet there is one *rational* prerogative we can claim, that of faith.
And divest ourselves of determinism, which is itself a belief.

Those who reasoned were strong in their belief in a sombre determinism!
Man linked to implacabie destiny, and chained to the hell of his own
automatism.

Yet in favour of freedom there is one feeling that pleads and wins the
cause: the feeling that we are free to make our own decisions. It may be
that there is more profound reality in this feeling, than in all the logical and
rational frameworks we put up. Let us follow our impulses and have faith
in our freedom. Our intellect, our senses, and the aspects of phenomena, will
then be reconciled. This attitude will enable us to reject the conclusions of
materialism, which are as improbable as all others: and, above all, contrary
to our instincts. A precious prerogative, for it is a way out. We were
seeking certitude: now at last we find it in the conviction that neither
logically nor scientifically can we ever acquire it. That is itself a certitude.
Let us make it our foundation.

{ Truth is the particular sentiment of trueness each of us may have,
{ and not some rational conception of it.

Let us give heed to what speaks in us, and if our intellectual debates
have led in some degree to the sclerosis of our instincts, let us find a way to
restore their elasticity. The abuse of reason is pernicious, for it stifles our
unconscious, which undoubtedly knows more than our clear-sightedness.
(Hardly difficult, in any case!) Our hearts, the hearts of women, laugh at
logic: it is from love and its irrationalism that life springs!

Our problem is how to attain happiness, that happiness which we alone
can build for ourselves: the terrestrial paradise in which our joys are conse-
quent upon the ordering of our acts and their adequacy. We should always
give ear to our elemental voices, though they may lack co-ordination and
often suggest mutual antagonisms. Only the perfect co-ordination of our
acts can unite them into one solid lucid structure, as coral is solid among
weeds, which are at the mercy of every passing current. The Currents are
the thousand possibilities which, at every moment, open to us, and from
among which we have to make our choice. The Corals are the ordering of
our voluntary acts: the tokens of their quality and adequacy.

To try and live by the light of geometry saves us from expecting the
possible co-operation of Chance, a god who generally deserts his devotees.
Such a discipline, like all disciplines, is an ethical system which bestows
certain values. Its help is precious, for we are free, but only relatively so:
because every significant act influences our subsequent acts.

There is no compass without a North, no dynamic Ideal without a

concept of Death. There are two opposite concept-types of death, and consequently of life.

Life-negative moves sinisterly towards the grave, where the body moulders in preparation for some unknown annihilation. Hecate. Hamlet. But life-positive, on the contrary, moves towards the realisation of an Ideal.

Our life is but one aspect of universal life, which perpetuates itself in other forms, a modality. Death is rest won after action : resolution in the furnace of solar transmutations. Not corruption, but living chemistry, eternal germination. Death is a convention. Let us live.

It is impossible to live harmoniously if we go contrary to the great injunctions of nature, like frogs trying to swim against the current and sticking in the same place. Observe nature : it bows before the least effort in the spark flashing between two poles, the leaf falling, water flowing, the donkey ascending a slope the easiest way : and yet the road is generally a long one, because the event passes through innumerable circumstances, each of which diverts it, even though for nature it happens still to be the straightest possible way. The river flows seaward, making a thousand bends; the leaf in falling turns and twists; the lightning-flash forks; the donkey takes all day; nature does not hurry. Are we also to drift?

All our activity, our haste, is in order to forget Death. We take the shortest road, straighten our curves, make aqueducts, cross mountains, bridge valleys : a wire subserves electricity and conducts it to the ends we assign it. Storms create waves of high frequency over a limited area, even though the energy expended is enormous, but wireless installations, which expend infinitesimal fractions of that energy, create waves that encircle the world. All because man has imposed a "form" on this fluid, which conquers the scattered forces that neutralise the storm. A lens concentrates the diffuse rays of the sun and creates fire by converging those rays. To converge is to refine something in nature, so as to render it more concentrated, compact, penetrative, intense : it helps to facilitate the manifestations of that phenomenon and to render it effective and useful for humanity. All convergence implies an application and achievement somewhere. Machines now manufacture combs for beehives, and modern bee-keepers supply them to their bees, who give more honey than they did and are thus more efficient. The trend towards efficiency is the complement of the law of least resistance.

Convergence is not only of practical importance, for there are many joys it procures for us. Natural phenomena in their original aspects appeared first as a chaos in which our intellects wallowed. Some mental concept then reduced them to some order. We "understood," and a less effort had to be made. Our senses, intellects, hearts, have their abscissæ and co-ordinates : they are our constants, and it gratifies us if we can succeed in attaching the forces of nature to them. Such a relation of nature to our axes we designate

Man marches straight before him, crossing valleys . . .

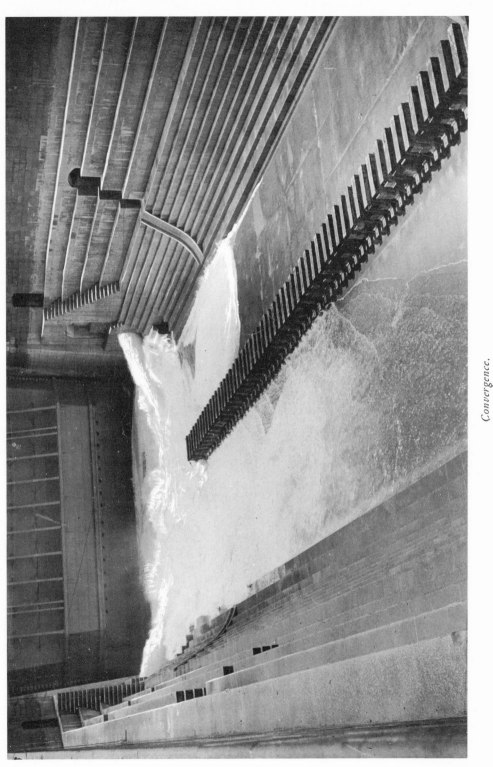

Convergence.

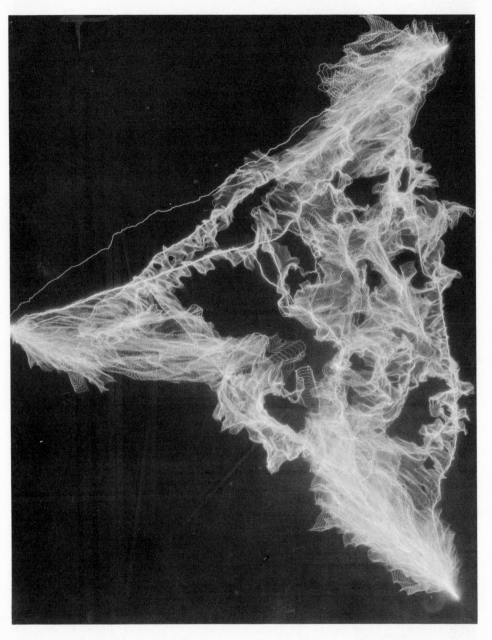

An Electric Spark. *Nature.*

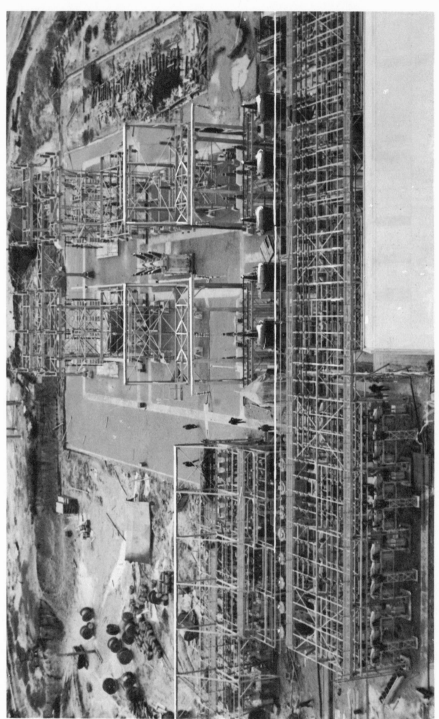

Man converges electric currents: resolves them.

the Laws of Nature. Anthropocentrism. It is important to us to feel that
we are one with nature : with the conception we now have of that universe
after having humanised, refined, geometrised it.

*

WE have in our hearts, our bodies, our souls, antennæ which in a rudi-
mentary way are capable of distinguishing Quality. The latter modifies the
natural law of least resistance and humanises it as efficiency. But for this
concept we should risk mistaking quantity for perfection.

All convergence establishes an " order." An " order " is a " structure."
In electro-magnetism different frequencies of vibration distinguish phe-
nomena such as heat, light and colour, X-rays, radium, wireless, etc.

Man is unable to perceive the universe except through the geometric
filter of his sensations. Nothing can move us but what is adapted to the
perceiving of our brains. When we become aware of phenomena which are
not directly perceptible, it is because some intermediary apparatus has adapted
them to our organs. Establishing a fact is equivalent to adapting its structure
to our own. To hear wireless, or see X-rays, we intercalate between the
vibrations and ourselves, an artificial sense which modifies the electrical
vibrations to conform with the structure of our ears or eyes. For instance,
the receiver in wireless telephony reduces the rate of emission of the vibra-
tions in question, and reorganises them in frequencies appropriate to the
conformation of our ears : thus they become audible. These sound waves
can be modified to the frequency of light rays, so that sound is thus adapted
to the structure of the eye. (Theremin's experiment.) Heat can be produced
similarly (the thermal galvanometer), and some day possibly odours, too,
and, who knows, concepts also? Mathematics, geometry, all the arts, are
forms of apparatus that reduce the incomprehensible to credible forms.

Everything is Structure.

The aeroplane is structure, though still imperfect.

In religion and morals, Moses, Jesus, Sakya-Mouni, Calvin, Voltaire,
Renan, Annie Besant, created mental and affectional structures.

The ordering of Boileau, Le Nôtre, was by symmetry; that of Shake-
speare by contrast. Order is multiform.

It is one of man's passions to disentangle apparent chaos. He has to
harmonise the universe to his own mental structure, and he does so by
choosing from nature what fits into the working of his mind. One of the
resultants of this activity is called Science. Concordances are but re-echoed
questions and answers. All human activity, whether technical or artistic,
tends to create structures which conform with those of our constants, and
free perceptible affinities from the magma of the real and possible. The

geometrising spirit is one of the consequences of the tendency to least resistance. It is innate. Yet it irritates M. Toukatchewski,* Generalissimo of the Soviet armies. It was Versailles that made him " see red."

> " The foundations you live on are rotten. As for Latin and Greek civilisations, what filth! In my opinion the Renaissance resembles Christianity in being one of the great plagues of humanity. Your intellects have been thrust back by it into the outworn conventions of the past, which have no relation at all to your present aspirations. It has made final the divorce between your thoughts and desires. As for your material needs, the development of industry has increased them tenfold, but your culture is an obstacle in the way of your satisfying them. That is why the Americans would be your superiors, if they in their turn had not been seduced by harmony and measure. These things, harmony and measure, are what must first of all be destroyed. I only know your Versailles from pictures of it. But that too elaborately designed park, that finicking architecture resulting from too much geometry, is hideous. Has it never occurred to anyone in your country, to build a factory between that Palace and the ornamental water?
>
> " You lack taste or else you have too much of it, which comes to the same thing. Whereas in my opinion, Russia's mission at present should be the liquidation of that outworn art, those antiquated concepts, that moral tone, and, in short, that civilisation.
>
> " Believe me, it would be well for humanity, if all books were destroyed: if we bathed once more in the cold, clear spring of ignorance and instinct. I even think it is the only way to save humanity from the sterility that has overtaken it. But we shall never achieve it other than by violence. This war and the shocks which it has given rise to, may possibly precede that first stage, the nudity of the world."

And yet, Comrade Toukatchewski, your photographs show that your soldiers keep better step in 1928 than they did in Nicholas's time, when I saw our allies shambling along the streets of Moscow like flocks of sheep. Your soldiers march past Lenin's tomb in uniforms à la Française, steel helmets on their heads (also à la Française). And they " line up " perfectly. My compliments. It is the classical structure. Are we to think, Generalissimo, that your soldiers have disobeyed orders?

And in a cubic mausoleum, much more geometric than Versailles (what

* This Generalissimo was replaced in 1928.

a tick this geometry is!), the body of Lenin, embalmed, rouged, and painted, lies under glass, offered to the eyes of Believers, like the wax figure of Little Sister Saint Thérèse at Lisieux. You see, comrade, there can be no fruitful revolution without order, by which I mean without humanity. No order nor humanity without the geometric spirit. Which is not to say that the kind of order at Versailles is the only possible order.

I understand exactly. M. Toukatchewski, you want the paths of instinct to be reopened. You are an artist. But do not let us mistake the purge for the meal. Your " superannuated moulds," you apply indiscriminately to outworn usages, and the norms of our souls: but no scientific or romantic dialectic will ever change certain constants, and one prime need is Liberty.

Those who expect liberty from anarchy, hope chance will bring it them: what they find instead is sterile effort, vicissitude, blows and wounds to body and soul.

We experience a feeling of power when, with facility, some desire, concept, plan, ideal, takes form: for liberty, too, comes from the feeling of least resistance.

{ Our tropisms are categoricals to which we must bow, if we are to feel free.

Soviet Army, 1928, passing before Lenin's Tomb.

At times we have stifled them, and so, opposing them unwittingly, have hobbled ourselves. For the carrier-pigeon, liberty means regaining his loft: he would feel a prisoner if prevented from obeying his tropism.

First let us make sure our demands are eternal. Then we can relate our every act to them, attain a geometric happiness, the only one permitted us. In this manner we shall be like those birds who, when the aeroplane moves in the direction of their lofts, rest lightly on its wings: but leave it deliberately, freely, when the direction changes.

Man changes little.

*

SUCCEEDING epochs do indeed in some slight degree add to our eternal needs, but what has modern man contributed to that abiding duality Love and Death? Everything gravitates between the poles of their magnetic field.

We love. Do we love more tenderly than Philemon, more madly than Anthony? Is our anguish deeper than that of Œdipus? Or our faith stronger than the martyrs'? Is our questioning deeper than that of Parmenides, Heraclitus, and, more than all, of Protagoras the sceptic who, long before Kant, taught that absolute truth could not exist, that all was relative to our senses? The only difference is that thought has acquired new technics for more conveniently translating eternal thoughts.

The man of action has not envisaged ambitions vaster than those of Alexander or Cæsar. We cannot imagine moral codes very different from those of Christ, Epictetus, or Sakya-Mouni. Even our bodies differ hardly at all from those of our progenitors 300,000 years ago. One day some Egyptian fellaheen dug an ancient Egyptian statue out of the sand, and thought they recognised the image of their "mayor," and called it the Sheikh el Beled.

General Mangin had a head like a Pharaoh. In every gallery of Roman sculpture will be found life-like portraits of our politicians; and we have all met living images of the mummy of Rameses. How many ARSINOES among our chorus girls, Cretans and Egyptians in the clothes shops? One of my school-fellows is the speaking image of Cæsar: he sells wireless sets on the Riviera.

The "medical board" of Sparta must have been appreciably similar to the boards that select Rugby teams. The nudes in the private or public harems of all the countries of the world could perfectly well be interchanged. The Venus of Willendorf would not disgrace a democratic *lupanar* nor the charming little thing of Brassempouy those of higher standing.

Our masks hide Man, man throughout the ages, unchanging.

Eternity. Time is harsh, harsh are our difficulties, harsh our toil: yet when we read this text our hearts soften.

Order at the service of Liberty.

Copenhagen Prison.

ETERNAL

MAN

(see p. 186)

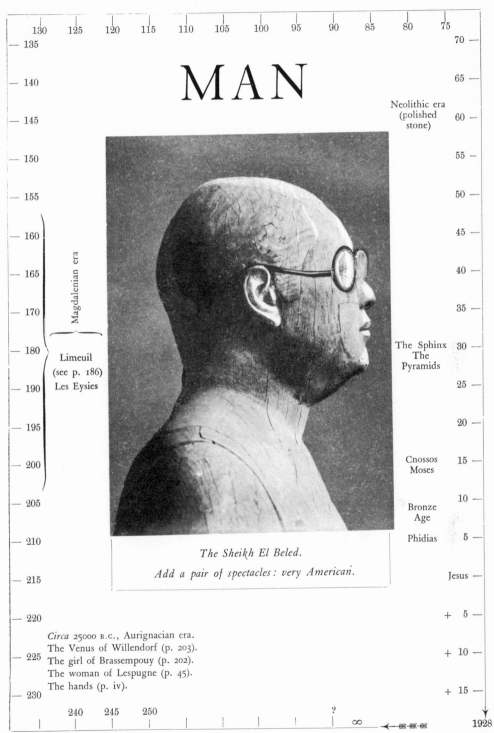

130 125 120 115 110 105 100 95 90 85 80 75	70 —

— 135

— 140 65 —

— 145 Neolithic era (polished stone) 60 —

— 150 55 —

— 155 50 —

— 160 45 —

Magdalenian era

— 165 40 —

— 170 35 —

— 180 The Sphinx The Pyramids 30 —

Limeuil
(see p. 186)
Les Eysies

— 190 25 —

— 195 20 —

— 200 Cnossos Moses 15 —

— 205 Bronze Age 10 —

— 210 Phidias 5 —

The Sheikh El Beled.

Add a pair of spectacles: very American.

— 215 Jesus —

— 220 + 5 —

Circa 25000 B.C., Aurignacian era.
The Venus of Willendorf (p. 203).
— 225 The girl of Brassempouy (p. 202). + 10 —
The woman of Lespugne (p. 45).
The hands (p. iv).
— 230 + 15 —

240 245 250 ? ∞ 1928

This frame enables us (very approximately) to situate in time the presumable dates of prehistoric works of art. Each section represents five centuries.

"*Give twofold the loaves thou givest to thy mother; succour her as she succoured thee when thou wast born; after many months still she bore thee on her shoulders, and her breasts were to thy lips for full three years. Thy excrement hath not offended her, and never hath she said: Why dost thou so? She led thee to school in the days of thy learning, and waited without for thee with the cakes and ale of her house. When thou shalt be grown and have taken a wife unto thyself, to thine own house, cast back thine eyes to the day thy mother bore thee. . . . Give unto her no occasion to reproach thee nor to raise hands in supplication unto Almighty God: let Him not hear her complain.*" (The Scribe Ani.)

*

Modern Revolutions:

"*The Great hunger and are in distress. Those who served are today served. Women of noble family flee away, their children prostrate themselves, fearing death. The rulers flee away; their high positions have been taken away from them. . . .*

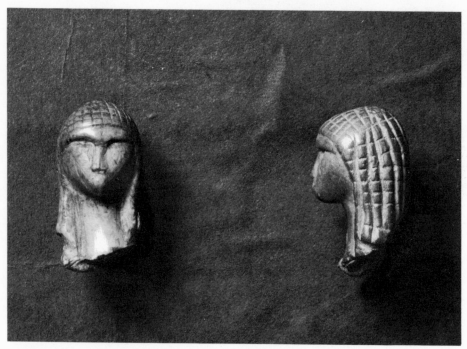

The Prehistoric Girl (?) *of Brassempouy (circa* 25000 B.C.).

The Prehistoric Woman of Willendorf (circa 25000 B C.).

"The poor of the land have become rich and the landlord is destitute. Behold what has come to pass among men, for he who had not the wherewithal to build one room even possesses nowadays lands surrounded by walls. The Great toil in shops. Their ladies suffer like servants. . . . Their food is doled out by slaves who are now their mistresses; when these mistresses speak it is painful for the servitors to endure. Their flesh is mortified because of their worn-out robes . . . their hearts are overwhelmed should one salute them. Nobles, great and rich ladies, prostitute their children, and he who slept alone because of poverty now finds noble women . . . The son of a man of quality can no longer be distinguished from others; the son of the mistress is the son of the servant. The butchers give false weight."

Newspaper reporting?　No, an Egyptian text of the epoch of Memphis. Here are three hymns to the sun. The first is by the Pharaoh Amenophis IV Akhnaton:

"How gloriously you rise on the sky's horizon, O Aton, inspirer of all life! When you appear, round and glowing on the horizon, all the earth is filled with your beauty. Your rays spread upon all the earth and all that was created by you. . . . You have filled the two-lands with your love, O magnificent lord who created himself; and all that is on earth, and engendered what exists upon it, men, the brute creation, and all the trees that spring up from the soil. . . . When you sink to rest beneath the western horizon, earth lies in the darkness like one dead. . . . The two-lands rejoice, men awake, and spring to their feet, for you have caused them to rise. They wash their limbs, put on their clothes. Their hands adore your rising; the whole earth begins its toil. . . . From your very being you draw out the myriad forms of life. . . . The ships sail up and down the rivers. . . . The river fish leap to you; your rays penetrate into the deepest seas. . . .

"You call into being the infant in the woman and create the seed in man; you nourish the infant in the womb, you calm it and still its crying, you nourish it by the breast, you give air to animate everything by you created. . . . You created the earth according to your desire; you alone, with its men, its domestic and savage beasts, all that lives on earth and walks on its feet, all that is in the air and flies on its wings. . . ."

*

Egypt.

Now turn to this verse from St. Francis of Assisi (twelfth century):

" *Be thou praised, O Lord, for all Thy creations,*
More especially for our Brother the Sun,
Who bringeth forth the day and givest light thereby,
For he is glorious and splendid in his radiance,
And to Thee, Most High, he bears similitude."

And now read yet another hymn of praise to the sun:

*"Nothing on our earth takes place without its intervention.
It is the sun which, penetrating deep into the waters of the sea,
breaks up the drops and renders them invisible, and sucks them
up into the sky, where, left to themselves, they coagulate into
clouds; which also, by unequally warming the diverse regions of
the globe, causes the winds charged with clouds to be born, from
which fall the fertilising rains, thanks to which life was able to come
into being upon the land; which also in the living substance of
the vegetable kingdom has created the green of chlorophyll. . . .
In the ocean as on earth all depends upon it. Innumerable green
microscopic algæ float on the surface in calm, clear weather. They
come to the call of the sun, for by its aid they manufacture those
food products which stimulate them to reproduce themselves, and
they are themselves the inexhaustible provender towards which
swarm the prodigious legions of infusoria, fragile larval forms, the
all but microscopic marine creatures of all sorts, worms, star fish,
sea-urchins, tiny crustaceans who make up the interminable cohorts
of Copepods . . . upon the surface of the sea that is inundated
with sunlight. But should the sky cloud over, and wind raise
waves, agitating the surface, which because of all the floating débris
is robbed of its transparency, the plankton retreats from the now
tainted surface and descends into calmer zones, taking with it all
those creatures who live at its expense, so that the herring, sardine,
mackerel disappear. The fishermen are unable to earn a living,
and their complaints reach as far as Parliament. And all this is due
to the sun."* (E. Perrier, Curator of the Natural History Museum,
France.)

Three hymns from the same bin: mankind changes but little.

Caracalla revolts us: Christ's ingenuousness charms and softens us. We
have to take hold on ourselves not to feel the sacred terrors that primitive
man felt in storms. The sea tranquillises us: we react to the desert as the
nomads of prehistoric days must most certainly have done. Look at the
photographs of any man whatsoever looking out at the desert of the
Pyramids, and you will always see the same expression: eyes fixed on the
infinite: the emptiness of everything.

Our analytical nineteenth century did its best to cut everything up into
morsels, to give special prominence to detail and variation, to lose all sense
of the general in favour of the particular and the exceptional; and yet, men
remain no less men, with the same eternal psychological make-up, the

D'Annunzio.

Mummy of Seti I, Thirteenth Century B.C.

WORK

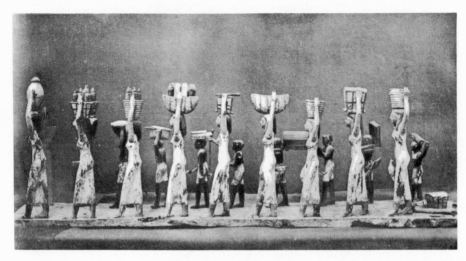

Egypt.

Russia.

Egyptian and British Armies.

same main arteries (for the little streets and newly built blind-alleys matter little to them).

Men are different from each other, but much more similar than different. Which is what enables Great Art to be eternal.

Had we really changed much, how could we still be moved by the expressions, thoughts, and arts of the ancients? Can it be denied that there are very many more ancient works of art to move us than modern ones? The blind excepted, how impressed we are by the masterpieces of Egypt, how moved by those of Greece, how amazed by those of Rome, how charmed by those of the Renaissance, and after all is said, what depths of emotion are evoked in us by the immemorial sgraffiti of prehistoric caves!

I am sorry that, in a book whose chief object is to deal with art, I seem always to be going off at tangents: but the ideas thus expressed have a real importance. What would our art be like if the works we produce with so much difficulty were to have the duration of a hat, say? But it is reassuring to know that, when they are founded on the deep constants of heart and soul and mind, they must be eternal.

Have our tastes even been sensibly modified? We fall easily into thinking it particularly modern to be capable of appreciating the implacable precision of some fine piece of mechanism, a ball-bearing, say: yet is

German Toy, 1928.

such appreciation in any way different from the impulse that led to the polish of a stone axe, or the gleam of basalt, or the covering with burnished gold of the tops of obelisks, or the casing of the Pyramids in smoothest marble? The columns of the Parthenon were so perfectly smoothed that even today a finger nail cannot catch in the joints of their drums. It is easier to satisfy love for perfect workmanship nowadays thanks to the co-operation of machinery, and that is all. The love of perfection, exactitude, high-speed production, efficiency, is eternal. (Bad workmanship may have been deliberately invented by certain modern artists. That only bears wit-ness to an individual decadence.) Are such virtues specifically racial? No.

August 15th at Antibes. Here are men and women from Provence, Italy, and afar: eating, dancing, embracing: sleeping or fishing, as in all places on holiday. And everywhere it is the same by the water's-edge, whether it be the Mediterranean, the Volga, the Guadalquivir, the Seine or Marne. The sun sinks, and all, Northerners, Southerners, Westerners, Easterners, fall silent. Racial differences? No!

My neighbours (an Italian group and a group of Frenchmen) stop fishing and begin to wind up their lines. Each group naturally has its photographer, desirous of fixing for eternity the glorious day that is ending. The French fishermen unwind their horsehair lines and, looking professional, pose immobile, their eyes glued to the float. Fired by this

Egypt.

example, the Italians also begin to pose for their portraits, perched high on rocks, their hats at rakish angles, their eyes fixed in the distance: but they do not unwind their lines, because they realise that they are too fine to show on the photograph.

There you have a difference in race; a very small thing. Try and take their women from them, and you will see whether fundamentally they are different.

The flutes of the Neolithic Age played the first four notes of the diatonic scale. . . .

It was in Seville, listening to the old gipsy Nina de los Peñes, that I learnt what tradition really was: the résumé of the innumerable experiments of successive generations. Perfect solutions (for which reason they should not be interfered with:) human, and expressing to perfection the most universal feelings. That is why all traditions resemble each other almost to the same degrees of temperature: they are like humanity, and, like it, are eternal.

A last conclusive proof of our basic eternity!

At certain of my lectures on modern art I successively projected different masterpieces on the screen without any attempt at order, and without attributing either date, or school, or artist's name to them: as, for instance, Seurat, the Egyptians, the Cubists, the Greeks, Cézanne, Negro Art, Michael Angelo, the incised carvings of prehistoric caves. A few specialists realised what I was doing, but the majority of my audiences thought it was all modern art. It is quite natural and most reassuring. Masterpieces are always modern.

Trepanned Skull from the " Caverne de l'Homme Mort " (Saint-Pierre des Tripiers, Lozère).

Note: *We know that prehistoric man had a good deal of surgical knowledge, and that his trepanning operations were successful, for certain skulls reveal evidences of post-operative healing.*

MAN
TODAY

Clock for Time-Transmission by Wireless.

OUR main needs are eternal. Nevertheless, an abrupt change in environment and social conditions has suddenly endowed man with new needs. I speak of town dwellers: for even today in Russian territory, or the heart of China and Africa, and, even less remotely, in villages everywhere, the world has hardly changed at all: at least not since the epoch of Les Eysies. We are born, and our business is to eat and reproduce our kind. Work is interrupted by long periods of repose due to intemperate weather. In the past one went out simply and patiently to hunt a bird or animal: then a projectile brought down food sufficient for oneself and one's family for some days. Or else a trap was set and one waited. There must have been some good gossip round the fire. People must have slept a lot. Mouths were very close to the earth.

> "*Game was available in immense herds. Never, perhaps, had the men of the epoch which preceded the cultivation of cereals had at their disposal such an abundance of food. As an example merely, I quote the inconceivable accumulations of horses at Solutré in the Post-Glacial epoch:*
>
> "*The skeletons of 100,000 horses were found there.*
>
> "*Game in the Europe we know has become very scarce and hunting something of a luxury; as for fishing, it exists as hardly more than a name: but when new countries are explored in which the wild animals have not yet learnt to be timid, one begins to get some idea of what the resources of our country must have been before civilisation practically wiped them out. Every kind of game, large and small, existed in the utmost abundance, and our rivers were full of enormous fish, to such an extent that a very few hours would have sufficed to procure large quantities of food. Thus the caves, as well as the sites of prehistoric camps, are full of bones which have been broken in order to extract the marrow, and the remains of fish. The conditions of existence were very different from what they are today, and the scattered populations could win their sustenance without undue exertion. . . ."* (Jacques de Morgan.)

As for carnivores, they could hardly have been dangerous to man, given that immense profusion of inoffensive horses. (But to make up for carnivores we now have man, and meat is scarce.) It is the scarcity of food that makes our own times so difficult to live in, and our attitude to life is the result of that struggle. What a difference there is between the life of a hundred years ago and life as we know it!

In capital cities it has become a veritable battle. There is so little time. Many work with the energy of a Napoleon, considered a remarkable

phenomenon in his own epoch. In those days armies regularly reached the field of combat a day late. We can only conclude that if battles sometimes did take place, it was because both sides were equally unpunctual. Bonaparte's genius lay in inventing punctuality, and the day that Grouchy did not keep to the time-table was the day that finished Bonaparte at Waterloo. A new era had begun: speed, exactitude.*

If our deepest needs have hardly changed, our present needs, for the most part material, have been added to them. To satisfy them all we

must submit to the exigencies of our environments: unremitting toil. Think of all the gears that have to be set moving in order to gain money, that indispensable relay.

The rhythm of life has accelerated terrifically: everything is precipitate. We never really stop, not even for Art. In 1830 the stout citizen of Haarlem, say, having supped at five, would go off tranquilly to listen to a fugue at the house of friends. There was no hurry: he had sold a few yards of cloth at a reasonable profit, which assured him the means of livelihood, and some day enough to retire on. No big " deal " could bother

* *Records: Automobile, 373 km. an hour: aeroplane, 513 km. an hour: automobile, twenty-four hour average, 182·66 km.*

him, and once his shop was shut, he could enter calmly into the serenity that is needed to listen to certain slow movements of Beethoven without nodding. Beethoven is often after-dinner music (but dinner at five), whereas we dine exhausted at eight or nine. Nowadays, on the evening wireless, it is really quite a pleasure to hear a good Charleston. (Where the immortal Mozart is so amazing is that he never sends us to sleep.) In painting, in literature, we ask today for stimulants that will make us jump : luckily, brief and energetic things can also be profound. It is a safety valve of the deepest importance to us.

For fifty years now, the new mechanisms have gratified us with valuable commodities (at least when we need them so much that we cannot do without them). But a crisis is imminent, for comfort has to be paid for by laborious toil. Mechanism has developed faster than ourselves, and society, swept into its precipitate rhythm, is already following with difficulty. When a new gadget enables an engine to run at higher speeds, it generally makes it vibrate excessively, and then break down. The designers do not always succeed in making the necessary adjustments in time. Where it is a matter of motor or aeroplane engines that are being driven all out (their work depending directly on the number of revolutions), those which do not vibrate excessively are practically non-existent, except for a very few specially constructed racing machines that have cost fortunes. Speed leads to complication : everything becomes clockwork : and a speck of dust can stop the miracle. Our society is being forced, and revolutionary agitations demonstrate the fact that, even as regards society, the speed it runs at cannot be augmented without risk. These social " vibrations " prove that not everything is for the best as far as the individual is concerned, and also, that " progress " is primarily a revolution, adaptation to which must be slow. Such adaptation calls for very strict discipline, which is quite opposed to individualism.

In our present stage of development mechanism hinders more than it helps. There was too much leisure in the past, today there is practically none. A friend of mine claims that we haven't even time to realise whether we are happy or not.

There is excuse for ranting against the difficulties of existence : for regretting the leisure hours we had in which to potter round. The pessimist sighs : " Ah, the good old days when we went to the office or the studio in the joyful morning sunlight, to the measured progress of the bus-tops in a Paris that looked like a print. But nowadays it is the Metro Underground : motor-buses : automobiles which convey us in one brutal flash, that tires us even before we have begun the day's work. Think of the effort to get some Sunday rest ! Thirty miles of cars packed close on all the roads out of Paris (and what will it be like next year, or ten or twenty years hence?)."

Clearly, toil in the great city has become something deadly serious now-adays. Machinery helps us. By doing speedily what we did slowly it gains time for us, but the conditions of modern life do not permit us to enjoy that leisure idly. If a calculating machine can, in a few turns of a handle, do as much work as a good old ledger-clerk, the way society is geared arranges that the time saved must be devoted to fresh labours, which have also to yield their maximum. Far from relieving us mechanisation compels us to live in conditions of great tension. But think how much we produce! Such efficiency, for those capable of envisaging its pos-sibilities, makes possible a vastness of activity that *is* something new. A thousand levers are put in motion, and the productivity of one man is immensely multiplied. Not everyone, however, has the capacity to handle a modern organisation. The heads of business, the organisers, must unite in one brain all the talents that in the past went to make great men. Not only the particular qualities that made generals, but also encyclopædic knowledge, the ability to direct, the eye for possible developments, diplomacy, perpetual foresight, creative impulse. Immense effort! A Renault, a Citroën, are true heads of the State. Napoleon was a sort of prototype of the modern man. The genius of Ford brought about the construction of factories from which, in nineteen years, have issued 15 million automobiles, 300 million h.p. Six hundred thousand workmen depend entirely upon them and indirectly 3 million individuals. Citroën already employs 30,000 work-men, and his shops have been in existence eight years only.

Some people see everything in sombre colours. Nothing in the world is perfect, yet there is room for rejoicing in the grandeur of this age and its immense possibilities! After all, it is reality.

Time, which rules and regulates everything, is the new discipline which we obey and by which we are modified. To economise time necessitates convergence of effort and obedience to natural laws. Modern efficiency constrains us to behave in a manner that conforms to the physical laws of the universe. Man is no longer that ancient vessel drifting aimlessly at the mercy of calm or stormy seas, but a cog geared into the fundamental laws of the universe. Mass production has led to the desire for perfection: it can be seen objectively in the best specimens of the modern output.

I have stressed particularly the differences between man of today and man yesterday, and have shown how the former is differentiated from the latter by the compulsion to precision, intensity, speed.

Compulsions, through force of habit, speedily create new spiritual needs. Because our trend is towards formal perfection, this age more than any other is one of organising, for perfected apparatus is accustoming our senses to precision.

As for our æsthetic sentiments, even these are being modified. For

Growth of Speed in the Hundred Years 1828-1928.

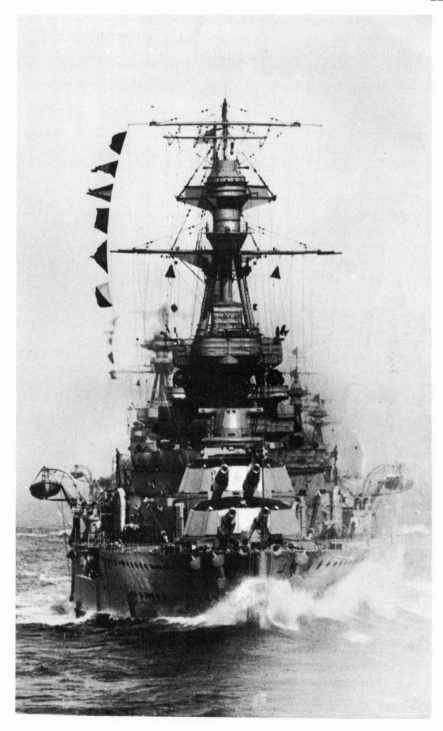

example, we no longer willingly inhabit sombre houses, we like seeing all the extent and every corner of our shells. Our clothes are clean cut, even woman's: we shave, they cut their hair. Things that are indefinite, misty, bore us terribly. All inexactitude troubles us. We have noted that the profound, the unavowed malaise of the thinking man of today, comes from the impossibility, for him, of knowing his destiny, and that to combat his suppressed anxiety he demands that phenomena shall be precise so that they may mask reality and be a substitute for it. Thus Art must be more dogmatic than ever before, and more precise: for without precision it is impossible to be dogmatic. It will be obvious, then, that to fulfil such a mission, no vague empiricism or wavering traditionalism will serve. For which reason the study of biology, psychology, and the profoundest analysis of how things function, helps to a more exact understanding of the complex mechanism of modern man. But only too often we get no further than the veriest groping. I am aware that on the question of Art it would be difficult to say anything more disagreeable than what I have just said. I appear to be interfering in something that does not concern artists.

"The artist is inspired . . . why oblige him to make an intellectual effort which he only too easily foregoes? What is the good of having genius if one must be laborious too? The Old Masters knew nothing, and yet they produced masterpieces."

Michael Angelo, Leonardo da Vinci, Signorelli, Piero della Francesca were scientists. And then also, a change has taken place.

It has often been repeated, and with justice, that Art is the most important achievement of a civilisation. In the past artists were often content to be artisans. But nowadays, since the artist wishes to be judged on all fours with the scientist, he must take his stand accordingly. We are at the most difficult point of the road. Art can become a summit, dominate Science itself, but to merit that pinnacle its manifestations must be quite exceptionally efficient. . . . And to achieve it, all the forces of precision must be brought into play to serve resources as universal as possible. Alas! we know exceedingly little, but is that a reason for depriving ourselves of the help of the little we do know?

It frightens me to see the habitual resistance put up by artists, as soon as there is any question of investigating a subject that does not bear immediately on their art. Art would perish solitary if it did not draw its sustenance from all our needs, including the loftier ones.

The spectacle of contemporary life is so astonishing that it makes the "empirical" creations of most modern artists seem anachronistic. If this goes on, the artist will soon be looked on in the astonished and pitying way we regard an old artisan who carves a rose on a wooden clog and is awfully pleased with himself. Such Diplodocuses will be the rare ethnographical

specimens in the museums of the future, demonstrating the survival of hypertrophied organs and primitive gestures that fulfil no useful purpose. They will be put under glass or preserved in alcohol among the other fossils. We have all but arrived at this already. You artists should realise it. Your influence could be greater than ever, for the need for art is more poignant than ever. But we ask for sports cars, and the majority go on giving us sedan chairs. Beware of bankruptcy. Look how painting has already been parked in corners and classified with antique clocks, old vases, wax flowers under glass. You can smell the decay. That is why people turn away from it. They want their illusion compact, powerful. If they could afford it they would buy a supercharged six-cylinder or a Bugatti. Our modern "tonus" calls for efficiency. Speed draws together. There are no more antipodes.

Can we really believe any longer in the existence of frontiers as regards ideas? Can we really go on working only for a chapel, a school, a clan, a group, a province, a nation? And not for all races: mankind in fact? Away with insularity. Each race has its proper genius and must exploit it for all races. Such an art is possible, because all men react unanimously to broad daylight or full night, or red or black, or love or death, etc.

✳

THE LIFE

OF THE

ARTIST

TODAY

ART, let us admit it courageously, manifests certain symptoms of fatigue. Fatigue or disharmony with life?

There is divorce between Art and the real values of the age.

Our resources are amazing, for are not all human intelligence and energy concentrated on perfecting technic? Inversely, art often comes into being as play. I write thus because I do not like to see certain fashions of our epoch left as blemishes upon it, for neither cosmetics nor fine phrases will ever dissimulate them.

The artisan has climbed high, but the artist is becoming an artificer.

The engineer is well educated and can talk learnedly about mechanics and many other subjects, but the artist has become a sort of machine without a driver. The result is a somewhat specialised sort of art, but there is every likelihood that one day the alarming question may be asked, "How, in an epoch so rich in invention, could art become something so limited and temperamental?" No doubt some great cataclysm will be invented to account for the anomaly. Archæologists suppose a similar cataclysm when they seek to explain the following anomaly: The Magdalenian age produced beautiful works of art and rudimentary implements, but the age that succeeded it is characterised by fine implements . . . and mediocre works of art! Prehistorians assume that the Azilians, with an equipment technically efficient, killed off the artistic Magdalenians. In our own day it is simple enough. No one has been killed but the lowering of the level of art comes from the artist's imbecile pleasure in the eggs he lays.

The artist depends too much on his *Gift*.

That Gift is merely a disposition, a predisposition, and we know the immense wastage of seed in nature.

A seed needs a certain environment and temperature, otherwise its potentialities are lost in the cemetery of unattainable possibilities. The air in which this " gift " can breathe is that of the great and noble (and ten hours' work a day).

The only efficacious " gift " is the will to elevation : a special tropism. No doubt we all have it, but it is as fragile as an oak sapling. The overwhelming proportion of failures of the " so-gifted " comes from the fact that they imagine the " gift " itself to be sufficient. Besides, it is an error to think that only " born genius " can lead to great destiny.

Training means activity and thought so often repeated that finally they are completely integrated and capable of being called upon at any moment to function adequately, the impulses arising from them leading to exactly the same consequences as those of the inborn gift. Think a moment. A child of the mountains knows naturally how to climb, but are mountain peoples the only good alpine climbers? Training gives us results equivalent to those of talent.

Talent results from efforts that have been made to converge to one end. All that counts is the impulse, and it matters little whether it comes from predisposition or a built-up ideal.

Talent in art is the innate awareness of what is great : or equally, the acquisition of such consciousness. In each case the result is identical, the prime cause being indiscernible.

Cézanne, if judged by his earliest works, had the talent to become a Delacroix or Courbet : Wagner, Meyerbeer : Debussy, Massenet : but finally, by means of will and effort, they acquired the talent to become Cézanne, Wagner, Debussy.

Our creations are, in the first place, ourselves. Ourselves, *i.e.*, the mechanism which creates the work. Let us build up that self, find ourselves again. Little by little we shall become, with time enough, what we have wished to become. Let us follow the deep impulses of the heart, and lay our intelligences under contribution to perfect that secret machine which does the creating in us. Let us carefully devise and direct our acts, for the past we create for ourselves (our unconscious being the integration of those acts within our deepest nature) shapes our destiny, determines it, and gives us our inheritance. I would say that Fate exists, but that we are responsible for it.

We do not at first " go off," make what we wish.

For our painting, writing, thinking, to have validity, we must first

and foremost get to work upon ourselves. And thus with creation. We must deserve it.

We are the fathers of the men we shall be tomorrow. Usually we treat ourselves like benevolent friends . . . let us be our own chiefs, severe, respected.

Creation is led up to by each moment, every gesture of our lives : not by a sudden decision. It is the degree to which, little by little, we have raised ourselves, that brings us level with certain heights. No one can leap from the foot of a mountain to its summit : it has to be climbed : yet the necessary muscles have to be trained, and there must be the desire to achieve it.

We have already agreed on the necessity to organise and crystallise our lives round an ideal. Such a crystallising should have as its object the creation of an art worthy of a great civilisation. Let us create this image within us.

We know through Freud the extent to which our unconscious determines everything in us. Our Psyche, ignored by us, governs our acts. Freud reveals to those who suffer from it their interior dictator. This Imago of the sick has among adequately adjusted people a healthy sister, an Ideal, but so successfully integrated in our unconscious that it governs after the fashion of the Imago. The Life Force ! An irresistible compulsion occupying all our existence, the fruit of which is perfect creation. Young artists, lose no moment, rely on the constants : the profound idea of Beauty is not to be toyed with. Understand clearly that only those acts which merit accomplishment are in harmony with noble deeds : learn early to love what is great, very great : thus will grow within you that rigid orientation which, vitalised by every act, will eventually become a second nature. The fecund Imago will bar the entry to those accidental and sterile images which seek to enter into empty places. It is not in our power to avoid every grief, but we can close our hearts to spiritual wretchedness. And, in difficulties, the certainty of having always lived in the service of an integrated ideal, will maintain our structure intact against the destructive onslaughts of remorse.

An incised stone thousands of years old, reveals to us that on the banks of the Vézère once flourished a great civilisation.

Certain artists are satisfied to minister to our minor needs. But within us still thirst desires, which only the greatest and most noble artists can refresh. To be pure in heart is what we must strive for : the aim of art is beauty, beauty in its every form. Taine said : " Ugliness can be beautiful, but beauty is still more beautiful."

Let us live our epoch, but beware of attaching importance to the vogue, needs of the moment, which last but a season. The vogue appeals to fugitive tastes, pleasure : it passes away like leg-of-mutton sleeves and " Valencia,"

with the difference, however, that "Valencia" will always be a pretty little tune, while the fashion soon becomes as dead as mutton. The vogue is always what is pleasing, but the aim of art is not in pleasing. It may seem absurd to many people to look at things from my point of view: that of labouring with a view to the opinion of men not to be born for centuries. Let it! That same ambition was no doubt common to all who still mean something to us.

If the efficacy of this eternal ideal has been properly understood, and everything is made to converge upon it, how can life ever be wearisome again? It becomes a wonderful voyage!

Our support, our plans, our foundations: the eternity of our constants. Upon these we buttress our efforts, anchor our spirits. We must learn to listen to our tropisms: they have cried out so long unheard that now they are exhausted, silent.

Let us accomplish only such acts as are desired by our most fundamental impulses, motivated by high ideals. Fortunately, we are so made that, unless we absolutely insist on going wrong, crashing our gears, snapping the levers that direct us, we are imperiously made aware of certain impulses that call to us. And among them, in charge, is the desire to create. It would seem that the need to elaborate creations that shall be solid comes from our uncertainty as to what is beyond. Great men have been those who meditated, and, meditating, realised how ephemeral they were. The stronger the consciousness of being ephemeral, the stronger was the desire to survive. Thus we have creation.*

Art calls to us with its noble voice. The bee seems to obey a duty in organising its perfect cells in which to store its honey. Let us listen to the bees that murmur within us, for reason alone is not enough to make us act, but an inner need which we must learn to listen to, or wake if it sleeps. We are conscious that action which leads to worthy deeds will aid us joyously to pass through life. Living is an art. With identical bricks some build their happiness, others their despair.

I listen to my heart and its desires. I listen to the needs of my spirit. What was fugitive I have done my best to cut out, for I love that order which helps our belief in the eternity of things and ourselves. I am glad it is transcendental. Who can prove I am in the wrong? I rake over my little garden and pluck up the pretty plants that venture to grow outside the flower beds: I sacrifice them, though sometimes with regret. I resist for a moment, but in the end I tell myself it is better so. I look, I listen, I feel. I perceive, I apprehend, I make my deductions: I build, I adjust, I polish my structures. I strive to regulate my activities so that they

* *To strive to leave behind a complete image of himself is the one vanity that can be pardoned a man of lofty spirit. (Bernard Grasset.)*

shall be mutually related and adapted: yesterday's prepare tomorrow's. (Naturally, it is difficult sometimes: there are, of course, set-backs.) Happiness is the conception we build up of it.

Up to forty " running wild ": but after, one may hope to do good work.

Yet what most frequently remains of a man after that age? His level falls? How tragic is the spectacle of a mature man who can push his creative effort no further! Nowadays a man is generally finished when he ought to be ripe. To have learnt so much, and lived and suffered and sometimes toiled so much, and to have succeeded merely in losing every possibility of ecstasy. To have spent so much to find oneself dried up, defeated. And yet it is very possible to know how to control in oneself, those doors which open on the miracle of the universe. All that is required is to ward off sclerosis from our innate powers by the wisdom that will not tolerate blinkers. Never must the mystery of things be forgotten, for from it springs all art. And it is deeper for the aged than for the child. But only for such aged as have not been brutalised by the stupid conviction that they know everything, having lived long. And if that life was ill-spent? Stendhal said: "The proximity of the sea destroys all pettiness." The sense of mystery destroys all complacency. Cherish it.

Raphael had said everything at thirty ,and was already going to pieces. Mozart grew greater all the time. Would anyone have taken any notice at all of Michael Angelo's earlier work if he had not been tremendous as an old man? Cézanne died, his message uncompleted: Seurat disappeared young: what a tragedy! Renoir's greatest works were painted by limbs that death had already invaded. Delacroix, Ingres, Beethoven, Tintoretto were no exception. And how natural it all is! A great man succeeds in making himself so, labouring his gift, at every instant creating himself: the longer the work continued, so much profounder grew the man: his *opus* is but a consequence of that protracted effort of creation of himself by himself, his art bears witness to his incessant improvement or deterioration. It was while standing before Rembrandt's last painting, " The Return of the Prodigal," that I grew convinced of this law. Last wills and testaments are not written at the age of twenty.*

* As this work ended I made acquaintance with Élie Faure's last book " L'Esprit des Formes," and found therein the confirmation of my own position. He writes:

" No one has ever asked why, for example, the period in which a musician produces his finest work, and, above all, the writer, should nearly always be between his fortieth and fiftieth years; whereas nearly all the great masters of painting, the education of the brain by the eye being slow, difficult, and entirely dependent on its own efforts, have produced their finest works only after their fiftieth years, and, in cases where they lived into extreme old age, improving always in technique, and the exercise of their powers. Among the former, think of Veronese, Rubens, Rembrandt, Velasquez, Poussin, Delacroix, Cézanne; and among the latter, of Cranach, Franz Hals, Goya, Hokusai, and the sublime examples of Titian and Renoir.

What grandeur there is in these works of men, who, seeing death approach, but living great lives, renounce nothing, and go on toiling for posterity to the very brink of the grave! A whole life is concentrated there!

Some are of the opinion that such a scheme of living would be desirable, but impracticable in a society like ours, where conditions are so difficult for artists. What is difficult nowadays is to be the dilettante, the drawing-room artist. But if the artist could turn his days into a carefully divided garden: for example, kitchen garden in the morning (some paid activity): it would be possible to keep his afternoons for palaces: eight splendid hours of work for art. (It would be advisable also to save from the morning gains the sums necessary for efficient technical organising by which to make up for time lost in the morning.)

The ancient Jewish writ laid down that every intellectual was to practise an occupation other than that of the spirit. Law most wise! St. Paul was a tent-maker, Spinoza polished lenses. Other instances are Leonardo da Vinci and Michael Angelo working as engineers, El Greco as an architect: Montesquieu was a jurist, Balzac a printer, Bossuet a prelate: Buffon, Goethe, Lamarck, naturalists: Berthelot, chemist: Taine, Renan, Michelet, Henri Poincaré, professors. Paul Valéry had a clerical post at the Agence Havas, Barrés was a deputy. Claudel and a number of young writers like Rubens and Chateaubriand are diplomats. Stendhal was soldier and consul, Descartes officer, Beaumarchais financier, Shakespeare and Molière actors. The list is a long one. One even asks oneself if many great creators existed who practised nothing but their arts (after mentioning Philip, architect of the Escurial, who was also king, St. Thérèse d'Avila, poet and saint, and Villon, thief).

The artist, at least at the beginning of his career, should protect the liberty of his art by work which is as remote and different as possible from it, so that nothing in him shall be injured. Some think it is time lost. But it can definitely be affirmed that work that consists in paying court to critics, picture dealers, and amateurs of art is no less so, where art is concerned.

" When I sought to choose out some painting from Titian's old age to illustrate this text, I found myself faced with a strange difficulty. Having resolved to give only such reproductions as did not occur in my four preceding volumes of ' L'Histoire de l'Art,' I perceived that the paintings that did illustrate them, and which I had collected without any attention to chronology, choosing them uniquely in harmony with my preferences, had all been painted after the master's sixtieth year. The ' Doge Gritti ' at sixty-four, ' Paul III.' at sixty-nine, ' Salome ' at seventy-four, ' Diana Bathing ' at eighty-three, ' Education of Aurora ' at about ninety, ' Nymph and Shepherd ' and ' The Fall ' at about ninety-two, his self portrait between ninety and ninety-five, and ' The Passion of Christ ' at about ninety-four. And one of the nudes, referred to earlier, I should have liked to reproduce to demonstrate the radiant and spiritual youthfulness of the master's spirit as it approached its hundredth year. Failing it, I have chosen the dazzling canvas in the Prado which he began to paint towards his ninetieth year and did not finish possibly till he was ninety-eight."

MENS SANA. Many intellectuals look poorly. Hear Renan:

" Gymnastics, for instance, is considered by many as an agreeable change from mental activity. But would it not be more useful and agreeable to exercise the occupation of a carpenter or gardener for two or three hours, taking it seriously and with real interest, rather than tiring oneself with antics and unmeaning movements?"

*

CONCLUSION

HOW will art manage in the present state of drift? We are machines which demand attention and also special "instructions for use."

Talent is certainly less something inborn than the acquired capacity of knowing how to use oneself and perfect oneself.

Turn your day into a time-table, unvarying, implacable. However impulses may tempt, they must be sternly denied except in the time allowed for them. The artist too often believes that he must sit about in readiness for the kind attentions of the "Muse," but that amiable creature quickly learns to be in time for her appointments (as easily, in fact, as learning to miss them altogether). A discipline must be imposed on her. Inspiration is not a flame, like the Holy Ghost, but a potency gleaming in us like a night-light, which should glow brightly in working hours. We must train our inspiration, for it is ourselves always. The romantic conception of will-o'-the-wisp inspiration must be done away with; inspiration must obey. It does not care for processes of slow digestion nor little sleep; it likes best method, regularity, a jockey's regimen.

Inspiration has a just right to week-ends off. On holidays the eyes, the heart, the head, must be bathed in the light of plains, and the world contemplated. Our mother the sea, the blue of heaven like the scarves of miraculous virgins, the sombre green of oaks, earth's foundations. Return only when the sun's last ardours fade. That should be good for a week.

Realise that this age is a difficult one to please: it demands from art products potent to overcome and stabilise the feverishness of today. Production results from convergence. The focal point of convergence must be our ideal, placed so high that nothing can ever reach it or put a bound to our climbing. Some find attempts at breaking records stupid. If speed had a limit, it would interest us little: but speed has no limit other than that of

light, and from us to that. . . . Ideal speed will never be attained, but the impulse towards that infinite constitutes a lever that can never exert its full power. Men, like civilisations, enter on Decadence not when they have lost but GAINED their ideal.

When I sometimes begin to feel lassitude creep over me, I say to myself: " If one form of Asiatic wisdom is to teach that all is vain, and that one should be inert enough to make no effort, our Western wisdom is that knowing all to be vanity we must act to the best of our human capacity."

DISCIPLINE

OF THE ARTS OF

SIGHT

Painting, Sculpture, Free Architecture, Dancing*

✳

* What will be said in this chapter is applicable to Painting, Sculpture, Free Archi-
tecture, Dancing. There is one difference between Sculpture and Architecture and
Painting: the fiction of the third dimension. In dancing, the movement is real,
whereas, in the other arts of seeing, it is potential.

TO MY FRIEND

RAOUL LA ROCHE

LOVER OF THE ARTS

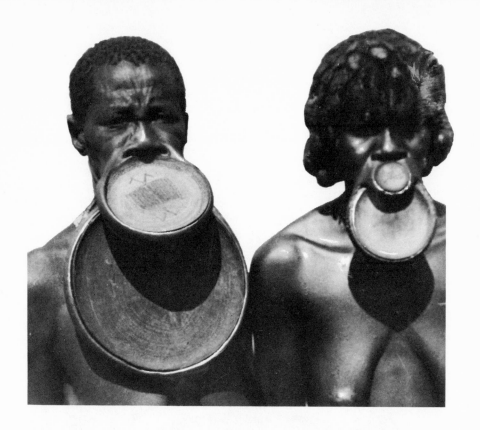

IN THE DAYS when men lived in caves, says the prehistorian Breuil, our ancestors perceived that:

> *"To prevent the implement sliding out of the hand, and to make sure of a good grip, it was necessary to modify the too smooth handle and introduce irregularity into it; whence the incisions on the edges, or the more or less deep striations on the plane or curved surfaces. But these incisions are not made irregularly: man had observed the pleasure to be drawn from the regularity of markings, and so he has been careful to make the incisions at regular intervals and parallel to each other, at times uniting them in recurring groups, the rhythmical arrangement of which he took pleasure in seeing."*

Here, very well described, you have the oldest æsthetic manifestations known to us.

Meditate a moment on these humble parallels. Is it decorative art? No, for the lines function organically. The essence of this art lies in there being no " art " in it. People use the expressions " decorative art," " ornamental art " very casually, a detestable custom in my opinion. Let us define:

Decorative art (ornamental or figurative) is a SUPERFETATION:

Lightning, Scrolls, etc., on a fine Specimen of a Condenser.

ornamentation or figuration inappropriately applied. A faun pursues three women round the rim of a plate on which a mutton chop reclines enthroned: ships sail towards a setting sun on a loud speaker: two saucers are inserted into the lips. . . .

Then those splendid Greek vases are works of superfetation?

Let us make ourselves clear . . . a fine and beautiful thing is never superfetation. Certain amphoræ even had no base. Useless for holding liquids, but useful because beautiful. A lyrical potter is a sculptor, an architect, a poet.

I am well aware that the Greeks put out utilitarian vases that were

Bowl by Paul Bonifas.

nevertheless ornamented. They did at times indulge a taste for the decorative: for bad taste. Decoration on a useful object is generally a transfer that serves no purpose: art should be put back in its place and utensils in theirs. Decorative art is done on drawing-boards and can be stuck on almost anything.

THE THREE TYPES OF ART*

1. ORNAMENTAL ART is the relating of non-representational form and colour. Sensation is its main object. The interplay of geometric shapes stimulates the intellect.

2. STRICTLY REPRESENTATIONAL ART is imitation; its ideal is photography.

* *The author uses the word " ornament " in a special and non-pejorative sense, as including also what is generally considered Decorative Art in England and America, while omitting all the petty activity of the decorator: flowers, birds, prettinesses, etc.*

The Roman Arch. Orange.

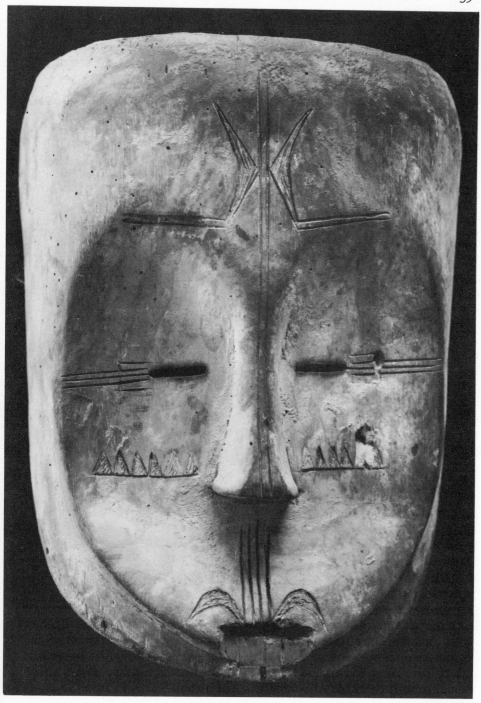

Decorative-Ornamental.

3. REPRESENTATIONAL-ORNAMENTAL ART. Here representation is treated as a simple theme, but this form of art tends more or less towards ornament, which endows it with a strong emotive attraction and gratifies our need for geometry: association plays a highly important part in it. Nearly all great art belongs to this category.

It is not possible to give first place, theoretically, to either ornamental art or representational-ornamental art. Each of these arts can claim the honour ·of masterpieces (and trifles). Let us say merely that its average productions justify themselves. Art is great whenever it succeeds in evoking intense feeling. Feeling, Emotion, the Mind.

When this threefold need finds simultaneous gratification, we are completely absorbed. This saturation creates a condition of euphoria, the content of the *opus* acting as a substitute for reality. In such cases our hearts are strongly and poignantly affected, we breathe more deeply. The measure of quality is the degree of intensity of the feeling we call elevation!

How is it that the fetish-worshipping Negroes were able to carve out gods which move us more profoundly sometimes than certain images of our own Christian God? Yet the cults in which these objects served, mean little to us, and we know but a fraction only of their symbols and observances. Their sacred masks are not symbols for us Europeans, but related forms which lead us, through our eyes, to a paradise similar to that to which Great Art of every epoch leads us. The Egyptians, the Negroes, when they carved a god, a mask for a sacred dance or sacrifice, did not "copy" any natural effigy: they constructed forms that "affect us."*

Indeed, for the fetishist, as for our palæolithic ancestors, masks are not only works of art, they are also religious accessories; and as such belong to the class of concepts which pure plastic does not always succeed in transmitting integrally, save, no doubt, the sense of mystery, which is the weft of all religion, because fundamentally deep in all men. What is important here is that Magdalenian art or Negro art, by means of plane or curved masses, straight or broken lines, colour, various substances specially related, directly affects us, in the same way that Michael Angelo's "Moses" powerfully affects the Negro, although the latter understands nothing of the former's symbolic intentions, nor we those of prehistoric man or the Negro.

Which is proof of the justness of our convictions in regard to human constants and the possibility of an art designedly universal.

Less primitive races, which are exceptionally sensitive to the direct influence of form, have not feared, in their recent masks, to welcome elements of European origin, such as saucepans or top-hats. They use them

* It is highly probable that the art of the African Negro derives from that of Egypt.

in manufacturing the head-dresses of the participants in the religious fes-
tivities, or in the masks for sacred dances. Rich with the experience of an
age-long selective tradition, they feel or they know, that form and colour
and the symphony evoked by them provoke certain definite reactions in men,
and that every form and colour is linked with a specific emotion. A language
that is felt (not symbolical), and which is that of all great universal and
permanent art.

> The universality of Great Art is possible, for all men have
> common factors, physical and moral.
> The Negroes were able to realise that the top-hat owed the
> nobility of its appearance, not to the use which convention had
> dictated for it among Europeans, but to the specific appearance of
> the cylinder with its dominant verticals and its specially serious
> colour, black.

Never will a cap seem decent at an important ceremony. The Soviets
have made it a specifically proletariat symbol, but their processions lack
solemnity, because the form of the cap has none, so that the significance of
the symbol is insufficient to impress our senses. Despite the fact even that
Moscow, from all the different kinds of headgear available, selected the
" Russian " cap; which resembles somewhat the top-hat on account of its
ascending verticals.

These rather strange examples permit, for those who will give thought
to the matter, of the separation of the conventional element which clings to
formal objects, that is to say, their symbolism (variable), from what is direct
emotion, particular to form (and constant). Universal constants are the
medium for a plastic, true, pure, and beautiful : inescapable tropisms to be
made use of, instruments exactly tuned.

Yet visual art is easy to understand. It is enough merely to look at it
for its influence to be felt. Can we not always go on looking?

Be the painting ancient or modern, by Poussin or Cubist, first of all
to be avoided is the attempt to discover what it depicts. . . .

> "A painting by Delacroix, seen at a distance which does not
> permit of analysis or even understanding, even then produces a real
> impression on the soul." (Baudelaire.)

Let us give first place to the injunctions that issue from colour and form,
and put ourselves in a state of passive contemplation that will be non-
critical, receptive.

Our eyes, unless especially educated, are tiny, irresponsible organs that
flit lightly over things in order to retain only those aspects which have
virtue for the conservation of the species, but are quite inadequate to the

apprehending of a work of art. We must encourage the activity of our senses.

"For that depends on feeling. At the most I can say to the reader: 'Is that how you feel?' Try it yourself; you will find it interesting." (Stendhal.)

How few there are able to create within them, that interior silence, and cast aside their prejudices, hasty criticisms, the hurly-burly of all that assails us from without at every moment, which neutralises or opposes the " direct emanations " of the work of art!

Only training (and training demands determination and effort) can render us docile to visual influences. I beg that full importance be attached to this remark: there is no one more blind to art than those who do not know how to see, except possibly those who will not see.

We open our ears because everyone accepts it as an undeniable truth that music cannot be heard with stopped ears. But the painters have not yet succeeded in making it clear to all that painting cannot be appreciated unless looked at. I mean looked at and not merely seen like a shooting star: one moiety supplying practical information, the other contemplation, delectation. The spectator of some plastic work thinks he has done his duty when, his mind elsewhere, he may have lent his attention to it for three seconds . . . and the kind of attention! In so short a space the object is judged! The eye, an organ of comparison, functions in order that primarily we may know in what respects the work differs from the natural object. This explains the usual objection that " a landscape, a body, an object are out of drawing," by which is meant that nature has not been successfully imitated. This perpetual comparing of the fiction with the reality, is what prevents the enjoyment of direct sensation, or its association with the sentiments that would naturally arise from it. The one reality that counts here is the painting. Yet the average mortal only looks with pleasure at the facsimiles of nature that magical reputations underline for him with an enormous finger. He sees stupidly and with accepted ideas.

The function of the amateur's eye is not to tell him if a certain green in a painting imitates well or ill a certain green in nature: the object of that green is first to give the sensation proper to that green, and following on it the feeling directly associated with that special green. Open your eyes, look at a painting by Seurat without bothering about the subject or its significance. Look with simplicity and without thinking of other things: you can do your thinking afterwards.

" Why all these little spots? There aren't any spots in nature."

" What did I tell you? You begin arguing even before you have felt anything. Could, then, even the best of reasons convince you of the virtue

Judge how forms have expression from the different headgear.

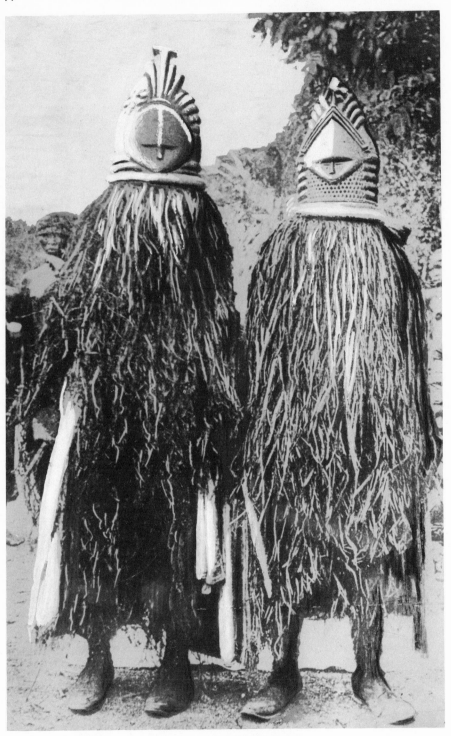

Sacred Dance Masks.

of a technic about which you feel nothing? Feeling nothing, of course, one doubts everything. Learn to feel. Is it enough merely to see, and see badly at that?"

Attune yourself to what emanates from a work of art, like the antennæ of a wireless set in response to a given frequency. And though we, who find a lively pleasure in Seurat, may be very much so, we are not altogether sottish, snobs, degenerate, vicious. From the very first moment a quivering of all our senses attracts us to him, even though the picture be among a hundred others, for its vibrations cut out everything else and establish "contact" at once. Still, it is important that the "receiving set" shall be able to adapt itself sympathetically, and so it must first of all be adjusted. If the flourishes of painting, pretty buttocks, sherbet delights, or the flowing hair of virgins pale as wheat are the only things that can make you vibrate, it is certain that you are not attuned to Seurat: he is dry, dry as a *brut* champagne, which you may not care for. You have every right to prefer liqueurs or liquid dentifrices.

What we love in Seurat is its traditional French simplicity and the clarity and polish of all really great things. We are not saying that that is all we admire. Think of the heat that emanates from Renoir's "Two Women Reclining," which was his last work, and is now in the Luxembourg.

Here is a reproduction of Seurat's "La Grande Jatte"; clean painting, where all is harmony. Is it anecdotal? Chance makes no judicious choice. Seurat said: "Art is harmony." Doubtless in those words he was expressing something similar to what the Greek geometers of antiquity represented, that basic structure which our mentality assumes to be in everything and imposes on everything: that discipline which it gratifies us to imagine the world is subservient to: that apparent or real hazard in the play of phenomena which, by regulating, we reduce to a sanctioned unity.

That is what we love: order, method. We admire it to such an extent that the geometry of "form-types," whose perfection exalts us, moves us to tenderness. Seurat's trend is towards pure ornament: there is geometry in the Ionic spirals of the monkey's tail, in the outlines of the posterior of the lady in the crinoline, and, most of all, in the law which governs the whole painting. A deeply moving coherent multiplicity which, arising from the interplay of two tiny coloured spots, more and more closely unifies, develops, orders, binds, co-ordinates, and flowers. Homogeneous and impressive structure, unity in complexity.

Let us make clear the sense in which "geometry" is made use of in this book.

In Euclid let us appreciate the limpidity of the hypothetical formulas, the crystal foundations on which to base a system of the universe. We shall see later that our plastic language depends on Four Pure Elements, the seed of every existing form. Yet our predilection must not lead

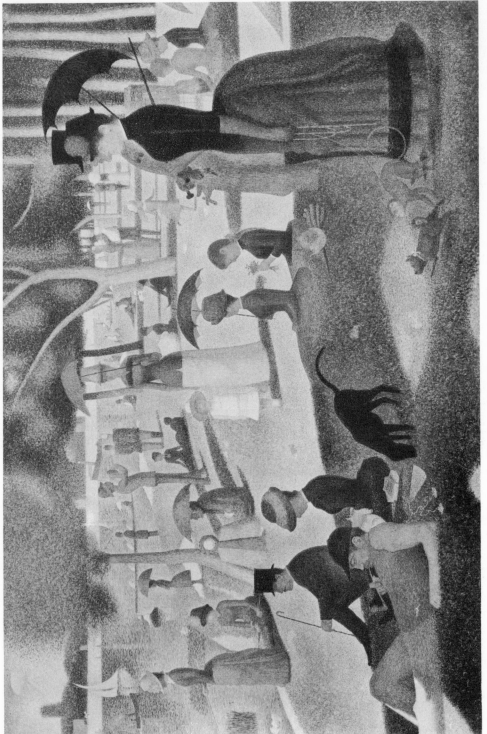

La grande jatte.

Seurat.

us to arrange everything in squares and circles, and paint only rectangular bodies and circles. Literally, it would be copying, imitating: therefore useless. When Seurat thinks of Euclid, he paints trees, grass, a lady: but he dominates them by general laws of structure that create harmony. The circle, the square, the rectangle, are obvious facts, like the pet dog or the lady: to paint a pet dog to the life, or a triangle in all its crudity, is the same error: stupid pedantry. Besides, a circle or square are the deceptive materialisations of a pure concept impossible of materialisation, besides being highly specialised geometric forms. Worth meditation by painters and sculptors and "constructional" architects are: the circle is the most extreme example of curved forms, the square of quadrilateral forms, etc., and opposed therefore to that common denominator which they are justified in desiring, but seek where it cannot be found. What matters is the harmony known to the Greeks, Piero della Francesca, Uccello, Leonardo da Vinci, Poussin, Cézanne, Seurat, and to us today. All art is free so long as the inspiring laws of structure inform it and move us.

"Laws. Art has no laws!"

"Art has laws! And here is an example that proves it. On a screen, for example, project the negative of a film, and it will move you deeply. The negative is the double of the normal image, it is its contrary point by point: but a film where the values were false would merely have bored us. There is a law, then, which, even when inverted, remains a law, and when transgressed avenges itself. Such are the organic threads which weave into the work its coherent structure: a necessary condition for emotion.

It would be better, too, when looking at a work of art, to eliminate all search for symbolism. Mathematical signs, for example, have only symbolic value, but, in contradistinction, form in modern painting is of value *primarily* as sensation. To indicate clearly its nature let us draw a curve. To a mathematician such a form will remain nothing but a curve, the intellectual approach being a "symbolic" one. The line described below may be the chart demonstrating the biological effects of poison upon a being: stimulation increasing from zero to a maximum, then falling back towards zero and death. Yet it is pleasant to the eye: a striking example of the influence of forms and symbols upon our sensibility.

This same form in a representational painting would represent a breast,

and endow the image with the specific feeling that is associated with such forms.

In ornamental art the essential aim of such a curve will be to evoke the sensations special to such forms.

There exist hills which are very similar to breasts in shape, and they are pleasant, not because the form is that of a breast, but because the curve, like a breast's, belongs to the category of lines that make us inevitably feel a certain charm. The curves being analogous, similar sensations are evoked.

Symbols are a conventionalisation. The plastic element* in art is not. There you have the basic difference. It is not always realised.

A swift glance is enough to permit the complete visualisation of the symbol composed of the signs $2 \times 2 = 4$. The maximum productivity is almost instantaneous: but if a plastic form be examined, the emotion it inspires goes on growing.

I draw a dove: the notion of charm grows out of it, not because of a convention (like the word-symbol "softness"), but because of the curves of the dove and the ease with which the eye follows them. Such forms compel certain sensations and feelings. They are as irresistibly charming to us as feeling that fire burns. We know nothing about the souls of doves: it is very probable many have the characters of donkeys, but their forms assure us they have charm, and we believe them. The saying "Don't go by looks" clearly means that form is convincing.

And here is proof.

The word "proud" can be "set up" in infinitely diverse types and the sense always remains the same.

PROUD Proud PROUD

PROUD

PROUD Proud *proud*

proud proud **PROUD**

proud *proud* PROUD

PROUD proud

* *The fashion among certain psychologists is to reduce everything to the vague and general concept of "symbols." According to them, woman is as much a symbol as a*

But the communicable expression has varied, and to how great an extent!

Every form has its specific mode of expression (the language of plastic) independent of its purely ideological significance (language of the sign).

The language of the visual arts is made up of categorical forms, which are only signs, as it were, inadvertently.

The spring of the valve is not proud at all.

Proud mouldings of Doric cornices! This valve is proud!

Sensation, and sensation alone, unavoidably makes us feel these things, not the conventional sign.

The " sign " element is the word *proud* as written in English, *fier* in French, *stolz* in German, *fiero* in Spanish, etc.

Another proof. Very bad casts often differ from the original statue by the merest fraction of a millimetre, yet the impression they convey is very different. If art was a mere matter of signs the effects would be equivalent. Diderot wrote: " A line displaced the thickness of a hair embellishes or spoils."

A sign is a short cut; a " complex " of intellectual substitutions for which a key is needed. It is in some respects a cryptogram. Sensation does not need keys, and is not conventional but categorical.

number. Assuredly, all that we see or hear or feel is to some degree symbol, but to make one word express too much only leads to confusion. To affirm that everything in art is symbol would force us to admit that some arts are conventional and others categorical and not conventional: almost the same difference as between the concept command and obedience, both of which are capable of being forcibly shouted into the skin of the word " command."

A sign, in common parlance, is a "convention." And if at times the sign resembles what it represents, as a cross does the Cross, that is because by its nature, it is something specific, representational, hieroglyphic.

A sign can have any shape at all, so long only as there is preliminary agreement as to its significance. We could agree that $+$ meant $-$: the proof being that by reversing all the signs in an equation the answer remains the same. But a sign cannot make the curve express what a straight line expresses, or make ice seem hotter than fire.

To write 30° C. makes no one sweat.

In short, one of the chief confusions where the plastic arts are concerned, comes from the fact that the majority of spectators, certain æsthetes and art critics, treat painting as though it were a page of literature, which is, in effect, composed of words only: otherwise, signs. It is true indeed that all the arts have the same aim: namely, to inspire states of feeling and thinking in us: but the technics are many, some concerning themselves with sensation, while others are conventional. Plastic art and music depend directly on the functioning of our senses: a painting must first be felt.

Symbols are somehow cold, like everything that is conventional. The greatness of the art of sensation comes precisely from the fact that it dispenses with every symbolic convention: the loftiness of Gothic structures makes even the unbeliever feel religious. The vast horizontals of Egyptian art calm the most troubled soul.

COLOUR AND FORM

IT is customary to talk of art, either vociferously, as of the noble cult of boxing, or in a mysterious whisper, with vague phrases for muzzy ideas. How can one see clear in an obscurity which seems to have been created purposely?*

Is there any point in seeking the clue to this imbroglio in that

* It is self-evident that this chapter is schematic: it posits certain essential basic foundations. But for the most part there is only confusion in these matters. Works on æsthetics from a scientific point of view bring in so much complication of thought and speech that they hardly do more than totally obscure the issue. One is struck, in reading the majority of such works, by the realisation that, if the chapters on speech and the arts of language are relatively clear, those which touch on the visual arts are not. Doubtless because such thinkers have observed thought clearly enough, but left their eyes in their ink-wells. These professors of æsthetics flounder in the nets they have themselves stretched. Nevertheless, the works of M. Charles Lalo can be read with profit and pleasure, and if his ideas on the fugitiveness of art seem to me questionable, it is no doubt M. Durkheim's fault. Yet writing clearly, alertly, and intelligently, M. Lalo conveys his profound knowledge and his original views on the philosophy of the arts. Acquaintance should also be made with the writings of M. Henri Delacroix; he goes deep at times, but what a mania for the universally applicable sign!

" complex," which all works of art are? To work through the snare some go about it like butchers, hacking through Gordian knots, while others proceed laboriously like flies caught on fly-paper.

If smell were the object of our study, it would be of service to elect as our typical smell some simple odour, rather than a perfume by Coty, which is a complex of different elements. Similarly, it would be better not to begin the study of music with Schoenberg, but with the properties of sound, as distinct from its organisation as music: and of painting, by such appreciable elements as are outside æsthetics, and not by the work of Tintoretto (or Meissonier), as is usually attempted by professors of æsthetics.

First let us analyse the foundations of visual art.

" How can one blindly utilise the language of sounds without having first investigated the significance of each of them?" (Stendhal.)

The visual art-product is an extremely complicated phenomenon, but it is composed of prime elements, which are relatively simple, as we shall see.

In the absence of sensation, there is no perception: without perception, no emotion. We do not very well know how the eye functions (what is there, indeed, that we do very well know?), but it seems that, apart from all intellectual elaboration or appreciation, form and colour operate intensely enough seriously to modify our anterior states. Reds, for instance, greatly excite such creatures as have eyes, whether animal or human. Compulsive tropisms, energetic and universal enough to modify behaviour!

In the Lumière factories at Lyons the laboratories for manufacturing photographic plates were illuminated ruby-red: as a result, the employees, violently excited, came to blows. As for the women workers, they had quantities of children: all they could have. Too bad! Pacifying green replaced the red, and they ceased having more than the usual number. (Here you have the consequences of a "tropism" such as few "signs" could vaunt.)

Physicians have treated various psychoses by means of "light-baths" of different colours. (At Sainte-Anne, under Dr. Toulouse, the windows are yellow.) A scrap of scarlet cloth will fascinate the tender frog: bulls behave like frogs at *corridas*, and the vegetable kingdom under different coloured lights is affected variously.

Such results seem to explain how complicated states of feeling and response, can be created at will by the influence of organised colours, neither conventional nor representational, solely by virtue of their tropisms. (Compare the effect of high or low notes on our state of being. All

the affective value of music resides in the opportune utilisation of diverse auditory tropisms.)

Through the eye we perceive two sorts of sensations generally considered unrelated, colour and form : actually they fuse into each other. All substance is seen by the light it reflects, and all light is colour. We imagine we conceive form as distinct from matter, and in consequence colourlessly : but that is only a convention of our minds, which does not concern the visual arts, because not in a true sense, sensation. In laboratories, of course, the seeing of colour as divorced from form has been realised through the medium of coloured rubbed-down glass screens, but it is utterly impossible in actuality to create form without colour. Here I am, of course, calling colour, not only the theoretical colour of the physicists, but also black and white : for only physics can theoretically (and theoretically only) consider white as the mingling of every prismatic colour, and black as the absence of light and so colourless.

The colourless exists, then, only in our imaginations. Even such substances as have relatively no colour at all, like crystal, have their special colour. What we call white paper is yellowish, blueish, pinkish, greenish, violet . . . it can be proved by juxtaposing various " white " papers.

In short, anybody talking painting, sculpture, architecture, dancing, is talking of sensations provoked by different substances disposed in different forms, made visible by their colours.

But painters envisage the part colour plays as something quite different. Some make use of it for its purely colourist properties : that is, a little in the manner of a dyer dipping material into pigment (which can be any colour whatsoever, be the material what it may), and others as a property of the formal elements of the painting. As I consider dyeing something superadded, I must be permitted to call " true " colour a specific property of matter, in the manner in which, for example, sand is sand-colour and not violet.

There is " true " colour and " false " colour. It seems probable that " true " colours are those to which the eye naturally accommodates itself, and false, those which are difficult for it : as, for example, certain reddish violets, made up of the two elements pink and blue, which it finds painful to endure, the accommodation seeming difficult because the eye cannot at one and the same time, adjust itself to blue and red. It never can succeed in doing so simultaneously, and its hesitation unduly tries it. These colours never appear clearly stated because of this impossibility in relating them.

In my opinion, false tones are those equivocal tones which demand from our sensibilities a similar abnormal complicated effort.

Before my eyes at this moment I have a box of matches, one side of which is blue, restful in tone, the other being printed in red on white, the

somewhat obvious appeal of which is certainly effective. The striking edges are brown: a severity in no wise painful: but the edges of the box are that violet-red I have just mentioned, and which makes me experience a kind of dazzlement which is truly painful. It seems clear to me that when I seek some focus of accommodation in the blue, the red troubles me, and so on. It is the same also in respect to the other colours.

It is no part of my intention here to go very fully into these matters. I wish merely to orient the mind in the direction of certain orders of phenomena on which painting absolutely depends, the knowledge of which has not been altogether useless to such as are already aware of them.

For a great many years I was asking myself why pictures painted in very bright colours tired us so speedily, and why a Chardin, for example, never does. Nevertheless, bright colours, as of drapings and flowers, can be most attractive.

It is because the stimulation due to a bright colour mounts rapidly, reaches its peak, and descends almost as rapidly. Sudden stimulus, swift fatigue! Tones less violent, those of nature, operate slowly and their effect persists. Which may be translated, noise can very quickly split our ears, but good music holds us in thrall.

It is no good fighting against these things, against our senses, our organisms, our fatality. If we wish to remain in contact with something, it must not be roughly handled. Force is not brutality. Biophysics is here absolutely in accordance with æsthetics. That is why it is not vain, to know something of the way in which man functions, if we desire to influence him. Colour has its dangers.

"And Renoir's bouquets, what do you make of them?"

"I find in them testimony to an eye that was enchanted by what it saw, and yet was able to discipline colour so as to produce his masterpieces. To praise a painting for its 'charming colour' is rather like telling a woman her hair is a pretty 'shade': nothing could be more insolent. Of a fine body we say, 'That's a beautiful woman'; and of a fine picture, 'That's a fine picture.' Alas! a large proportion of modern painting has lovely hair (even dyed a little)."

No one recalls the special colour of some odd corner in a painting by Cézanne. "It is a fine Cézanne." But we remember how at times he produced indifferent water-colours with emerald green. Wherever, in a work, a portion can be imagined of a different colour, it is because the colour is bad. Colour should not be able to be imagined dissociated from form, or conversely: good paintings must necessarily reproduce badly. We must not say, if we love form, that colour does not count, nor that the former should be the dominant factor: if it were so, one could entirely

dispense with colour: economy, that great law of the universe, would demand it.

Nor let us say (which is truly the most lamentable reasoning any man ever sustained) that the art of painting is first and foremost that of colour, because it makes use of colours.

It is said that "sculpture differs from painting in that it does not make use of colour," which is true: but it utilises colour. A bronze, say what you will, is not the colour of marble, and that is what I mean by colour: something integral to the form itself.

Colour as dye, is in painting what gilding is to sculpture: something super-added.

The frequency with which this truth goes unrecognised leads to the perpetration of works which give an impression of being false and adulterated. It is not by such means that we shall succeed in touching what is deepest in man. Certain contemporary paintings prove it abundantly.

How few painters there are to whom any other praise can be given than: "What exquisite vision! How enchanting! Truly, his scarlet is inimitable. No one ever painted such blue, I could eat it!" Indirect homage to the chemist and dyer, and direct homage to the chef.

It was believed that Picasso had invented a new system of painting: drawing, instinct with its own life, plus colouring independent of it, and yet melodiously accompanying it. It is sad to relate that all great painters proceeded similarly when they were on the wrong path. An example is Ingres' "Joan of Arc," which is in a blue both false and shrill: the drawing of this picture is most eloquent, but its colour is mere "colouring." The earnest of a fine work is that it cannot be imagined different. But certain Picassos can perfectly well be imagined painted in other colours. He has himself done so often in his replicas. His colour is frequently interchangeable, a proof that either it or the form, is bad. It is also true of those recent Matisses, which verge on "colour." Try and imagine Corot's "Femme à la Perle" in violet.

To colour is to camouflage: the drawing then squeezes through. But art is not a matter of squeezing through.

The basic keyboard of the work of art is the diverse sensations consequent upon various stimuli. Since each colour has the property of stimulating us differently, those which most fully and least ambiguously affect us, must be chosen from the infinity of those possible.

Also there must be added to the sensations emanating from form and colour the sensations that result from the substances employed.

Some are crude, some severe: others sweet, caressing, etc.: a whole gamut. They reinforce or diminish the effects of both form and colour. The same form in steel, bronze, terra-cotta, operates differently, for the

substance in refracting the coloured light transforms it, diffusing and polarising it. "Touch" in painting, the "handling" of bronze, stone, etc., is a manner of modifying, qualifying, the light waves.*

Note yet another manner in which coloured substances influence us by recalling tactile sensations: roughness, smoothness, and even temperature. Are reds not termed warm, blues cold? A tone reminiscent of steel linked to its specific sensations colours the memory with the attributes of that metal, etc. Such associations are very constant.

This is a keyboard too!

PERSPECTIVE THROUGH COLOUR

OUR eyes being naturally adapted to yellow, that predisposition explains why different colours in a painting appear to be situated at varying distances from us. Actually our eyes are normally emmetropic: that is to say, *adjusted* to yellow: and myopic for violet, and hypermetropic for red. We are forced to make unequal efforts to accommodate our sight to blues, violets, oranges, or reds. Try it! Stare at some coloured spot in a painting, and you will realise that you do not simultaneously perceive the other colours with equal distinctness. This is the manner in which perspective functions through colour.

The Eye is—		Relative Apparent Distances
Myopic for 	Violet Blue Green	Distant
Emmetropic for ...	Yellow Orange	Middle distance
Hypermetropic for ...	Red	Near

The only non-perspective painting would be a uniform plane surface in one colour, and even that would seem more distant if blue, rather than red or yellow; thus the walls of a room seem to us close or distant, according to their colour, and the room itself more or less large. It is not due to a special relation of the colours to each other, but to a real tropism affecting us through colour.

* *The plucking of the chords, the striking of the keys, vibration . . . modification, qualification of sound waves.*

FORMAL PERSPECTIVE

THE third dimension of matter, depth, is always rendered in painting by an optical illusion, and this is true even of linear design.

Geometric perspective, called Italian, is a system which works through rememorisations, released by the representation of the aspects assumed by natural forms, in their various positions in space. It is a logical perspective which creates by means of *trompe-l'œil* the evocative illusion of volume and depth. It is often redundant, for the colours themselves permit of the direct rendering of illusions of relative distances: but this reflection belongs to the domain of æsthetics, and here it is technic that is specially in question.

MODELLING

MODELLING is a form of *trompe-l'œil* permitting of an even more complete illusion as to volume and lighting.

ELEMENTS OF FORM

WE shall now investigate the constituent elements of forms. I wish to be clearly understood. I am not suggesting that- paintings are to be constructed by mechanically distributing the elements I shall mention later: I merely demonstrate the mechanism of those communicable phenomena which, first and foremost, are comprised in every work of art.

It is, if you like, a sort of mathematics of sensation which I am trying to formulate. I am not offering the solution of a puzzle, but a point of view, and a way of understanding that should lead to a knowledge of how to feel.

Even at the very limits of our perception and understanding, the tiniest elements appear to obey the laws which control the cosmos. Adequately cultivated, such an outlook will add to our perceptions, the joys of lucidity. Thus, for example, we find a greater satisfaction in looking at cells and crystals when we know how they come into being, and that they unite with each other according to rigorous laws.

An acorn, inert microcosm animated by tremendous concentrated potencies, in a favourable site and moment, begins to wake under the impulse of solar and tellurian forces. It germinates, and new cells add themselves to the first cells, according to the gnomic norm of elemental loves. For lustra on lustra, the miracles of chemistry transform that acorn into an immense green structure, governed by those forces to which number

and our reason bow. Seen from this angle, an oak is no longer wood for sawing, nor provider of acorns for swine, nor an excuse for emerald green, but part of the universe, a universe in itself. Spring-board for the spirit and joy for the eyes, and for those feelings in us which are moved by seeing the infinitely small in tune with the infinitely large.

So with the work of art. In it we should see a genesis always beginning and always developing, from the smallest element to the largest. Reason is not entirely vain, since it provides such pleasures. (I think of those art critics who would like to pith our brains, to the great advantage, as they think, of our art and happiness.)

Microphotograph of a Diatom.

*Star-cluster (M 13) in Hercules. (Photographed by Ritchey at Mount Wilson, U.S.A.
Exposure 11 hours.)*

THE
CONSTANTS
of the sensations and elements of form in
nature and art

GAMUT OF STRAIGHT LINES

ALL forms can be grouped into four sensations.

The two primary elements are Verticality, and its contrary Horizontality: the other two related to them are Obliqueness and the Curve.

Let us study the straight line. We all feel that

1. The communicable affects originating in the straight line are specific and exclusive to it.

2. Such affects are always augmented by other properties due to their orientation.

3. The vertical is a straight line which recalls the force of gravity: thus it is to some degree dynamic.

4. The horizontal is a straight line which emphasises the contrary of the vertical: it expresses inert stability, repose.

5. All obliques partake of these two states of feeling, to the extent of their divergence from each of the two opposing orientations.

Suppose a perpendicular to fall slowly. We feel it to be "losing" vertical feeling in favour of horizontal feeling. An oblique line at an angle of 45 degrees, considered as sensation, is as distant from the vertical as from the horizontal. If a man falls, in thought we fall with him, and when he reaches the ground we ourselves are at rest: this participation, imposed upon us by the tropism of form, is the basis of a universal language of feeling.

259

DIVERSE CURVES

WHAT is specific to the curve is to some extent its obliqueness. The uniqueness* of each curve comes from the direction it takes in relation to perpendicular or horizontal sensation. (I adopt here as my first axis the vertical.) When a curve is flattened its sensation approximates to that of the straight line. It is at its furthest from the straight line when it is a circle.†

Follow any particular curve. We feel that what gives it individuality is the " movement " which causes it to converge upon, or diverge from, the two sensation axes, vertical and horizontal : the progress of its divergences. The proof is that given an interrupted curve, we perfectly apprehend the development of the completed curve.

A rocket outlines its trajectory : the closer it remains to the perpendicular, the more it triumphs over gravity. We feel, as it were, dragged in the direction that variations in the form impose upon us, and it is this switchback leading from the point of departure to that of arrival, this journey tending to serenity if it tends towards horizontality, or to abrupt-

Its function, *one might say. Note that this is the term used in analytical mathematics also. It is not the only point of contact. Mathematics is the art of dealing with intellectual structures, and plastic art, that of dealing with sensed structures brought into relation with affective and intellectual structures. More exactly, the attempt at relating the analysis of forms to sensations of gravity is not an abstraction, but is based upon real sensation. My insistence, if excessive, is because I know only too well that short-sighted critics will never understand I am talking about a " geometry " of sensation.*

† *Purism. A judicious choice among the infinite possibilities of angular directions and possible curves will construct a scale for expression. For an angle to produce a direct, individual impression it must be appreciably different from another, otherwise its effect is equivocal : thus a temperature, an intense luminosity, an intense sonority, an intense weightiness, must vary sufficiently from a given norm for the variation to be perceptible without ambiguity. Thresholds! The Purist classification of form and colour is based on thresholds. And the same is true for colours and straight or curved forms. Universality depends upon forthrightness. However we wish to express ourselves, let us choose out such tropisms as affect us clearly and unequivocally, in the smallest things as in vast general definitive trends.*

ness if it climbs vertically, which determines the specific qualities special to the curve in question.

All form is the echo in us of our awareness of gravity.

GAMUT OF SYMPHONIC RELATIONS

THE presence of two or more forms creates a relationship, the resultant of quantities of qualities in apposition. The possibility of symphonic relations!

RESULTANTS AND DOMINANTS

THE combination of forms of different size and orientation is what constitutes "complexes." They can be reduced to three sorts of combination:

1. ADDITION of the same qualities.

2. SUBTRACTION. Addition of opposing qualities in varying quantities.

3. NEUTRALISATION. Addition of opposing qualities in equal quantities.

DOMINANTS

THE expression of a tower is the result of its extreme verticality. In a wall, on the contrary, the horizontal quality dominates.

SIGNIFICANCE OF STRAIGHT LINES

THE effect of straight lines is to impinge on us at every angle:* a language severe, mineral, virile.

SIGNIFICANCE OF CURVES

COMBINATIONS of curves are more supple, there appears to be less effort: thus we have a feeling of continuity, nice lubrication. The law of least resistance comes in here.

Curves, language of sweetness, charm, grace, femininity. To draw, paint, sculpt, practise architecture, dance, is so to dispose straight or curved forms and colours, as to provoke sensations and associations specific to each of them (so, too, with sounds in music).

GAMUT OF MOVEMENT

THERE is only one easy way of passing through each form. Tropism. To pass through these lines from right to left an arduous effort must be made.†

But conversely, it is easier to follow these lines from right to left.

We pass along a gentle curve with much less difficulty than over a broken line, because in fact the eye, while investigating a form, is not

* *Angles are a divergence from the vertical. Variations in curves are to be considered as "curvilinear" angles.*

† *"Time" intervenes in the plastic arts as in music. That is why I say "pass through" a curve. A form does not take effect instantaneously.*

immobile: it follows it. Sudden changes in direction hold up forward impulses of the eyes: muscular brakes are applied suddenly, the eye returns to zero, new starts must be made with great expenditure of motor effort.

Thus the vertical, looked at from bottom to top, is more tiring for the eye to follow than from top to bottom, because in the first place, we have weight against us, and, in the second, the eye's movements are facilitated, etc.

SUSPENSE

Our mind always tries to organize what appears unorganized or not organized enough. It also tries to resolve the discontinuous in continuous. Our mind tends to complete the incomplete or interrupted forms. We feel first suspense, then satisfaction of completion. (Phenomenon much in use in music.)

TIME

A form does not yield its full effect instantly. We have to "follow" it. Time intervenes in arts of sight as in music, dance, literature.

The Horizontal.

The Vertical.

Neutralisation (A Normandy Pigeon Loft).

Obliquenes·

Curves.

MODALITIES

WHAT has gone before permits us now to consider modalities as typical forms of feeling and thinking. Such modalities find their expression in certain forms, colours, and, of course, sounds or ideas.

Rectilinear forms:

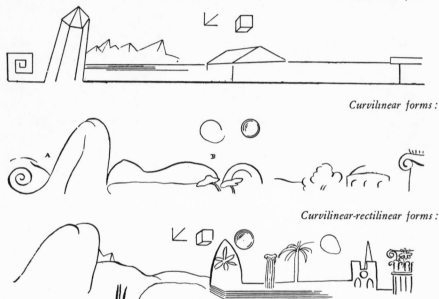

Curvilinear forms:

Curvilinear-rectilinear forms:

/ When a particular kind of feeling is dominant in certain epochs,
/ the general distribution of certain "modes" creates what is known
\ later as its "style."

Modes depend on manners of thinking and feeling, and not on technic: fashions of building, painting, writing, are determined by modes of feeling and thinking. The gravity of Doric thought produced the dense *Iliad*.

"*Fear fell upon Hector as he beheld him, and he dared not stay longer where he was, but fled in dismay from before the gates, while Achilles darted after him at his utmost speed. As a mountain falcon, swiftest of all birds, swoops down upon some cowering dove—the dove flies before him, but the falcon with a shrill scream follows close*

after, resolved to have her—even so did Achilles make straight for Hector with all his might, while Hector fled under the Trojan wall as fast as his limbs could take him. . . ."

In mild Ionia the Odyssey came to birth and loving curves about the capitals of Temples!

"... Then she took the whip and reins and lashed the mules on, whereon they set off, and their hoofs clattered on the road. They pulled without flagging, and carried not only Nausicaa and her wash of clothes, but the maids also who were with her.

"... When they reached the water side, they went to the washing cisterns, through which there ran at all times enough pure water to wash any quantity of linen, no matter how dirty. Here they unharnessed the mules and turned them out to feed on the sweet, juicy herbage that grew by the water side. They took the clothes out of the waggon, put them in the water, and vied with one another in treading them in the pits to get the dirt out. After they had washed them and got them quite clean, they laid them out by the seaside, where the waves had raised a high beach of shingle, and set about washing themselves and anointing themselves with olive oil."

In the fifth century the Greeks simultaneously constructed proud Doric temples and gentle Ionic ones. Two mentalities co-existed: the Doric severity at times yearned to soften in volutes. They were heroes by day, but at night in the camps they had their gentle captives.

A dramatic, a sacred inspiration animated the builders of the Middle Ages, and as a result they gave birth to our cathedrals: Gothic is the result of a spirit and not of a manner of building. The ogive was invented because such curves aspire to the vertical, which reaches to God. The Romans had no use for acute angles; but Christianity drew its serenity from Mediterranean Romanism. A mystic anguish had somehow to externalise itself. The reign of the angle was inaugurated, and in its tropisms the soul's disquiets could find calm, and in this manner find an issue for itself. From the cathedral of Chartres we issue once more at peace with the world.*

* *The invention of reinforced concrete has been interpreted by some as the origin of a new style, but that is mistaking the means for the end. Concrete allows us to build, with facility, forms appropriate to the demands of the material and of purity of style too. Naturally, the vault made by intersecting ogives was invented in order that the Gothic cathedral might be constructed: the form, or rather what it expressed, was desired and so invented, for the full Roman cintra does not permit of the expression of the loftiest mystical sentiments. The means serves the expression, the need seeks it out. The heart desires, the spirit concentrates on satisfying it, and technic crowns all.*

Окрестности Москвы
Environs de Moscou
Царицино, дворцовыя ворота.
Tzaritzino.

Russian " Gothic." Eighteenth Century. The architect hung himself from this arch.

Negro " Gothic."

Modern Catalan " Gothic " (Barcelona).

Gallo-Roman (Souillac).

Nature in Doric Mood.

Nature in Ionic Mood.

Hindoo feeling? No, an enlarged bud.

We do the things we must, and only those. The modes of the time dominate us and shapes express it : all we do reveals it.

The modes of the Kings of France . . . and France too. (See Note p. 317.)

The object of the arts is expression. There is a mode of expression which corresponds to every feeling, satisfying and communicating them. Thus Doric, Ionic, Byzantine, Roman, Gothic, etc. . . . are the consequences of different kinds of feeling.

RENOIR, THE "GAMINE," AND GEOMETRY

"BUT, SIR, Renoir cared nothing for analysis: he painted as his genius dictated! Since when have painters been a sort of mathematician, psychologist, and Heaven knows what else?"

"I can't tell you how Renoir felt. I know that he said to M. Joyant: 'I don't paint with my hands, but my tail.' And Michael Angelo said: 'One paints with one's head, not one's hands.'"

What I suggest is that painting should concern itself only with what has been conceived clearly by the spirit. We seek to be responsible. Many people know the time by instinct, and it will often do: nevertheless, a good chronometer is sometimes very useful. Renoir was an empiricist of genius. Laws are no less effective because one obeys them unconsciously. But there is no harm in being aware of them. We want an art that shall be precise, and so our methods must be so.

Besides, I just set an innocent trap for you, for I knew you would begin to talk tearfully about painting by instinct in order to combat that spirit of exactitude which I so much admire.

Just take the trouble to look at the photograph opposite, and you will see that, in order to illustrate my remarks on curves, I have chosen precisely those of the nicely upholstered form of the charming creature by your friend Renoir. The only difference was that then the curves were horizontal in order not to remind you of the original: for that would have spoilt everything at a time when we had not clearly defined the primary affects of sensation. The rocket and the mountain were her arm:* sensations, expression, feeling, all analogous: formal analogies.

In short, the curve represents an arm, a breast, an abdomen, a thigh, a knee, a leg: but it owes its effectiveness first and foremost to the "movement" of its curve. Reflect a moment on the vertical abscissæ that preside over this sweet and delicious melody. That is why the mountain of Rio de Janeiro has the charm of a woman's arm, as this girl's arm has the charm of the delightful mountain.

The pleasures of apprehension augment those of feeling.

Echoes on echoes. Can you hear the echoes?

Representation enhances the direct affects of forms, by reverberations

* See curves, pp. 247, 262, 266.

which have their origin in associations of ideas. I do not say they are to be neglected, for we shall deal with them shortly: but they are a consequence and not fundamental. Does a fine but useless vase represent anything? It is a fine vase, that is all: and yet it is everything. A painting is first of all form and colour. Cézanne relates that, visiting Courbet, he noticed a brown patch in a painting nearing completion, and asked what it represented. Courbet replied that he did not "yet" know. Then at the next visit he said: "I've got my brown; it's a faggot of wood." Similarly, a curve will become a leg, a buttock, an abdomen, a breast.

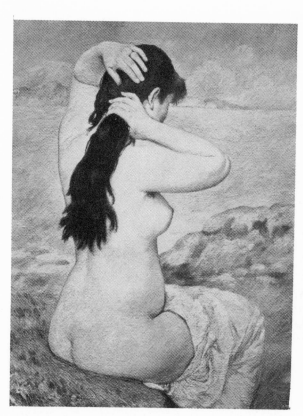

ASSOCIATIONS IN RELATION TO SENSATION

SENSATION: the substance of the work; the associations: ideas, sentiments.

Blue recalls the sky, because the sky is blue: yellow, the sun: vivid tones, flowers. Ochres are forceful because earth is that colour. The colours of flowers are suitable to express grace, fragility.

Upon a black surface paint some spots, star-colour: and it becomes a sky, with something of the feelings evoked in us by night. Certain neckties are celestial, certain water-bottles oceanic, certain plaid rugs fields seen from airplanes.

Observe well the shop-fronts of oil and colour men. They hang out signs in various panels of different coloured paints. Here is a rectangle painted blue on top, green below: a lawn under the sky. And on the other side, it is blue below and green on top: water beneath trees; and red on top, blue below, sunset at sea. . . . A similar experiment can be carried out by looking at the coloured plates of flags of all nations to be found in most dictionaries.

When the inevitable mechanism of these associations is realised, how can one not be surprised by the surprise of painters whose colouring doesn't " do " what they expected of it? They paint with the colours of flowers, and are astonished that their picture seems feeble in spite of the lavish outlay of striking colour: it is striking but has no power. The colours of

butterflies, flowers, or stuffs are not able to express profound feelings, but only butterfly, horticultural, or "textile" feelings. It is the same with the language of form.

> "*It is not within our power to separate ideas that nature associates together. I should change my opinion if I were told that negroes are more affected by darkness than by the brightness of a fine day.*" (Diderot.)

THE SUBJECT

A LESSON we can also derive from the shop-fronts of oil and colour men is that there can be no such thing as non-representational painting. The panels already referred to represent nothing: they are pure "construction," but we read landscapes into them. So with the efforts of the Neoplasticists. To them, it is pure painting, but in effect turns out to be tiles and rugs.

Here we touch a most delicate, and in these days, even dangerous matter: the choice of subject. Must we be ostriches and evade the serious questioning of ourselves? It is obvious that feeling must be more important than the subject. There can be no true art without that foundation. Yet once again: three apples on a plate by Cézanne, entirely "wash out" some scenario by Greuze.

Nevertheless, *Eleazer and Rebecca* move us more powerfully than three apples by Chardin or Cézanne.

The feelings which certain scenes evoke in us, augment the sensorial pleasures we experience.

A fine subject never did anyone any harm. Is Cézanne, to go back to him, as moving when he paints a wooden hut in the suburbs, as when painting the noble mountain Sainte-Victoire? The plastic qualities are certainly the same in one picture as in the other, but the grandeur of the subject adds something; it augments that elevation of the spirit without which nothing can be truly great.

Let us learn to profit by the partial illuminations brought to our art as a result of successive revolutions: but do not let them limit us. Why should we go on depriving ourselves of the pregnant resources of noble subjects? My conviction is, that the revolution we need today, is in subject matter.

And this inspired subject is not necessarily the human form, which nevertheless, is what most nearly affects us. No doubt, in the world of pipes, the pipe is the finest of all subjects: but we are human beings.

1. The choice of indifferent subjects has had its revolutionary point: it has succeeded in restoring us to a sense of the senses. For which thanks!

2. Art by appealing to form and colour only, as distinct from representation, has had its emotional significance pitifully reduced, and, in addition, rendered ambiguous: it is as though we were looking for noon at 2 p.m.

3. The only possibility of changing the situation is by admitting some degree of representation.

4. Given representation, it is preferable to choose noble subjects; to wit, those rich in plastic values and associated emotions.

5. A work is important according to the qualities inherent in it. Those which come from the choice of a fine subject cannot be considered negligible.

6. The subject is nothing in itself! it is of value if the fashion in which it is exploited moves us. But the manner of expression has no value if what is said is of no particular significance.

The criterion whether it is worth being said or done is its "elevation."

*

SUPERVISED HYPNOSIS. OF SIMPLE AND COMPLEX. THE NATURAL NORM. THE SUPERNATURAL NORM. HALLUCINATION AND HYPNOSIS. GEOMETRY'S LASSO. STABILISE HYPNOSIS. MIRRORS FOR LARKS. SUBJECTIVE LAWS OF NATURE. NATURE RHYMES! STRUCTURES. ANTÆUS. PAINTING AFTER NATURE.

TO SUCCEED in assuaging reality a work of art should:

1. Respect the profound and innate sense in us of nature's fundamental reactions, and not too much outrage them: for then we are led to compare the work with its subject, which brings us back to the literal reality (as a monster reminds us of the normal creature).

2. Yet remain, nevertheless, at such a distance from nature's aspects that the disturbance introduced into habitual aspects may deprive us momentarily of our rationalising facilities. Thus some illogical woman's argument, falling suddenly into a closely reasoned discussion, unhorses the arguers and makes us ponder.

Being no longer controlled by the powerful impulses of "common sense," and the "normal," the valves of our unconscious open, and permit

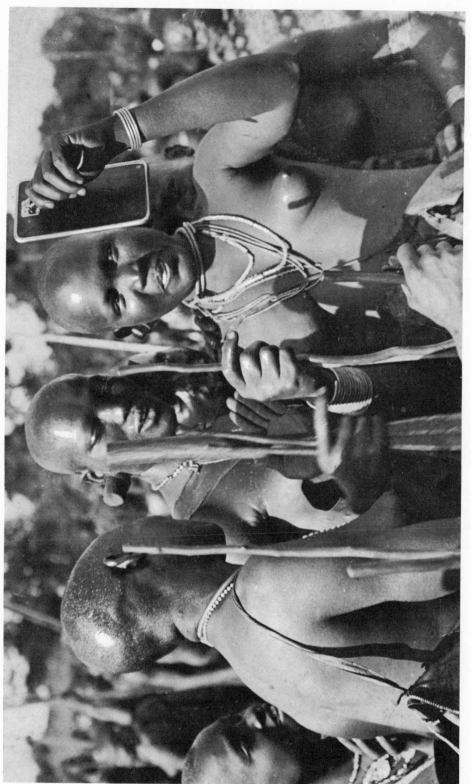

Negress seeing herself for the First Time in a Good Mirror.

the fusion of our slumbering, suppressed, or unwitted potentialities. Thus a world of new sensations and awareness comes into being. Faustian joys!

The problem is how to create a form of hallucination that will be a substitute for the simple perception of the work of art as an object (poem, music, painting, or architecture).

By categorical dominants, the work of art arrests us as glittering metal does a fish or savage. This is the realm where geometry reigns. Its forms have hypnotic potency. It puts at the service of art its power and authority, the rhythm on the haft of the Magdalenian dagger, or BEWARE DANGER inscribed in simple geometric letters on a simple plate. Brief injunctions! The composition is what should arrest us. (You know the experiment: a chalk line and the hen is motionless, fascinated, its beak down on the line.) But once this check has operated, more complex relationships must enter into play to hold us. Allurements to capture us and subsequent stimuli to keep us. Posters seize on us, but we do not stay long: it is a by-blow merely. The manufacturers of automatic signs have realised this, but too many modern painters and some of the most robust even, have not realised it. A work of art should reverberate quite otherwise in us.

The work should convey a feeling that it conforms profoundly to the dictates of nature (which does not mean to say that it must keep to habitual aspects of it). In order to make this rather vague formula clearer, an example will suffice: paint the statue of some Pharaoh violet or green, and the effect will be ridiculous, a fine organic thing ruined; yet every day we see these same faults, which add a certain piquancy to certain kinds of painting, but not for long.

So when we admire some natural object, it is merely because the harmony of form and colour affects us? No, it is because, above all, we have an instinct in us, and at times an awareness, more or less conscious, of the ordering of the universe: and the object we admire answers to that order, and reveals to us the measure of its adaptation.

Diderot wrote these astonishing sentences, which are very modern indeed:

"*Michael Angelo gave to the dome of St. Peter's at Rome the most beautiful shape possible. The geometer De la Hire, struck by this shape, drew it to scale, and found the outline to be the curve of greatest resistance. What was it inspired that particular curve in Michael Angelo, among the infinity of others he might have chosen? The day by day experience of life. This it is which suggests to the master builder, as surely as to the sublime Euler, the angle of the buttress which is to save a wall from falling: and also*

A surprise.

The outskirts of Cairo as seen from an Aeroplane.

teaches him how to set the sail of a mill at the angle most favourable to its rotation."

This explains also, how it is that motor-cars, aeroplanes, boats, race-horses, appeal to us in proportion as they are efficient in eluding the resistance of the forces which we know and feel are in opposition to their speed. Seemingly, our works must also obey these natural injunctions: tiny universes harmonised with great ones by means of that relay, man.

The sea moves. In that infinite monotony nothing catches the eye. Suddenly a wave unfurls its perfect spirals. The sea is performing a precise act. It is as though the whole ocean were compact in that perfect wave. Sometimes nature seems to have attained the creation of a perfect type: that is, has objectified a conception clearly formulated. A law has been adhered to closely. Thus we are enabled to read one of nature's metrical verses. It fits in well with our geometry.

Bees construct their cells to an obvious geometry: solutions crystallise out in constant forms: waves are propagated according to curves that can be formulated and reduced to equations: capitals curl on themselves like Ionic shells. Joy for the senses and the mind. The geometer, the analyst, at the same moment light on concordances that seem miraculous to us. Is the world geometric? Is geometry the thread that man has seized which links all things? Or is it that the laws which guide the brain are geometric, and so it is able to perceive only what fits into its warp and woof? The fact remains that seekers discover either algebraic or geometric relations. The abundance of concordances has caused the wisest critics to affirm, that if a particular hypothesis be justifiable, the others certainly are not. I believe, rather, that in such multiple concordances the proof should be seen that everything depends on the laws of our intelligences, and that the diverse modalities of geometric or algebraic analysis, since they are but diverse forms of our thinking, must inevitably harmonise with each-other. They but render, in various languages, the same phenomena.

Everything appears to develop according to mathematical "forms," which happen in fact to be elementary forms of the language of art: of all the arts. It is inspiring, but the contrary would be incomprehensible to us: yet what is most astonishing is that we are astonished by it. How could geometry and algebra, abstract transfers of the concrete universe, not reveal systematic concordances between us and the universe?

Mathematical constants adapt themselves equally well to Egyptian or Greek art. They apply also to those natural objects we call beautiful. Does that mean that artists were conscious of nature's norms, and used them in their art? Or does it mean only that every effort of creation, to be truly great, must submit to certain constant laws? We cannot say. Yet it is true that the Egyptians, Arabs, Persians, and certain men of the Renaissance like Piero della Francesca and Leonardo, were mad on mathematics, and applied certain arithmetical or geometrical principles to their art. On the other hand, we can assert, that although certain moderns ignore such principles, there are many who pay great attention to them. What is important is to be able, even remotely, to intuit or feel certain constants. It matters little whether they be arithmetical, geometrical, logarithmical, ot appertain to some other system: the important thing is that they should be present. If

they are, even though too uncertain to constitute a precise technic, yet they will be certain enough to fecundate a trend, a spirit, an ethic, an æsthetic.

That is why art, in the highest sense, cannot be free. For a work to be great a certain harmony between man and nature must come into being. Fine naturally beautiful things are the product of instinctive art. Nature, instinct, intellect, sometimes converge, blending into forms that inspire us. When the artist succeeds in creating some such miracle, it may be he is unveiling the abscissa and co-ordinates of the perceptible universe: or alternatively, those of our deepest depths: which comes to the *same* thing.

I suggest that it is possible that forms are the consequence of a sort of call from space! Matter, by which I mean the densest waves, would appear to infiltrate itself, as into a mould, into such space as offers least resistance to it: it then becomes perceptible to us.

How much more beautiful and moving is the universe when conceived as ethereal palpitation of those waves which make up all things, and yet are nothing if universal laws have not moulded them into structures perceptible to our senses and intellect, which themselves are adapted to the universal structure, and to us. Out of chaos we make a world, a consequence of art, which in return reveals our proper structure to us.

Structures are all we can perceive. Thus it is that the universe is only " structure," and that the Artist is the God of man. This phrase has a double meaning. I wish it so: it is an analogue: Kabbalistic.

The least thing in the world, the tiniest note of sound, the smallest form, the least idea, bows its head to a universal injunction, for which the Titans of the spirit have provided the plausible equation. Pantheism of the law of waves! God, in fact, who vibrates: and each of whose vibrations, crystallised into a system, is a being. A work of art, a structure of twofold significance: concordance with the universe, concordance with man.

The artist must grow familiar with these links. Then his spirit will be attuned to those detectors, senses, mind and heart. The universe does not lie merely in the artisan's ten fingers.

⎰Only the spirit has the power of unanimously embracing contra-
⎱dictory aspects and fusing them into one. ART is that fusion.

No true art without such an attitude! The great of every age, in every art, have been those for whom the world of appearances was but one melodic aspect of universal harmony: for a poet, I once wrote, or for a painter, or a scientist or musician, a glass of water is not only a glass containing water.

If your imagination be lethargic, you must look deep into a piece of rock crystal, or take in your hand a stone axe: meditate Einstein's six formulas

which reconcile all possible phenomena, or listen to Bach : or it will suffice simply to watch a bean take root. Some mysterious operation then takes place in us, we perceive those natural syllables which penetrate deep into our unexplored hearts : and, without our knowing how, they reveal the correspondences in all structures. Identify ourselves with the bee when we see its hive! Does the bee know what a structure is? It makes one, and that is our link : nature itself, without aid of insect or man, creates the salt *trémie* : and that is our link with her. We translate the steps of saline crystal into the great staircase of Versailles, in spirit climb the stairs. Conversely, that staircase turns into a crystal. A flower is no longer one of nature's smiles, nor sixpenn'orth at the florist's, but magnetic waves directed along certain axes, so rapid that they become matter, colour. And if the colour of the rose be a wave of a certain frequency, as no doubt its aroma is too, that etherealises it still further.

Reality is metamorphosised into a prodigious agglomeration of vibrations, obedient to equations that are majestically simple.

This immaterialism is very far from materialism. With heads held high and feet solid on earth, let us seek out the norm that underlies all aspects,

and organise primary forms in structures permanent and impressive to all eternity.

In studios, in studies, we have always heard urged, either the complete rupture with nature, or the "return to nature" : and that by means of the most material and limited of our senses : but in opposition to these I suggest that we cling to it, but in spirit. That does not mean gaping at nature lackadaisically, with a palette on your thumb.

Diatom seen under the Microscope.

The Nebula of Andromeda through a High-Powered Telescope.

Be it said in passing :

Andromeda : hundreds of thousands of million times greater than the earth.

Man is nearer the atom than the star.

10^{27} *atoms compose his body.* 10^{28} *human bodies would provide the material to build a star.*

It is by studying the stars that we have been able to conceive of the structure of atoms.
(" Astronomy.")

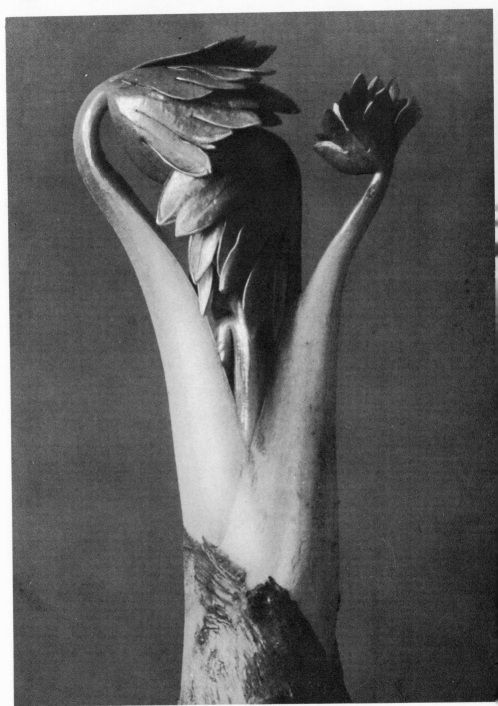

Daphne.

It is what is not seen that should be painted: art is the rendering perceptible of mystery.

ANTÆUS, son of sailor Neptune, regained his forces by reclining on his mother Earth. He was vanquished when Hercules held him suspended in his arms. His power ebbed like a lake cut off from its springs. Profound myth! Thus we empty ourselves when we cease to draw our nourishment from Nature.

Nature is not merely what she appears to be. It is not enough to sit down in front of her and represent her in painting: she is inimitable, because the emotion does not issue from the fragment we happen to be copying, but from the ensemble of all the things that surround us, of all that we intuit without perceiving, of all that lives and works in us, and that our awakened senses reveal or guess at. A work painted "after" something will never be anything but an objective "parcel of reality," empty of all subjective emotion.

Nature must be contemplated anew if our batteries are to be recharged, if our sense of astonishment is to be quickened. Then, when even two apples or a pipe are painted, a harmony will be manifested which will have affinity with those emotions which only nature can evoke. It is not possible to paint false, if youth be thus maintained.

Holidays were invented that we might abandon ourselves, breathe in real air, in sunlight, vivifier of red blood-tissues, or of green: green sprouts of young ferns, the geometry of whose spirals exalts the soul, clean-cut, yet warm with all the mystery of life. Bathe our eyes in the sky's blue depths (no ultra-marine, that!). Take in your hand the little creatures that crawl or fly: the velvet moles, tender sparrows, hieratic insects, microscopic necessities of the universe, infinitesimal earnest creatures, active and worn by a destiny as obscure as our own. Forest, mountain, ocean; we must indulge in them that we may cease to fear either the depths or heights.

We must lie flat and stretch out on the earth: everything changes when we take up the position of the newly born or dead. Seeing things from a height of five feet six inches when we are erect, shows them as at our service: the world is at our feet. But stretched out, the blades of grass about us become forests, and God's creatures beneath our eyes equal to us: our blind egocentricity corrects itself, because we see where we stand in the ensemble of things.

Saturn, trembling in the crystal lens of the telescope, makes us ponder as a glow-worm does a child: so too, the Milky Way generating universes, or a sleeping seed that a touch of moisture brings to life under the microscope. Roses of Jericho, Brownian movements of constellated atoms, no matter what, must be seen under the microscope: and then our gaze must be turned within, upon our own abyss, in search of that ineffable axis which is the abscissa of the vast Whole.

WAVE STRUCTURES.

FILMS.

STRUCTURES.

Steel Skeleton of Dirigible.

Microphotographs of Radiolaria and Diatoms.

STRUCTURES.

The Moon.

Sky.

Earth.

STRUCTURES.

Saturn.

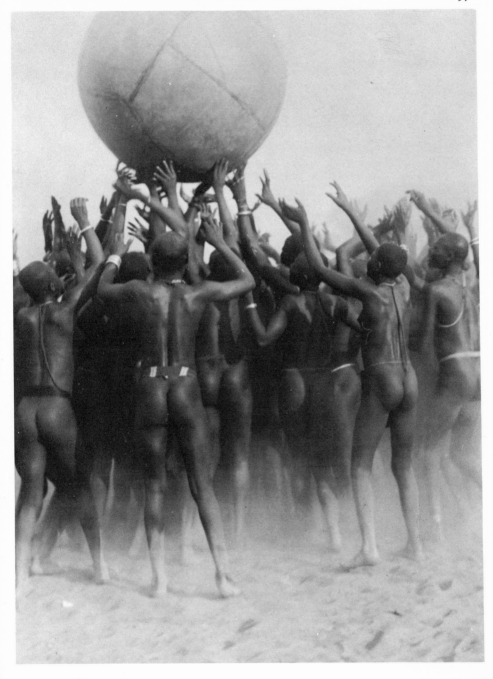

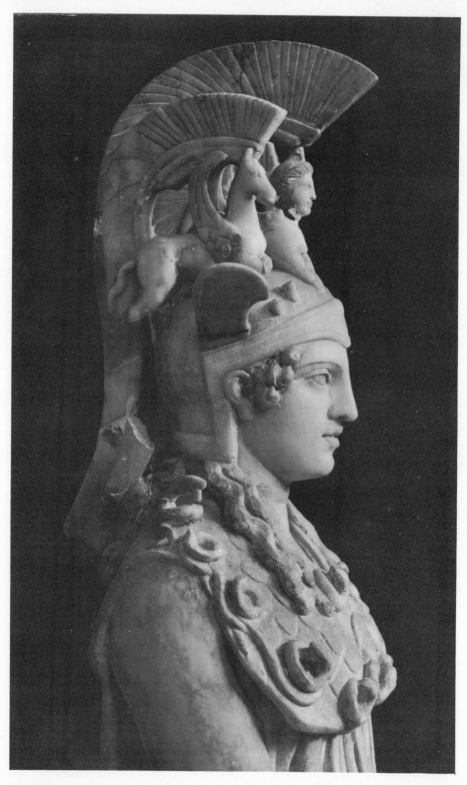

" Commercial" reproduction of the Athena Promacnos of Phidias. Our commercial art . . .

CREATE!

A NEED: an anguish, a restlessness, a buzzing: something is deeply moved in us: there is an uneasy disturbing throbbing: we feel the need to create. And that that need shall be realised, that a stray limb shall be grasped and dragged to the light, we must explore ourselves.

A diver's effort, descending or rising again from the sea bottom, must be made: an alternation of somnambulism and clairvoyance. Then everything fades out, the thread breaks. Gazing deep into ourselves, we seek again to make the circuit. By degrees, from the mist of the unconscious, there issue elements that are all but definite: we hook something relevant to us, but tenaciously it resists. And, surrounding all these fragments, there is night. Those summits which, half waking, we have seen surge forth, grow clearer. We unveil, or rather we image: to image is to give form to our dreams.

Our lucidity can, then, lend itself to help adjust the scattered fragments. The act of composition lies in finding the means of rendering perceptible such imaginings: objectivising. But will mankind succeed in crossing that bridge? Have his elaborations universal interest? Judgment must decide. It is a good thing to have an assured technic, but a keyboard must be ready.

The art of composition is the disposing of inspiration on such a keyboard.

We must not sow seed in our fields until we know that it is no weed we are sowing. Every work of art is determined from the first gesture, for every portion of it must depend on every other: the same thread must weave it throughout, each element must complement the next. Not all our ideas are worth-while or fecund. Too often we believe there will be plenty of time to deal with difficulties when they arise in the course of the work itself, but that is a grave error. The work must issue from the conception that lies behind it, as normally and fatally as a creature which comes to birth, must all its life, develop along the lines of the initial impulse.

And when, after protracted discipline, the creative effort can be envisaged in all completeness, then make the draft. From that moment no fundamental change can take place: it is either good or bad. But the attempt must be followed through and realised as completely as possible. That is what I mean by a draft.

Then carry the work out in final form, perfecting always. And here will intervene the craftsmen's conscience. Perfect; but do not overdo!

In this manner conception and realisation will bring to birth works of art which will not call to mind forceps, but instead, climb naturally like rockets, the laws of whose trajectories exist before ever they are fired.

We can no longer accept those works of art which are full of bits and pieces and afterthoughts: painful as a bad presentation extracted limb by limb and sewn up afterwards: books badly conceived, vacillating thoughts. What we want is the finest work, bearing witness to the meditation that conceived it. Execution is but the fine realisation of a conception ripened in advance. The work should be the most precise approximation to how it was conceived.

In art the decisions are always "on points." How unfortunate that the best works cannot "knock out" the worst!

PURE ART

PURE art is not what is achieved: purity, as I understand it, is a maximum efficiency, intensity, and quality issuing from an utmost economy of means. Our brains are so made that we inevitably respond to the restrained eloquence that is able to express itself economically and finally. That same tendency determines primary forms, as, for instance, the egg, or the rocket's flight. If the egg be slightly asymmetrical, we dispose of it with the less pleasure. Rockets have been invented that twist about, but the ingenious contrivance that complicates the laws of their trajectories, makes them displeasing to us: like those fine feathers or lovely heads of hair that have been forced into waves. How infinitely more moving is that youthful classical rocket which so clearly bows to both speed and gravity, the one impelling, while the other restrains, its incandescence describing an exact equation for our senses and our spirit. We are aware at once of the dispute between the two antagonistic forces, the former slowly ceding to the latter, according to a fatality intuited by our instincts, complacently approved by them, foretold by our calculations, and perceived as a parabola by our eyes. A lyricism that inspires because of its threefold effect upon our feelings, sensibilities, and spirit. Nothing is more lyrical than a rocket, nothing more exact.

In art, therefore, such inevitability must also be present. Everything in a work of creation must be and appear to be the pure resolution of these problems. An immense difficulty!

ELEVATION

ART is the very apex of human effort. Art, but not everything that answers to that name. Generally, the beautiful is said to be what pleases,

but that is false. Great Art is that which elevates. All the rest is but pastime, trifling sensation, the limited inventions of specialists: quite unimportant, in fact. But to attempt to issue from the present confusion, which puts master-pieces, insipidities, and " too-sweet " creations in the same sack, we must yet again (but for the last time) go back to the Deluge and define Elevation.

Judas betraying Christ! Does that elevate us? I defy anybody to go on whistling naturally in a cathedral. Of course, it can be done purposely, but only by outraging natural feelings, and thereby implicitly acknowledging that certain facts have all the potency of a categorical imperative. The fact that we are inevitably moved by certain human creations, certain forms or combinations of forms, sounds, ideas, colours, demonstrates that we are detectors tuned to register certain relations of sounds, ideas, forms, colours. Tropisms!

Certain of these phenomena affect us in such a manner, that we experience what, in the case of the cathedral, we should call Elevation.

Every masterpiece of every art, be it pleasing or displeasing, makes us conscious of that irresistible force. That token makes manifest the master-pieces that certain lives have been, that certain works of art are.

There are people in the world who do not care for elevation and much prefer a cocktail; yet if Bach happens to be played in some café, the drinkers are moved. In Rome, in that tiny chapel where Michael Angelo's " Moses " is enthroned to all eternity, the tourists' silence witnesses to the grandeur that enthrals them. In Italian churches the voices are loud, but in the chapel of the Medicis, in Florence, the quiet is disturbing, potent, like that which precedes the storm: the voice of a dead master makes itself heard.

It has been said that a masterpiece operates like a natural force, and it is true that the great forces of the universe have in them such power as elevates us. The great forces of art dominate and silence in us the chatter of our passing individuality and recall us to the sense of our pettiness: thus for a time they deliver us from the burden of ourselves. When we descend from the mountain we are for a while better. Thus it is when we frequent masterpieces: they make us forget ourselves.

BEAUTY

WE must be grateful to the dictionary "Larousse," for so exactly revealing the common error. Beauty: "what is pleasing to the eye or spirit."

Masterpieces are practically never pleasing. Their effect upon us is too striking for the definition of "pleasing" to have any true application. If M. Larousse had looked at the Sistine Chapel, Notre Dame, the Parthenon: if he had heard the " Pastoral Symphony," Bach, or read Shakespeare or Sophocles, all beautiful things, would he have called them pleasing? The

editor of the Dictionary must have been thinking of comic opera. No doubt his favourite writers and painters are the free and easy collaborators to *La Vie Parisienne*.

All we can say is that the feeling of elevation gratifies us. To say it pleases us is, as an explanation, inadequate.

The truth is that a masterpiece inevitably calls forth strong emotion: some feel pleasure because of this emotion, but others feel pain: we must have nobility ourselves to be able to support grandeur. Beauty, one of man's essential yearnings, is the feeling of being raised up. There are no glorious ascents without fatigue, and for that reason the greatest works are not pleasing.

To say that a work pleases or displeases us is to gauge the emotion that we feel, and first of all to observe that it moves us and brings us to a state in which our kinesthesia, our personal disposition, leads us to react negatively or positively, agreeably or disagreeably. As though it were the examination marks given by a necessarily partial examiner. Whether the work pleases or displeases depends on the onlooker and not on the work.*

But now let us be quite clear! I do not mean that beauty is what is tedious. Watteau even, can at times elevate one, Mozart always, Cézanne often, and, from time to time, Renoir.

THE SUBLIME

EVEN as I begin to speak of the sublime, I ask myself if the word even will be understood. Assuming things continue thus, dictionaries will soon be suppressing it as obsolete, completely meaningless. Haydn, Mozart in "Don Juan," and the "Enchanted Flute," transport us into the sublime: Wagner imitates Mozart, but heavily, and makes of the sublime the trashy finery of the stage: the false romantics destroyed all consideration for the sublime by calling their swollen, flabby bladders by that name.

Nevertheless, it is indeed the sublime we experience in contact with every effort of creation capable of elevating us. But those of our own age, who take pleasure in what is facile, will hardly accept my fundamental idea that the aim of art is to be "great," and that the sign of the most elevated greatness is "sublimity."

I write, and I am certain I shall be mocked by the wags, for whom I care nothing. Such wags sneer at Art from the lofty heights of their pettiness. For them "Great Art" is but a joke: a picture made of human

* *This conception of beauty explains the differences in the appreciation of works of art. In minor epochs minor folk understand nothing of beauty, and only appreciate what gives them pleasure.*

hair is as good as the "Gioconda" to them, better even, because it amuses them more: an 1870 paper-weight of glass is worth all the Poussins on earth to them: Delacroix is an old bore! We are no longer children; we want to be amused!

One art only counts. Great Art. Enough. Or would you have me set deaf old Beethoven at your heels, or Bach and his twenty-two children?

According to the Dictionary.	*I suggest.*
BEAUTY, *n.:* What is pleasing. PLEASE, *v.:* To be agreeable, charm the mind or senses. (Larousse.)	BEAUTY : The feeling of elevation.
PAINT, *v.:* To represent by means of colour. (Darmesteter.) PAINT, *v.:* The art of representing an object, a scene, a being, by means of colour. (Larousse.)	PAINTING : The organising of optical phenomena in such a manner as to create sensation, the associations connected with which provoke thought and feeling. Good painting elevates.
SCULPTURE, *n.:* The art of sculpting. SCULPTOR, *n.:* An artist who sculpts. SCULPT, *v.:* To carve with a chisel. (Darmesteter.)	The only difference between Painting and Sculpture and Architecture is that of technic. Painting works with the *illusion* of space, while Sculpture and Architecture work with *space* itself.
ARCHITECTURE : 1. The art of constructing edifices. 2. The proportions, the architectural character of an edifice. (Darmesteter.)	FREE ARCHITECTURE : Sculpture on a large scale. UTILITARIAN ARCHITECTURE : One of the functions of the engineer.
PROSE : Form of speech not subject to metre or the rhythm of verse. (Darmesteter.)	PROSE : The art of creating sensations, thoughts, and feeling by the artifice of words : (*a*) Utilitarian prose. (*b*) Free prose : transmission of sensation, thoughts, feelings; its quality is in proportion to its capacity to elevate.
POETRY, *n.:* A work in verse. (Darmesteter.)	POETRY : That art which associates with the medium of free prose, the abundant possibility of inhibition of the critical faculties by rhythm, elliptic forms, and music, every method being legitimate if elevated emotion results.
MUSIC : An art that provokes certain feelings by means of melodic progressions or harmonious conjunctions of rhythmic and metrical sounds. (Darmesteter.)	MUSIC : Darmesteter's definition seems adequate. Add only : Fine music elevates.
DANCE : Succession of cadenced movements of the body, to the sound of instruments or the voice. (Darmesteter.)	DANCE : Symphonies of form interpreted by means of the human body in movement. Fine dancing inspires feelings of elevation.

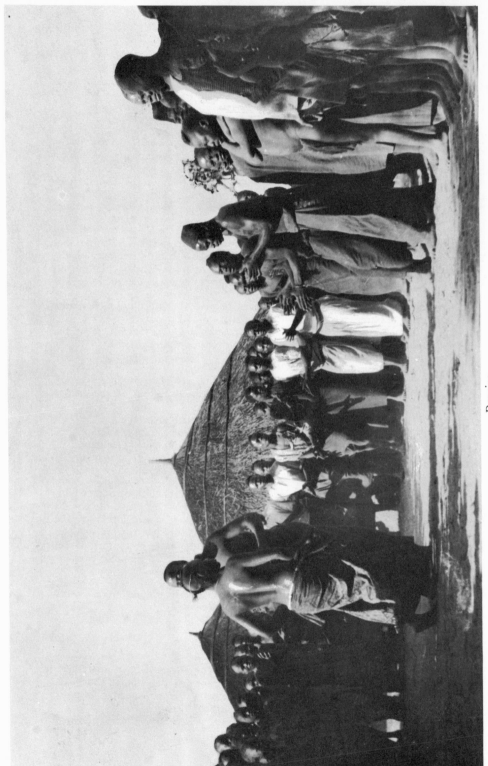

Dancing.

DISCIPLINE OF THE ARTS

2

MUSIC

The following chapters on Literature, Music, and the Speculative Sciences are but canvases for the more elaborate development of the ideas already put forward: what I say below should apply also to the preceding chapters and complete them.

MUSIC is the most direct of the arts. Its effect upon our senses is immediate, and no pretence of any kind of imitation intervenes, as in the arts which depend on sight. The harmonic fibres of our ears respond to sound, and the associations bound up with feeling are released. It is as though these vibrations were able freely to modify the motions of our affectivity. Not alone this, for when the music is great and intelligent, mental harmonies waken in our spirits.

The problem of music would be less obscure, if we could agree to stop talking of it as a miracle, swaddled in a great deal of writing.

It is usual to distinguish sounds from noises, and to accord to the former the right to be considered music. An outworn convention! After jazz, noise has a freeman's right in the city of music, for the simple reason that it is capable of evoking emotion. Do the jagged sounds of Wagner or Berlioz lead in any direction other than of noise? To wish to reduce music to those sonorities called musical, or to admit as legal only those notes situated at regular positions in the scale (which are always of arbitrary construction), is a pretension analogous to that of the Impressionists, who excluded mixed colours from their painting, on the grounds that they were not pure primary colours. Sounds termed non-musical, *i.e.*, noises, are sonorous substances comparable with those coloured tones so difficult to identify in the spectroscope. Yet they are very individual to our senses, as, for instance, the colour of the earth, of trees, of sky, complexes of every sort

of compounded colour-sensation, acting and reacting each upon the other. Noises are sound complexes.

There are no false notes, or forbidden or illegitimate sounds, in the sense that if need be, even cacophony can be a medium for art. All means are good if they contribute to that elevation of which I have spoken. Certain brutal or cruel chords, create effects which it is right should be made use of if they help expression. In any case, it is this same liberty which timidly, little by little, is coming to be accepted under the name of dissonance. Enough time had to elapse before the "triton" that caused so much stir was accepted: people disliked it. And the same was true for certain conjunctions of sounds, tones, forms, or painful ideas, which today are constantly in use, even in Conservatoires, the École des Beaux-Arts, and the Institute.

No more than in the other arts is it a matter of pleasuring or agreeably caressing the senses, but only of affecting them. Scales are but sample-cards, chiefly in pastel shades.

Harmony was an attempt at systematic classification. Praiseworthy enough, it would have been fruitful, if the idea of doing nothing that might jar upon the ear, had not spoilt everything from the start.

Much of my argument in this book has been to demonstrate the slavery of the other arts to their imitation handcuffs, my aim having been to discover a method which, casting off arbitrary laws, might discover new and eternal ones.

It is this task I leave to the musicians in so far as it concerns them.

What I have said of the plastic arts dispenses me from repeating myself here; those who will have followed me undoubtedly have the sense of analogy, interpolation. I would ask them to call to mind the chapter dealing with formal elements, comparing sound with form, and to reflect how associations link up with them, and how such associations can be controlled by choosing such only as are stable.

Music is a structure entirely comparable with that of visible forms.

I refer once more to my definition of Modes as the fashion of expressing a state of thinking and feeling.

5

LITERATURE

WORDS are symbols whose sense depends entirely upon the conventions specific to each language. As a result, you have writing's extreme difficulty in being universal.

A phrase translated, is usually nothing but a bare skeleton. It has no rhythms of sound, no over or under tones, no etymological, grammatical, or syntactical allusions.

Universality is always the sign of greatness in all the arts. And it is that which makes the greatness of both science and music.

Goethe is great in all languages.* Shakespeare and he, it is true, lose something in translation: but in French, in Japanese even, they remain immense. Faust is not just German, Plato Greek, Newton and Byron English: their speech is that of thought and feeling, and, as it were, the very cast of our own structure.

A great Russian writer can be published in Turkish, translation only being needed. And if the music of the Russian words were lost, would that be irreparable? No, for Stravinsky would always remain. Dante when he began the *Divine Comedy* hesitated whether to write it in Italian, Provençal, or French.

There are some people who question the universality of art. They say: "Chinese music means little to us." But does jazz mean nothing to the Chinese? It moves them despite their conventions, and there are *palais de danse* in Pekin. Chinese music is super-refined, but for the Chinese themselves, is it, after all, any more than a lulling caress, a delectation of the tympanum?

The "Pastoral Symphony" might seem gross to a refined Manchu, for

* *Certain poets, critics, writers, have, because of this affirmation of mine, decided that I understand nothing at all of poetry. Very well. On Friday, the 11th of October, 1929, comparing a translation of "Faust" in my possession with that of Gerard de Nerval, I read as follows: "I feel no longer inclined to read 'Faust' in German, but in this French translation it seems altogether fresh, new, and clever." (From Eckermann's conversations with Goethe, January 3, 1830.)*

Goethe says, further, in "Poetry and Truth" (Part III., Book XI.): "I revere the rhythm as well as the rhyme, by which poetry first becomes poetry; but that which is really, deeply, and fundamentally effective, that which is really permanent and furthering, is that which remains of the poet when he is translated into prose. Then remains the pure, perfect substance, of which, when absent, a dazzling exterior often contrives to make a false show, and which, when present, such an exterior contrives to conceal. I therefore consider prose translations more advantageous than poetical for the beginning of youthful culture; for it may be remarked that boys, to whom everything must serve as a jest, delight themselves with the sound of words and the fall of syllables, and, by a sort of parodistical wantonness, destroy the deep contents of the noblest work. Hence I would have it considered whether a prose translation of Homer should not be next undertaken, though this, indeed, must be worthy of the degree at which German literature stands at present."

I had not realised that I had thought just as the great Goethe; doubtless we are both right, considering that the thoughts of the Great Master have, after a hundred years, cropped up again in me.

** *Gerard de Nerval mentions that "Goethe wondered for a moment whether he ought not to write his works in French."*

the very reason that the decadent of today, prefers a "modern" figurine to some magnificent Easter Island idol, and a complicated musical trifle to the impressive tom-toms of Thibet. But it is Easter Island that prevails against Monet, Beethoven against the Chinese, Goethe against Mallarmé, the Thibetans against the Conservatoire of Music.

Literary constants! Thoughts, feelings, and sensations of universal interest as signified by the word "universal"; that is, having their equivalents in all tongues.

There must be no more of that special literature local to Paris and its outlying districts, books to be read by at most a thousand people. Paris in this respect is merely provincial. What we want is a literature of daring enterprise inspired by powerful conceptions. Solid thinking that will stand up to changes in climate, rising from the solid foundations of our constants. If a thought is untranslatable it is because the idea behind it is purely local. *"This said in Piedmontese was altogether more energetic and appropriate,"* wrote Stendhal. So there we have it: the idea was too "Piedmontese." Often we are too Parisian. It is our ideas that should have resonance, not our words.

For instance, I read in that most prosaic paper *The Auto:*

"A TOUR IN THE ATLAS MOUNTAINS"

"Does fishing mean anything to you? These children sitting on the edge of cliffs plunging vertically a thousand feet, their legs dangling in the void over the terrifying gulf, cast into the abyss their supple bamboos, baited according to the most ancient traditions of their race. And the bait is a white feather, for they are fishing for the birds that wheel upon the void."

It is not a poem, but how infinitely more poetic than so many " poetical poems" or what are considered such! There you have, clearly exposed, the mechanism of the interactions of poetical fact, material translatable into any language. (Intentionally I chose out this example from the general news columns, in order to demonstrate how poetry functions.)*

Another example:

"It is enough to lift a hand on the earth to modify the force of gravity on Sirius, or, more modestly, to cast a stone into the waters of the Seine and raise the sea level at San Francisco." (Daniel Berthelot.)

* *I said earlier that the newspapers, even though little given to literature, often provide rich pasturage in the way of the poetry of events, the interest of events.*

We have had enough of phrases that mean nothing: enough of word posies, of painting and music in literature, of hind foremost and harlequinades.

Less of obvious art, but more of necessary art! Cicero said: *"There is an art of seeming artless."*

I dream of a poem that shall be FINER IN TRANSLATION. It will be purified of everything that is not worth the saying.

*

WHEN have I said that the beauty of words was futile? I merely think that it is not everything.

*

WHAT has been said about human culture applies also to writers: we do the best we can, and our best is according to our deserts. Deserving implies training, training concentration, concentration effort. Effort of the brain.

There is no great achievement that does not come from a great person. How can so many authors resign themselves to be so petty! How incompetent, technically!

4

SCIENCE

IN this section there will be nothing relative to science in its technical, experimental aspects: but its philosophic implications will be considered.

Unreserved must be our admiration for the gigantic labours of the profound experimentalists of the nineteenth century: to them we owe an enormous accumulation of facts: a palette, in fact. The danger of analysing the infinitely small finally resulted in a sort of myopia. The search for variations obscured to some extent the significance of constants. Those who, like Darwin, Haeckel, Comte, were able to liberate themselves, went to the other extreme, hypermetropia.

But harmony was established: Berthelot in particular had a remarkable capacity for synthesis. It would seem as if our own age is able to ally extreme precision in measurement with width of outlook. Vast concentrations of knowledge, like the formulas of Einstein, come into being. Rigorously dependent on the findings of the most meticulous analyses, they trace the majestic parameters of a new conception of the universe. They integrate everything we know and still allow for all we yet may know.

Contrary to the general idea, the syntheses of science do not spring into being solely in response to our curiosity. They are instead the pasture of

what in our spirits rejoices in harmonious forms. But chiefly it is the most elevated hypotheses which move us most, affecting as they do those spiritual planes where the problems of our being come into question. Science is a palliative to our need to know.

The bread the scientist offers us is not the pure flour of truth, but still it is eatable and tastes good. Nor is science the less useful, though it be relative: for it still makes us wonder.

If the themes on which the other arts are based are eternal, because of the stability of our feelings and our senses, science too, is stable for the same reasons. The solutions offered by the Alexandrians seem out of date only to those mediocre people who believe that science, the later the better, is synonymous with ultimate truth. But for us, who know that truth in its essence must necessarily escape us, it is from the point of view of " structure " that thought, feeling, sensation, as applied to differing systems or cosmogonies, are appreciated by us. Their many so-called antiquated theories, even when contradictory, are poems which assuage.

The scientist who believes that something which is merely a new modality is a definitive truth, would be committing the fault of the modiste who believed her latest creation to be eternal in its significance. A person given to generalisations should therefore refrain from attaching too much importance to " new discoveries "; they are new themes merely. Thus the painter, the writer, and the musician who call themselves modern, because they draw their inspiration from modern subjects or objects, and the thinker who trots out a credulous ode to the last theory, all date very quickly. Not him, however, who, within the bounds of relativity, and resigned to our basic ignorance, does homage to the imprescriptible categories which make up our beings. Whatever the attitudes of tomorrow, Pythagoras, Heraclitus, Plato, Descartes, Fontenelle, Condillac, Buffon, Lamarck, Poincaré, will lose nothing of their interest, or at least of the structure of their thought: for the form and method they have left us are eternal.

To reveal basic syntheses, the interdependence of all that is or seems, is an inexhaustible project. Such aims cannot but be significant to us, since the promulgation of such laws is inevitably part of our human nature.

Which is not to say that science is to be made romance: but that scientists should not lose sight of the fact that we are human, and that the secret chord which, when plucked, animates us, is identical with the infinite harmonies that link us with the universe about us.

Science, like certain limited companies, has changed its purpose: it set out to say the final word, and has instead become one of the arts of illusion. Its creations are but eloquent similitudes. The dividends are excellent, but that is why I have had to rank it with the arts.

What alone truly interests us, is what fits in with our fundamental

make-up, the image of which must always prove affecting when its pure lineaments take shape before us. That is the science which gears into our mechanism, and sets in motion our profoundest instincts. Stripped of the divinity with which the nineteenth century endowed it, it gains in humanity and in art.

The Einsteinian attitude of mind, upon reflection, is revealed as a magnificent seeking after what is constant in variation: a constant from varied angles, stability in mutation.

An example of the humanising of nature to serve the needs within us, is the attempt to reduce to an electro-magnetic monotheism all "universal" forms, its various aspects being but diverse structures of the one God "vibration." Co-ordination! This science is sister to the arts in that, passionately, it seeks out constants and their underlying unity. This is the trend that in science, and in everything, moves us: the impulse that relates the polymorph to the underlying unity, and which seeks always to integrate a little more of chaos into form.

Such forms being those of our senses, our spirits, and our hearts.

*

OUR ART, PRECISION

Our token is Precision.
Precision of Living.
Precision of Thought.
Precision of Technic.
The trend of our mechanism, sociology, and our politics is always towards more justice, which is a form of precision.

We desire
$\left\{ \begin{array}{l} \text{an Architecture} \\ \text{a Painting} \\ \text{a Sculpture} \\ \text{a Music} \\ \text{a Literature} \\ \text{a Thinking} \end{array} \right\}$ that will be Precise.

An art lofty,
An art sane,
An art noble, affecting that triad $\left\{ \begin{array}{l} \text{senses,} \\ \text{heart,} \\ \text{spirit.} \end{array} \right.$

Let us be clear. I am not opposing an art based on construction to an art of hit or miss. What I want to say is that art is a sort of trap to catch

us, and that, tempered hard as we are, the only trap that can succeed must be exact and categorical. An art solid against our onslaughts. Authoritative!

Something is wrong. My voice, instead of issuing clear sounds, is dead, without echo, as though overcome by the same lethargic melancholy which planes over all the " artistic " world (but over that only).

We must recover the sense of grandeur, aim very high in order not to hit low. Why should the man of today, so perceptive and so entirely adequate, when he knows how to feel and think and will, why should that man fear an art that is Great? There is in Phidias no form finer than those we can conceive today. There is nothing in Bach, in Rimbaud nothing, in Racine nothing, in Pascal nothing, to which we cannot find an equivalent in quality today. Art is inspired fire and impulse. It is a rendering of a manner of conceiving the universe and mankind.

We must learn to " comprehend " the Universe.and Man.

We must be modern, which means act in such a way that our manner of life creates an art that will elevate humanity today and, if possible, tomorrow and for ever. In short, an art that will transfuse our souls with passionate seeking!

As Vauvenargues said:

> " If sometimes the counsels of passion be more daring than those of thought, it is because passion gives more strength to carry them out."

It is usual, in conclusion, to lengthen out the periods, I know. But I do not wish it so. I am writing for such as have no need to have their ideas wrapped in swaddling bands: for those whose feet are firm and their heads held very high.

THE END

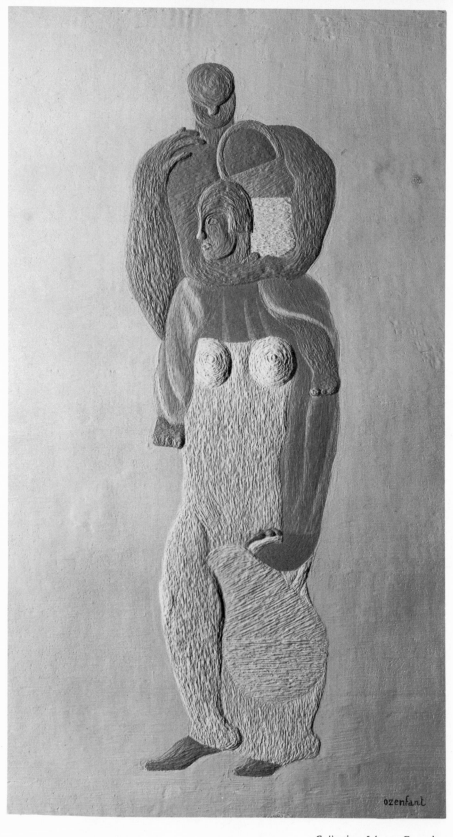

ozenfant

Collection Léonce Rosenberg.

NOTE

SOME ROYAL SIGNATURES
(page 273)

THE eminent graphologist G. E. Magnat was kind enough to analyse the signatures of certain French Kings for me. His remarks are worthy of reflection in relation to the problem of modes.

1. CHARLES VII., "the Victorious," by the grace of God and Joan of Arc: for to say true the signature is a flight, a rout. Observe in front of the *s* of Charles the small protective stroke that is like an arm raised to protect a face.

2. LOUIS XI. As great as wicked: a King whose pride is royal in appearance but bourgeois in its motives. The manner of finishing the *y,* like a whip-lash that is all but the slash of a dagger, and the manner of making the *s* as though it were a bun, are particularly characteristic. The *L,* on the contrary, has a greatness which reveals at one and the same time King, scoundrel, and opportunist.

3. CHARLES VIII. Seems eternally enthroned on a daïs and in counsel. The *s* which terminates his name is a purely decorative "splodge."

4. FRANÇOIS I. Preoccupied by order even in the midst of luxury. Seems to have organised his sensuality "conscientiously."

5. HENRY II. Quarrelsome and excitable: preferred the camp to the palace and the sword to the pen.

6. CHARLES IX. More pretentiousness than power: royal despite himself, and a coward in spite of his very convincing bearing. The *s* that terminates the name covers it, "prudently bending round itself."

7. HENRY III. The *H* is magnificent. The rest bears witness to profound changes in the nervous centres. The spinal cord is rotten: the man seems a living corpse.

8. HENRY IV. Grace, power, and kindliness: courage with no trace of bravado. Intelligence, in which "the mind is always at the service of the heart." One of the finest signatures known.

9. LOUIS XIII. Unusually conscientious: entirely meriting his name "Louis-le-Juste." But no enterprise.

10. LOUIS XIV. A truly royal signature on account of its simple and distant grandeur, not without grace. He also signed his name with no

flourishes. The flourish in this case is a simple line drawn " naturally," the line of which corresponds exactly to the circular movement of the wrist.

11. Louis XV. An elegant signature, but completely ordinary, the flourish limp and decorative.

12. Louis XVI. The signature is that of a bourgeois. Had principles and was sensitive, but without coherence: shows also hesitation and weakness. The flourish seems to relate to nothing, unless it be a sort of support insecurely fixed, which must sooner or later cause the destruction of the name it is supposed to support.

FOR

MEDITATION

*

LIFE

"'Resurrection, madame,' said the Phœnix, 'is the simplest thing in the world. It is no more surprising to be born twice than once." VOLTAIRE.

*

"What is important is to desire to desire what you ought to desire." LEONARDO.

*

"Much more would be done if people believed less was impossible." MALESHERBES.

*

"Let such as desire to perfect their persons first put right their souls." CONFUCIUS.

*

"Death comes but once, yet makes itself felt at every moment of our lives; the fear of it is more painful than the experience." LA BRUYÈRE.

*

"Omit foresight, and you will be complaining before you have begun." LEONARDO.

*

"Affected by all the objects that surround them, our senses cannot avoid being influenced either for good or ill. But man can make of his understanding the use he wills, and he is free to direct it and convey it ceaselessly in that direction which seems most suitable to him." PLUTARCH.

*

THE ARTS OF ILLUSION

"What in a short space will seem most antiquated is what will at first have seemed most modern. Every compromise, every affectation, is the earnest of a future wrinkle. But by such means Passavant was able to please

319

the younger generation. Little the future mattered to him. It is to the present generation he addresses himself (which is preferable to addressing oneself to that of yesterday). But as he writes for that generation only, what he writes risks passing with it. He knows it and promises himself no survival." ANDRÉ GIDE.

*

"I neglected nothing." POUSSIN.

*

"There are no details in the execution of a work." PAUL VALÉRY.

*

"I do not feel I have wisdom enough yet to love what is ugly." STENDHAL.

*

"Artes et scientiæ sunt consolamenta vitæ." ROGER BACON.

*

"If we question everything revealed to us by our senses, how much more then should we doubt those things which are recalcitrant to our senses, such as the essence of the Godhead, the soul, and other similar matters which are always the subject of dispute and argument." LEONARDO.

*

"Mankind within himself resumes all the laws of the universe." COMTE.

*

"Every subject seems simple and clear until that moment when we scrutinise it a little." EUGENIO D'ORS.

*

"One deludes oneself less in confessing ignorance than in imagining one knows much of things of which one knows nothing." RENAN.

*

"I am convinced a time will come when the physiologist, the poet, and the philosopher will all speak the same language and mutually understand each other." CLAUDE BERNARD.

*

"Man has a lofty understanding, but for the most part it is vain and false. That of the brute creation is less, but it is utilitarian and exact, and a small certitude is preferable to a vast delusion." LEONARDO.

*

"Two excesses: excluding reason, accepting reason only." PASCAL.

*

"Woe to the productions of an art, all the beauty of which is discernible but by artists." D'ALEMBERT.

*

"Eloquence dispenses with eloquence." PASCAL.

*

"How much art to enter into nature: how much time, and rules, attention, and labour we devote to dance with the same freedom and grace with which we walk, and to sing as we speak, and speak and express ourselves as we think." MONTAIGNE.

*

"Force issues out of order." TAINE.

*

"Great effects with little means." BEETHOVEN.

*

"A defect in bad poetry is that of lengthening out prose, while the character of good is in abbreviating it." VAUVENARGUES.

*

"He is a poor master whose achievement surpasses his criticism: he only moves towards the perfection of his art whose criticism surpasses his achievement." LEONARDO.

*

"What else is barbarism but an incapacity for distinguishing excellence?" GOETHE.

*

"We must be original without being bizarre." VOLTAIRE.

*

"The distinguishing feature of great beauty is that first it should surprise to an indifferent degree, which, continuing and then augmenting, is finally changed to wonder and admiration." MONTESQUIEU.

*

"I create according to certain ideas which my spirit conceived." RAPHAEL.

*

"*I am a painter, a sculptor, an architect: I have my art, my design, or my conception: I have choice and the preference I accord to my particular conception because of the special love I bear it. I have my art, my rules, my principles, which I reduce as much as I can to one primary principle, which is a rule also, and by means of which I am fruitful. With this primitive system and the fecund principle which together make my art, I engender within myself a painting, a statue, a building, which in its simplicity is the form, the original, the immaterial model of what I shall execute in stone, in marble, in wood, or on canvas on which my colours shall be displayed.*" BOSSUET.

*

"*He would not directly represent objects, but he would create in the soul exactly those feelings which are felt on seeing them.*" J. J. ROUSSEAU.

*

"*So many laurels which had raised their heads to the clouds soon found the earth too exhausted to nourish them. All that remained were a very few, whose foliage was pallid green and dying. The decadence resulted from a facility of creation and a disinclination to produce of their best, by satiety of beauty and the cult of the bizarre. Vanity was a protection for those artists who sought to bring back the age of the barbarians, and that same vanity, by persecuting those with veritable talent, forced them to quit their fatherland. The drones drove out the bees.*" VOLTAIRE.

*

"*Clearly, then, mode must enter into everything?*" DELACROIX.

*

"*The soul has no secrets that conduct does not reveal.*" A CHINESE PROVERB.

*

"*All great poets become naturally and inevitably critics. I pity those poets whom only instinct guides: in my opinion they are incomplete.*" BAUDELAIRE.

*

"*Never would he have believed that thought led to feeling: nor should I, yet I was much surprised to find when studying painting solely to while away the time, that it held a balm against the cruellest deceptions.*" STENDHAL.

*

"*The harmony of music results from the conjunction in the same rhythms of its related elements.*" LEONARDO.

*

"*Art is a harmony parallel to that of nature.*" CÉZANNE.

*

"*Old idiots are crazier than young ones.*" VAUVENARGUES.

*

"*Technic must always be erected on sound theory.*" LEONARDO.

*

"*What makes nobility in anything is its capacity for enduring.*"
LEONARDO.

SPRING-BOARDS, 1931

"*When Bach plays, God goes to the Mass.*"

*

"*There are only three billion seconds in a century. Art? To make us forget it.*"

*

"*People go to a lot of trouble nowadays to fabricate mystery. The Wagnerian dragon is less mysterious than a browsing cow. All the pomp and ceremony of some ultra-modern manifesto moves us less than a blade of grass.*"

*

"*They have eyes and see not.*"

*

"*Looking at organic things as if they were inorganic and inorganic things as if they were organic.*"

*

"*When I look at myself in the mirror, when I take hold of my hand and think that I am alive, I understand nothing, nothing of what it's all about. Mystery is in the very fact of existence, and not in illusion. Except for illusion, it exists all about us.*"

*

"*Art is the demonstration that the ordinary is extraordinary.*"
OZENFANT.

EVOLUTION OF PURISM

A UNIVERSAL law—of greatest economy—dictates that man, like the ass, is tempted to follow the easiest path. Some art critics have found it economical to fuse Purism with Cubism, or even with Neoplasticism.

Mondrian wrote in *Cahiers d'art*, No. 1, Paris, 1931:

"... la Néoplastique ... a continué et le Cubisme et le Purisme."
"... the Neoplasticism has continued Cubism and Purism."

Will this quotation of the father and theoretician of Neoplasticism be enough to confound certain "art historians" who consider Purism as a follower of Mondrian's Neoplasticism?

Purism could not have existed without Cubism, as Seurat would not have existed without Turner and Monet. But Purism can no more be reduced to Cubism than the Neo-Impressionism of Seurat to the Impressionism of Monet. In CUBISM AND ABSTRACT ART[1] Alfred Barr has drawn the following equation:

IMPRESSIONISM : NEO-IMPRESSIONISM = CUBISM : PURISM

Monet	Seurat	Picasso ·	Ozenfant
Pissarro	Signac	Braque	Le Cor-
Intuitive	*Rationalization*		busier
development		*Intuitive*	*Rational-*
		development	*ization*

Here: the main steps of Purism:

In my review *l'Elan*, Paris, 1916, I wrote:

"*Cubism deserves an important place in the history of the plastic arts because it has already realized part of its purist design, namely, the purging of the plastic vocabulary by sweeping out parasite words as did Mallarmé with language ...*"

But at the time, Cubism, through its shining star Picasso, seemed to have degenerated into a sort of "*rococo*" Cubism. (It was Alfred Barr who thus

[1] Museum of Modern Art, New York, 1936.

baptized this somewhat frivolous period.)[2]

R. H. Wilenski writes:

"... *by 1918 he [Ozenfant] had come to the conclusion that Picasso's Cubism was essentially empirical because Picasso, fundamentally romantic, had always worked in empirical ways. As he saw things, the Cubist-Classic Renaissance, which had been at first an abstract architectural concept, had become in Picasso's hands an art more comparable with romantic empirical painting than with the classical architectural art of Seurat and Cézanne; and convinced that great art could never be achieved by casual selection of material, he determined to do for Picasso's Cubism what Seurat and Cézanne had done for Impressionism—to convert it, that is, from an empirical art of personal expression to a new type of ordered reasonable classical art which he entitled 'Purism'.*"[3]

In 1918 at Andernos, near Bordeaux, I traced the principal lines of the movement.

A few months earlier, through the great architect Auguste Perret, I had met Charles Edouard Jeanneret (later le Corbusier); we understood each other very well. I divined in him a first-class energy; the future confirmed it.

I was worried about the way art was going; he was seeking a discipline, as this extract from the moving letter he wrote me on June 9, 1918 shows:

"... *Dans mon désarroi ... il me semble qu'un gouffre d'âge nous différencie. Je me sens au seuil de l'étude, vous en êtes aux réalisations ... je suis un maçon au fond de sa fouille, sans plan ... vous êtes pourtant, de ceux que je connais, celui qui me semble réaliser le plus clairement ce qui s'agite en moi ...*"

"... *In my confusion ... it seems that an abyss separates us as to age. I feel on the threshold of my studies, while you are carrying out your plans ... I am a bricklayer, working without any plans, in the trench You are, nevertheless, of those I know, he who seems to me most clearly to be carrying out what is stirring within me ...*"

I suggested we should work together. Five months later we both signed APRES LE CUBISME [AFTER CUBISM] and soon showed our paintings together. Between 1918 and 1925 everything we wrote was signed by both of us; all deserved to be, for each of us gave the best of himself.

Thus the strength of the Purist movement was the result of our mutual effort. It was one of the most stimulating periods of my life.

[2] PICASSO, 50 YEARS OF HIS ART, Museum of Modern Art, New York, 1946. (Probably the best book on Picasso.)

[3] MODERN FRENCH PAINTERS, Faber & Faber, London, 1940.

APRES LE CUBISME, the first art book published in France after the 1918 Armistice, was an optimistic, lyrical song on the beauty and lesson of machines and of some of their products, on buildings for use, and on the part to be played by science in art worthy of our time.

It also criticised the condition of Cubism at the time, but principally it criticised the followers of the Cubist masters. We gave our Tablets of the Law of Purism, stating that what we wished to express in art was the Universal and the Permanent and to throw to the dogs the Vacillating and the Fashionable.

By a sad coincidence the book was published on the very day on which Guillaume Apollinaire, who had supported Cubism from its birth, died. I read the news while going to the post office to mail the announcement of our book.

Many people read APRES LE CUBISME. Even Paul Valéry was interested in it.

It was launched simultaneously with our first exhibition at the Galerie Thomas in Paris, a gallery established for the occasion with the kind help of Madame Germaine Bongard-Poiret.

An amusing incident occurred. Léonce Rosenberg (who was later to become my friend and dealer) was buying and trying to sell—too few at that time— works by Picasso, Braque, Gris, Léger, Metzinger, Herbin, Gleizes . . . all the best Cubists, in fact. He had also arranged for Gaumont films to take a news-reel dealing with his protégés. Our show had just opened, and I suggested to the Gaumont Company that they should lend continuity to their film on Cubism by showing the start of Purism. The day the advance showing took place, we betook ourselves to the monumental Gaumont Palace, Montmartre. In the first five rows the glories of Cubism were seated around their manager. We saw the Cubists loudly applauding their works on the screen. Then in big print, AFTER CUBISM, PURISM, followed by Ozenfant and Jeanneret and their work. The Cubists had no idea their film would be followed by ours and we saw them curiously agitated.

Our exhibition was premature. We were clear as to ideas but less so as to how to make them visually apparent. But we worked on obstinately, painting by day in my studio and discussing at night.

Finally in 1920 we felt sufficiently sure of ourselves to found an important review, *L'Esprit Nouveau, Revue internationale de l'activité contemporaine*, in which we would work out the program we had traced in APRES LE CUBISME. It was the period of which Alfred Barr wrote:

"*By 1920 cries of Back to Poussin! Back to Ingres! Back to Seurat! rang through Paris: Back to Bach! Racine! Thomas d'Aquinas! Back to the Greeks and Romans, back to discipline and order, clarity and humanity. Benda's angry*

Belphegor, *Matisse's "Nice" period, Ozenfant's attempts to reform and purify Cubism, the apotheosis of Satie, Stravinsky's* Pulcinella, *so remote from his* Sacre du Printemps *of only seven years before, Cocteau's* Antigone *(for which Picasso also designed decors), all were incidents, serious or fashionable, of a general movement"*[4]

In the first issue of *L'Esprit Nouveau*, that of October 1920, we published an article on Seurat by Bissière, intending to make our trends clear by demonstrating one of our preferred masters. (Our review was probably the first to have a color reproduction of a Seurat—the magnificent *Poudreuse* now at the London Courtauld Institute. I recall how its owner at that time, Fénéon, an old friend of Seurat, offered it to us for 15,000 francs. Seurat was then very far from the appreciation he enjoys today. But we had no money and our jobs on the review were voluntary. . . .)

In February 1921 the second Purist exhibition by Ozenfant and Jeanneret took place at the Galerie Druet, Rue Royale, Paris. Maurice Raynal, an old friend of Picasso and the Cubists, thereupon printed a striking essay which still remains one of the most intelligent, most far-sighted ever written on Purism. In it he says:

"The exhibition of Ozenfant's and Jeanneret's works bursts like a sort of warning from Heaven. The two artists have sought to impose discipline on those who succeed the Impressionists and those who succeed the Cubists, in a word on all the future successors of any generous artistic movement . . . Unlike fashion, art must engender constant manifestations against which time cannot prevail. It is thus a real joy of the spirit that we relish in Ozenfant's and Jeanneret's works, the final upshot of a reaction against the stranglehold on art of manual skill, the effort to please, the cult of charm, and all factors whose effects are certainly irresistible but fugitive: as fugitive as aphrodisiacs . . .

"It appears that the work of Ozenfant and Jeanneret may be considered as a summons to respect and wholeheartedly bow down to the vital, primordial elements of plastic art. The beautiful is what universally pleases, *said Kant. Though we must make innumerable reservations as regards the verb "please," Ozenfant and Jeanneret direct our notice to the term "Universally," which they have made their own and in a much wider measure than Kant attributed to it . . . Their pictures are objects one is tempted to take in the hand. It is, therefore, no longer a question of a sketch or schema, or of a fragment of reality, but of a unique and complete whole. Their works are like words, words somewhat crude and divested of the charms of the adjective, words whose elements are linked by*

[4] PICASSO, 50 YEARS OF HIS ART.

*virtue of their mutual relation, relations which are needful summonses, relations
which are laws . . . It is an intuitive harmony with Hegel that they feel that,
however pure it be, art should none the less "transfigure" nature. In any case,
have we not here a consequence that results from all work of purification?*

*". . . They fear, in fact, lest phantasy, unbridled phantasy, should graft itself
upon the most disinterested efforts: they fear lest "Fauves" of Cubism appear,
like those who followed Impressionism. We speak of a summons to return to the
freshness of imagination, but even more* it is a pure and simple summons to
return to human nature. *Ozenfant and Jeanneret, in their theories as in their
works, seem to have formed the design which none had conceived of before, that
is* to teach us how to feel.

*". . . That is why, in an age which demands that the artist no longer content him-
self with being the blind, detached instrument of his feeling, in an age when the
need to strip off fragile or outworn values makes itself daily felt, Ozenfant and
Jeanneret's effort, by its sustained audacity, will leave its mark and develop as
one of the most needed efforts that ever saw light . . ."*[5]

In *L'Esprit Nouveau* we presented a series of articles on architecture. They
were signed le Corbusier-Saugnier. The pen-name le Corbusier was assumed
for the occasion to represent Charles Edouard Jeanneret; and Saugnier, my
mother's name, to represent myself. In 1923 some of these articles were remod-
elled and became the contents of VERS UNE ARCHITECTURE. When the work
was reprinted it bore the sole name, le Corbusier.

VERS UNE ARCHITECTURE was translated into most great languages. Through
this book Purism in architecture has influenced the whole world. In conclusion,
the works of Charles Edouard Jeanneret, called le Corbusier, in association
with his cousin Pierre Jeanneret, have won celebrity for these two great
architects.

At that time, however, Purist architecture still existed only on paper. The
first house to be signed le Corbusier was my own in Paris. The Ozenfant house
is often mentioned as the second of le Corbusier's houses; actually, if the build-
ing of the Besnus house at Vaucresson was completed a little before mine, the
plans for mine had been finished long before and the building of mine began
earlier.

In 1925 the partnership of Ozenfant and Jeanneret-le Corbusier ended.
R. H. Wilenski writes:

[5] "Ozenfant et Jeanneret," *L'Esprit Nouveau*, No. 7, 1921, Paris. For works of this period
see pp. 121 and 122 of the present book.

*Ozenfant's House, Paris, by Le Corbusier, Pierre Jeanneret,
and Ozenfant.*

"*. . . Jeanneret (le Corbusier), who had been trained as an architect, painted
Purist pictures while he worked with Ozenfant, and then went back to architecture,
broom in hand, sweeping away the flummeries of 'ye olde' this and that, rejoicing
in the new materials available, designing in terms of concrete, glass, and chrom-
ium, planning for the needs and possibilities of contemporary living, creating a
new Functional Architecture in Ozenfant's Purist-Cubist aesthetic. From 1924
onwards Purist-Functionalism became the guiding force in architecture, interior
equipment, women's dress, and so forth; . . . created the characteristic style of
the first two post-war decades. . . .*"[6]

[6] MODERN FRENCH PAINTERS, Faber & Faber, London; Harcourt, Brace, New York.
First edition 1940. (One of the few outstanding and original books on modern art.)

Ozenfant's Studio.

The Purist movement even influenced great original artists, which proves that the movement is "all right," as I had always hoped it would be; not a "stunt" or trick but a turn of mind, a way of feeling, an attitude vis a vis contemporary life.

> *"The monumental stability is . . . a new development in Léger's work . . . suggests a relation to the contemporary paintings of the purists Ozenfant and le Corbusier. . . ."* said Alfred Barr.[7]

> *". . . In painting, the effects of the Purist-Classical Renaissance launched by Ozenfant . . . were seen in the 1924 works by Herbin and Severini, in Léger's* Le Syphon, Athlète, Disque et maison, *and* Femme au bouquet *and in classically formalized landscapes and figure subjects by Metzinger . . . Matisse . . . may himself have been captured, at this moment, by the classical dignity of Purism-Cubism, just as in 1913-1916 he had been captured to some extent, and for a time, by Cubism.*

[7] CUBISM AND ABSTRACT ART, New York, 1936.

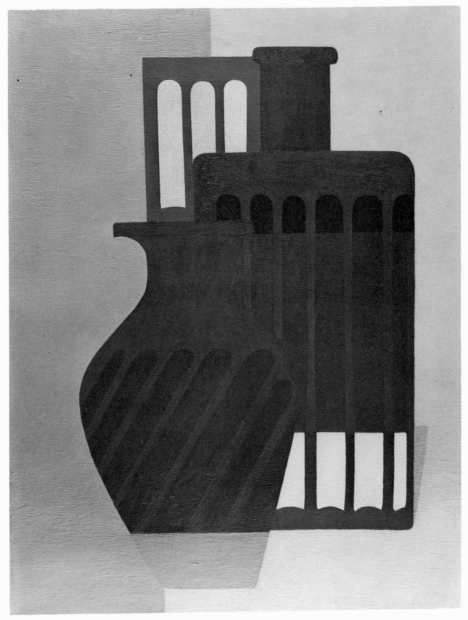

"Dorique" by Ozenfant, 1925. Collection of Museum of Modern Art,
New York.

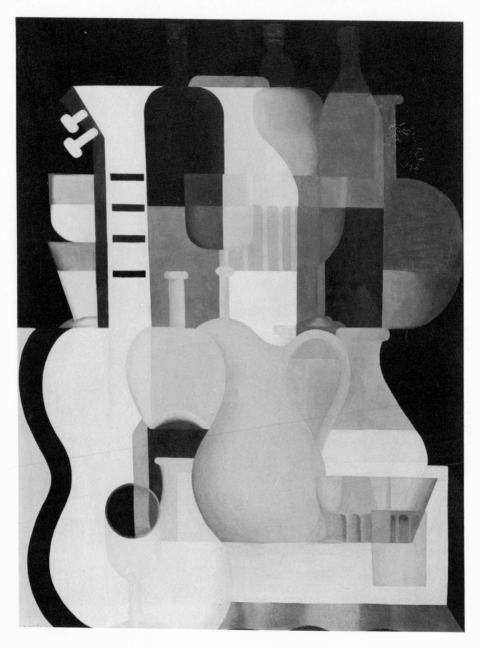

"Accords" by Ozenfant, 1922. *Art Institute of Chicago.*

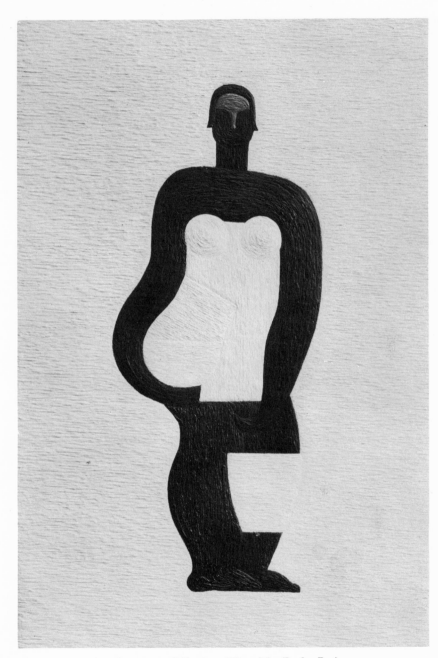

Ozenfant, 1927. Collection of Raoul La Roche, Paris.

". . . I look on Ozenfant's Purism developed to Functionalism by Jeanneret (le Corbusier) as the central artistic happening in the first post-war decade; thereafter I rank Surrealist contributions by Chagall, Chirico, and Picasso and the whole of Picasso's output considered as a series of personal gestures."[8]

Towards 1927 the human figure was re-introduced into the range of my themes: the human figure of which we had written in 1918 in APRES LE CUBISME, *"There is a hierarchy in the arts: decorative art at the bottom, and the human form at the top."*

Because we are men.

Between 1931 and the Spring of 1938, first in Paris and then in London, I was mainly occupied with my large (13′11 x 10′) painting *Life*, now in the Musée National d'art Moderne, Paris. When, early in 1931, I began its composition, I also began to write my JOURNEY THROUGH LIFE, in which I explained why I had embarked on the task. At the same time I daily noted the vicissitudes through which the painting passed as a result of political and social events, and I also photographed all steps of its evolution. (It was, I think, the first time the successive changes in a work in gestation had been photographed systematically. The experiment was later repeated by others with Matisse and Picasso, as in 1937 with *Guernica*.)

Here is Wilenski's comment on *Vie (Biological Life)*:

". . . Ozenfant's second contribution was an intensely concentrated effort which culminated in an enormous picture called La Vie (biologique)

"His works in 1929-1933 were all in the nature of conscious preparations for that major effort. Stated briefly, his aim in those years was to convert the architectural associationism of his Purist paintings to another type of associationism, another equivalent of Ratzel's 'a philosophy of the history of the human race [to be] worthy of its name . . . must be charged with the conviction that all existence is one,' another type of ordered reasonable art, designed this time to symbolize the basic unity of man's body and spirit with the eternal elements—air, light, earth, and the waters of the sea and river. For the execution of this project he built up a theory and a system as he had done for his Purist art in the old days. He set himself to fashion fixed symbols for man in his several aspects and other fixed symbols for the elements which could be variously combined to symbolize various relations. His symbols for the elements are supporting lines for the earth, and simple curves typifying the waves set up by man's contact with air and water. The symbols for man . . . are nude men, women and children, as single figures

[8] Wilenski, op. cit.

or in groups, each typifying some constant elemental aspect of man's being—love, loving-kindness, sensual delight, jealousy, melancholy, ardour, brutality, health, weakness, youth, maturity, maternity, old age, sleep, waking, and so forth. . . . *In all there were some fifty of these 'actors' in Ozenfant's repertoire from 1929 to 1933 and some appear in numerous compositions as fixed symbols for the type ideas; and all appear with hundreds of other figures in the final composition, La Vie.* . . ."

Vie ended an experimental period. This work and the previous series, *La Belle Vie*, have already had their repercussions:

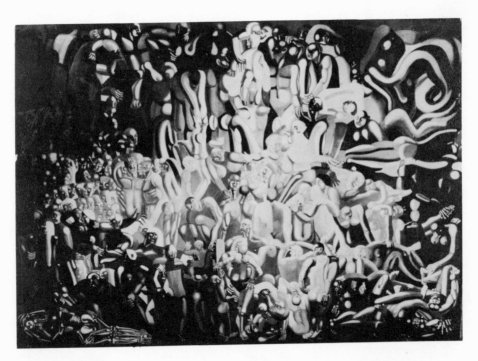

"Biological Life" by Ozenfant, 1931-38. Musée d'Art Moderne, Paris.

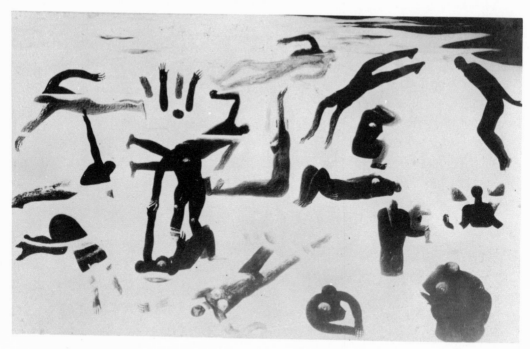

"La Belle Vie" by Ozenfant, 1929.

Detail, "La Belle Vie" by Ozenfant, 1929.

"The Divers" by Léger, 1940-42.

Detail, "The Divers" by Léger, 1940-42.

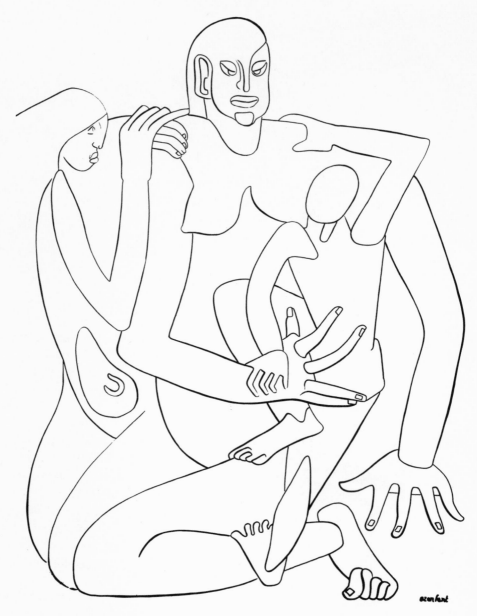

"Maternity" by Ozenfant, New York, 1941. (Painted Drawing.)

PREFORMS

IN 1938 I left Paris and London for New York, where I transferred the Ozenfant School of Fine Arts.

I became an American citizen.

I thought a great deal more about those irresistible appeals, the basic Tropisms to certain Form, Color, and Texture, making great art possible, universal, perennial. I slowly built the *Theory of Preforms*. Here are the outlines of this theory:[9]

Before coming to the United States I visited Athens. The Parthenon filled me with *happiness*. I tried to understand why this rhythm in marble satisfied me so exceptionally.

I thought: "I feel myself surprisingly elated as I look at this play of forms; this surely implies that the Parthenon totally satisfies *something in me*. Must not all possible satisfaction be necessarily preceded in us by a predisposition that the satisfying event fits? Just as a reply is inseparable from a prior question.

"Then, since I feel satisfied by the Parthenon, I must admit, therefore, that the need of this 'structure' existed in me *beforehand*.

"In other words, I am in *love* with the Parthenon."

Here perhaps you will say: "You had seen so many drawings and photographs of the famous temple and had read so much about it since you were a child that you were artificially conditioned to love it." True, the Hollywood publicity directs love towards the Hollywood stars. Yet, did you ever fall in love without having already seen or heard of the 'object' of your flame? Hasn't it ever happened to you to be suddenly struck with admiration for a landscape, a painting, a piece of music or architecture, a poem, an idea, a gesture, an act—or, more often, for something that takes place, something never previously seen or read, or felt, or even heard of? Once while you walked along a beach, wasn't your attention arrested by a miraculously rounded pebble or a divinely shaped shell; you fell in love with it at first sight, and yet you had never seen it before. You pocketed it to live with it.

[9] I started to write about these ideas in "Art en Grèce," edit. *Cahiers d'art*, Paris, 1934.

Are not our needs and the fulfilling facts comparable to a moulding and its symmetrical mould? Similarly: the relationship between lovers, and between the first member of an equation and the second member which satisfies it, etc. Are not our known and unconscious needs a set of negative *structures?*

When the positive structure is unveiled, the pre-existence in us of the coinciding negative structure is *revealed*. (When a truth is discovered for humanity, many feel they have had a premonition of this coming fulfillment. And some flavor of revelation accompanies the event.)

Then I began to feel that the word "structure," used often in this book, was no longer accurate enough; I was afraid of charging it with still more significance. And besides, the word "structure" stresses too much the "skeleton," the "frame work," and not sufficiently enough the totality of things or ideas.

After a series of mental and subliminal operations a word crystallized: PREFORM = the Form of a need.

I had developed, perhaps, a plausible symbolism of our psychological equipment.

Then I felt that the hypothesis of Preforms could be applied to all phenomena of the natural and human fields where sympathy and antipathy, concord and discord, conveniency and inconveniency, adaptability and unadaptability, compatibility and incompatibility—in two words, attraction and repulsion—play a part. For instance: the reason for the success or failure of chemical, physical, biological, psychological, or mathematical operations; the acceptance or rejection of ideas by our minds, $(2 + 2 = 0)$, or of some food by our bodies; the efficient or inefficient running of a machine, or of a society; etc.

Thus a degree of a *fitness* of the form to the preform could be considered as the measure of its efficiency, of its *quality*. Consider the degree of adjustment of a form to a die.

Look at this form:

It is an unassuming form, not a masterpiece—the proof being that we do not feel the complete satisfaction we experience when a masterpiece "works" in us. But it is fairly "good" form.

But it can be improved:

And it can be spoiled:

If a form can be spoiled or improved, is not that proof that the preformed needs in us are most exacting and know what they want?

To improve a form, is it not to adapt it better to its preform? To spoil a form, is it not to untune it, to uncouple it from its preform? In terms of preforms, a *fault* is a lack of adjustment of a form to its preform.

QUESTIONS

Is the Theory of Preforms idealistic symbolism?

It is a symbolism as are all theories, *but it is also a realism—i.e., a symbolism founded on the basic reactions of real man.* Preforms have nothing in common with the *Ideas* of Plato—ideal, transcendental models which man should strive to copy. Is the fact that we have no preforms for strychnine and a taste for the Parthenon and Bach, an idealistic idea?

To my mind, man physical and man psychological is a vast collection of preforms: the sum total of real human needs of all kinds, known and unknown.

Do we possess only pre-established preforms?

Little by little in the course of evolution, and even during our own lives, new needs that mean new preforms are undoubtedly being formed in us.

But surely permanent preforms exist and have existed in man from the beginning of time. (I have given proof of the permanence of some of our predispositions in the chapter on *Eternal Man* and *Man Today*. I think I proved it by showing that works of mind and art created hundreds of centuries ago continue to satisfy a part of us: some of our permanent preforms.

Do you claim that in each man the preforms of masterpieces are pre-existing?

When thinking, we sometimes reach ideas hard to swallow. But in the case of masterpieces, I do not see how those who enjoy them could enjoy them without having the need, the preform of the masterpieces. A fitness must have something to fit. The forms of the fulfilled need and of the fulfilling event must be highly "symmetrical."

Is it so hard to admit? Are we not admitting very easily that, for instance, our stomach can only digest substances for which it has chemical "fitness": preforms?

Does the theory of preforms imply that the future of civilization is predetermined in us?

I would be inclined to believe that much is written in each of us. Each century humanity reads a few new pages. But how many remain to be deciphered?

* * * * *

The Theory of Preforms, here outlined, will be the backbone of my next book.

The search for preforms, being the research for the most basic in man, may help to purify our thoughts, our feelings, our acts: our life. And as a natural consequence our art would gain in humanity, universality, lastingness.

NOTES

1952

L'Esprit Nouveau [*The Modern Spirit*], a review founded in 1920, and led by Ozenfant et Jeanneret.

31 26 Instead of against, read *about*.

33 11 Galena: detector used in early radio receivers.

38 24 . . . purity. Read *exactness*.

53 12 Rodin is now recognized as a very great ancestor by many of the most "advanced" sculptors.

55 6 . . . classical. Read *academic*.

56 3 . . . a few dreary *minor* Dutchmen.

61 16 Add *the Chinese*.

84 Note Add to this bibliography: Alfred Barr, Jr. PICASSO, 50 YEARS OF HIS ART, N. Y., 1946.

93 14 Picasso worship: writing about a book on Picasso published in
 Note 1946, *Daniel Catton Rich*, head of the Art Institute, Chicago, says: "*The authors have turned Picasso not only into hero but God; he is The Creator, no less, 'gigantic,' 'fecundating,' and 'universal'.*"

Then there is the quotation from Plutarch, placed by M. Sabartes, at the beginning of a book on Picasso: "*Plus tu te montres homme et plus tu parais Dieu.*" ["*The more you show your humanity, the more you appear a God.*"]

94 end I asked Picasso to concentrate on some works in which he would sum up all he knew and give himself totally. This, in fact, is what he did with *Guernica*.

I was then living in London and when the Universal Exhibition of 1937 opened, I went to Paris and visited the Spanish Pavilion in which *Guernica* was being displayed.

It moved me very, very deeply. Joyfully I went that evening to the Café de Flore where I had a good chance of finding Picasso. There he was, outside, at a small round marble table. With deep emotion I said to him:

"You have given us a masterpiece! It's plain you have suffered."

PAGE LINE

"Why no! Not at all; what do I care . . ."

(At the time Picasso had domestic difficulties and thought my reference was to them.)

"No! Picasso . . . The war in Spain . . ."

He understood and rose to embrace me.

This little story is a sort of "genre" painting and *Guernica* is one of the greatest historical paintings we have.

130 last line Read *Nevertheless, to release ourselves from the antagonisms of the world . . .*

137 31 Instead of specialists, read *engineers*.

151 2 Bacon said: *"For we cannot command nature except by obeying her."* (Novum Organum).

154 6 This was written in 1928. In fact, an atomic pile in its essentials, looks just like a pile of concrete.

168 10 "Lion Noir"—"Black Lion"—is a traditional French shoe polish.

177 last line Delete this line, which no longer expresses accurately my present status of thought. I will make that clear in my next book. Add those lines of Voltaire: *"Resurrection, Madame* (said the Phoenix) *is the simplest thing in the world. It is no more surprising to be born twice than once."*

182 16 One problem only preoccupies us, *known, unknown, or repressed*—and that is Death.

183 18 The enormous atom plant at Oak Ridge is practically automatic and is controlled from a room linked to some ten miles of instrument panels with fewer than twenty human operators to the mile.

197 2 The Generalissimo was finally purged.

204 16 Akhenaton, XIV Century BC.

214 1 *Our main needs are eternal:* The idea that there has been little or no change in the fundamentals of human nature shocks most

people. The scientist Professor Kapitza, one of the leading figures in atomistics, was severely criticized in Soviet Russia when he said: "*Human nature does not change . . . as is proved by Shakespeare's enduring appeal.*"

215 Note In 1952 one talks of 2,000 miles air speed.

228 25 Add Cranach, Franz Hals, Goya, Hokusai, Rodin, Renoir, Cézanne.

229 13–22 The ancient Jewish writ laid down that every intellectual was to practice an occupation other than that of the spirit. Most wise law! St. Paul was a tent-maker, Spinoza polished lenses. Other instances: Leonardo da Vinci and Michael Angelo worked as engineers; El Greco was an architect; Montaigne and Montesquieu were jurists; Bossuet and Fénelon, prelates; Goethe, Lamarck, naturalists; Diderot, educator, journalist, and teacher; Taine, Renan, Michelet, Henri Poincaré, professors. Paul Valéry had a clerical post at the Agence Havas; Barrès was a congressman; Leconte de Lisle and Musset, librarians; Lamartine, statesman; Rubens, Claudel, Giraudoux, Chateaubriand, diplomats; Stendhal, soldier and consul; Beaumarchais, financier; Shakespeare and Moliere, actors; Malherbe, Maupassant, Huysmans, civil servants; Corneille, Boileau, Racine, La Bruyere, La Fontaine, king's "employees"; Rabelais, physician; Buffon, arborium director; Voltaire, journalist and businessman; J. J. Rousseau, copyist; Alfred de Vigny, Ronsard, Descartes, soldiers; Balzac, printer and businessman; etc., etc.

259 1 *All complex forms are symphonies of four basic sensations.*

260 3 Replace perpendicular by *vertical.*

260 Note Its function, its *gradient* . . .
line 1

260 4 When a curve is progressively flattened its *effect* progressively approaches that of a straight line.

260 24 . . . that short-sighted critics will never understand I am talking *not of the geometry of geometers* but of a "geometry" of sensation.